COROT to BRAQUE

The High Museum of Art, Atlanta *The Denver Art Museum, Denver*

COROT to BRAQUE

French Paintings from the Museum of Fine Arts, Boston

Introduction and Catalogue by Anne L. Poulet and Essay by Alexandra R. Murphy

Published by the Museum of Fine Arts, Boston, Massachusetts *1979*

THE HIGH MUSEUM OF ART
Atlanta, Georgia
April 21 — June 17, 1979

THE DENVER ART MUSEUM
Denver, Colorado
February 13 — April 20, 1980

Library of Congress Catalogue Card No. 79-1719
ISBN 0-87846-134-5
Type set by Dumar Typesetting, Dayton, Ohio
Printed by Acme Printing Co., Medford, Massachusetts
Designed by Carl Zahn

This exhibition was organized with the aid
of a grant from the National Endowment
for the Arts in Washington, D.C.,
a Federal agency.

Contents

Foreword

The Museum of Fine Arts has recently embarked on a program of renovation of its galleries and storage areas, the installation of a climate control system, and the building of a new wing. Preparation for this extensive work has led each department to reexamine its collections and to consider the possibility of sharing some of them with other American museums during the time that they would otherwise be inaccessible to the public. This was, in part, the genesis of the present exhibition of French paintings of the nineteenth and early twentieth century, chosen from the holdings of the Museum's Department of Paintings. It is hoped that this will be followed by other exhibitions from the permanent collections to be shared with various institutions, thus making outstanding works of art available to a wider public in other parts of the country and abroad.

A long history of astute private collecting in Boston and the public-spirited tradition of Bostonians donating their French paintings to the Museum, as well as a continuous policy of purchasing, have given the Museum of Fine Arts a particularly rich collection in which most of the major artists of the period are well represented. The long-standing appreciation of French art and civilization by Bostonians is discussed in detail by Alexandra Murphy in her essay in this catalogue.

The exhibition is chiefly the work of Anne L. Poulet, who played the major role in selecting the paintings, organized the efforts of the Museum staff, coordinated the tour, and wrote the introduction and the entries for the catalogue. We are greatly indebted to her and to John Walsh, Jr., Mrs. Russell W. Baker Curator of Paintings, who has given his enthusiastic support to the exhibition from the very beginning, and to his staff for their efforts to create an exhibition of superb quality. Elizabeth H. Jones and her assistants in Conservation have spared no pains to make each painting look its best, for which we are grateful.

This project could not have been realized without the support of a generous grant from the National Endowment for the Arts in Washington, D.C., a Federal agency. They have made it possible for the exhibition to travel to the High Museum of Art in Atlanta and to the Denver Art Museum. As a result, Boston's French paintings will be seen and enjoyed by a large audience in the southeastern and western regions of the United States.

The Museum of Fine Arts is deeply grateful also to the Nippon Television Corporation of Japan, which shared in the expenses of the production of the exhibition and is underwriting the exhibition's travel to three Japanese cities during five months in 1979. It is the second exhibition of this kind from Boston sponsored by NTV, and they have made it possible for the Japanese public to become familiar with many important works of art from the Boston Museum. It is hoped that this precedent of international cooperation with a corporate sponsor will be repeated with equal success in the future.

JAN FONTEIN
Director

Preface

This exhibition has been assembled at an exciting time for the Museum of Fine Arts, during which a largely new staff of curators has had the pleasure of rediscovering one of the world's great collections of paintings. Weekly inventory sessions in the galleries and storerooms during the past year have confirmed what we had only dared to guess: that Boston's familiar European paintings are part of a huge collection that is even more distinguished than it had seemed. The storerooms have not always been easy to visit (owing to conditions that are soon to change) and for several decades few paintings have been rotated from storage to the galleries to give a notion of the depth and variety of the collection. Looked at fully and systematically, Boston's French pictures in particular provide a lively and nearly complete account of the contending forces of the nineteenth century, a visual history that is hardly rivaled by any American museum. Happily, the National Endowment for the Arts, always on the *qui vive* for ways to bring big museums and smaller ones together, has given us a chance, during renovation of the galleries and storerooms, to send an important group of French paintings to audiences in the South and in the Rocky Mountains, to share the pride and excitement of our rediscoveries.

Anne Poulet was helped unstintingly by dozens of people on the Museum staff, particularly by every last member of the Paintings Department. Elizabeth H. Jones, conservator of paintings, assisted by Brigitte Smith and Jean Woodward, aided in the selection of works and supervised the complex conservation task from beginning to end, including the treatment of some fifty pictures by Katrina Vanderlip. Scott Schaefer and Laura Luckey, assistant curators, helped with logistics, and Robert Starek, technician, did many months of painstaking work to repair and secure the frames. Rushton Potts, a volunteer from the staff, assisted Mrs. Poulet in research on a number of paintings, and Alexandra Murphy, research assistant, whose valuable catalogue essay on the collecting of French art in Boston speaks for itself, provided all sorts of practical and scholarly advice.

For their work on this catalogue we are especially grateful to Carl Zahn, who designed it and supervised its production; to Judy Spear, who edited it with sensitivity and conscience; and to Elizabeth Prelinger, whose knowledge of French and art history made her typing of the manuscript particularly valuable.

From the outset, Linda Thomas, registrar, lent her experienced hand to arrangements for transportation and insurance, scheduling, recordkeeping, and packing; the latter was done by Michael Crivaro with a great deal of care. Lisa Simon of the Development Office dealt effectively with our colleagues at the National Endowment for the Arts; Wayne Lemmon, the Museum's photographer, made excellent new photographs of all the paintings, which are partly responsible for the quality of the color reproductions in this catalogue; and Nancy Allen and her staff in the Library were more hospitable and helpful than we had any right to expect.

JOHN WALSH, JR.
Mrs. Russell W. Baker Curator of Paintings

Introduction

The paintings included in this exhibition were selected from the collection of approximately six hundred French pictures in the Museum of Fine Arts. The choice reveals not only the extremely high quality of the collection but also the depth and breadth of its holdings, representing many of the most important painters and artistic currents of the century. The period spanned is almost exactly one hundred years, from Corot's early landscape *Farm at Recouvrières, Nièvre* of 1831 (cat. no. 4) to Derain's classical postwar *Landscape: Southern France* of 1927 (cat. no. 68). This was a particularly rich and complex century in French art, one during which important changes took place in patronage, artistic education and goals, and painting techniques.

From the founding of the French Academy under Louis XIV in 1663, the educational pattern for a French artist was established and maintained with few changes until the mid-nineteenth century. After a period of training at the École des Beaux-Arts, students competed annually for the Prix de Rome, a prize that provided the winner with a scholarship for three years at the French Academy in Rome. In Italy the artists were expected to study and to make copies after ancient Greek and Roman and High Renaissance art. When they returned to Paris, they were then usually patronized by the crown or the state, providing official art for public buildings, parks, and churches. There was a strict hierarchy of subject matter to which the artists were expected to conform. The highest category was history painting, followed by lesser categories such as religious painting and portraiture. Before the French Revolution of 1789, when artists worked primarily for the crown and the nobility, there was little opportunity for an artistic career outside of the academic system. Artists such as Fragonard, who did not complete their academic training but still found favor and patronage among the nobility, were rare.

One of the extraordinary developments of the nineteenth century, eloquently documented by this exhibition, is the gradual decline in the importance of the École des Beaux-Arts and official academic training in the formation of major artists. Among the thirty-four painters represented here, Bouguereau, whose career followed the prescribed academic course, was the only one to win the Prix de Rome. His picture *Fraternal Love* (cat. no. 28) was executed while he was a student at the French Academy in Rome and, in its close reliance on the High Renaissance model of Raphael, it reflects his following of traditional teaching. Couture competed for the Prix de Rome six times without success, an experience that embittered him against the entire academic system. His studio, founded in 1847, became for young painters such as Manet and Puvis de Chavannes, an independent place of study where an artist was encouraged to develop self-expression, a concept that was the antithesis of the academic approach to painting.

Gérôme, whose works were often purchased by the state, never competed for the Prix de Rome, but was nonetheless elected to membership in the prestigious Institut de France. The only other artists in the exhibition to be accorded the same honor were Delacroix and Bouguereau. These artists were among the most renowned figures of the time, and their paintings commanded the highest prices. Delacroix, the leader of the romantic movement, remains prominent today; however the names of Bouguereau and Gérôme are far less well known, their paintings less famous and appreciated than those of Manet, Cézanne, or Van Gogh, all of whom worked entirely outside the academic framework.

While many of the artists in this exhibition were not trained at the École des Beaux-Arts, the majority of them did submit their works to the annual (or biennial between 1853 and 1863) Salon from the 1830s through the 1860s. The Salon was France's major exhibition, providing the artist with maximum exposure to the public, the critics, and potential patrons. The juries who se-

lected works for the Salon were usually composed of men who upheld the standards of the École des Beaux-Arts, and they regularly rejected paintings that they considered unworthy of exhibition. Théodore Rousseau was refused admittance repeatedly during the decade between 1837 and 1847, and Manet frequently met with rejection.

By the early 1870s independent artists began to find a number of alternatives to the Salon for showing and selling their paintings. Courbet and Manet had led the way by holding separate exhibitions of their works during the Exposition Universelle of 1855, an undertaking Courbet repeated in 1867. Following their example, the artists who were to become known as the Impressionists decided to exhibit in the spring of 1874 at the studio of the photographer Nadar. Despite the fact that initially they were not financially successful, they repeated these exhibitions eight times, the last one being held in 1886. It brought them extensive critical attention and an identity outside of officialdom.

Another important factor in the artists' evolving away from dependence on the Salon was the support of dealers such as Durand-Ruel, who backed them financially and then promoted the sale of their works both in France and abroad in England and in America. He bought from many of the Impressionists, including Monet, Renoir, Pissarro, Morisot, Degas, and Sisley, often providing the financial stability necessary for their survival.

The growth of the industrial middle class during the nineteenth century was one of the most significant elements in the decline of the power of the Academy and official art. While the number of major government and church commissions was small and the competition was keen, there was a large clientèle of bourgeois collectors who were anxious to decorate their homes with works of art. It was first the Barbizon artists, and eventually the Impressionists, post-Impressionists, and early twentieth-century artists who produced paintings appropriate in subject matter and in scale for the private home. Whereas pure landscapes, still lifes, and peasant paintings were disdained within the academic hierarchy, they were easily understood and enjoyed by the private collector. This pattern of private collecting has played an important role in forming our current view of the French nineteenth and early twentieth centuries, for the holdings of many American museums consist mainly of donations from private sources.

As the Academy's control over patronage and the definition of acceptable subject matter waned, painting genres that had been held in disregard during earlier centuries took on new prominence and importance. Landscape and genre scenes, previously viewed as lesser art forms, became the vehicles for major innovations in style and technique. Coinciding with the changing political and social mood in France after the advent of the July Monarchy in 1830, there was an explosion of activity in landscape painting. Until that time French landscape painting had been dominated by the style of the great seventeenth-century classical compositions of Poussin and Claude Lorrain, which consisted of a systematic idealization of nature, usually with the addition of historical or mythological subjects and figures. Both Claude and Poussin had painted in Italy, and their style was perpetuated throughout the eighteenth century at the French Academy in Rome, where young French landscape artists studied.

At the beginning of the nineteenth century, however, particularly after the defeat of Napoléon, new influences became apparent. English romanticism in the form of landscape painting, literature, and prints was the subject of avid study in France. One of the most important artistic events was the Salon of 1824, when about thirty English paintings were shown, making a profound impression on Géricault, Delacroix, and Corot. Constable and Bonington were particularly influential, their fresh studies from nature providing an example for the young landscape artists in demonstrating that the nuanced, shifting effects of northern skies and countryside were as worthy of painting as the sunny Roman *campagna*.

Exposure to Dutch seventeenth-century landscapes was an important factor that came into play after 1830; it led French artists to explore their own country and to

depict the transitory light effects of native skies, terrain, and seasons. Corot's *Farm at Recouvrières, Nièvre* of 1831 (cat. no. 4) clearly reveals the artist's awareness of Dutch prototypes. His large painting of the Forest of Fontainebleau (cat. no. 3), exhibited at the Salon of 1846, testifies to the acceptance by the Salon jury of a pure landscape and of a scene from a native French forest, both of which were new developments in the 1830s and 1840s.

The Revolution of 1848 marked the moment of the triumph of naturalism in French art. Artists such as Corot and Rousseau, who had earlier had difficulty receiving official recognition, became members of the managing committee of the new short-lived, jury-free Salon, and during the following decade the genre of pure landscape painting prospered, particularly that of the Barbizon artists. Rousseau's painting *Pool in the Forest* (cat. no. 14), a scene from the Forest of Fontainebleau dating from the early 1850s, is typical of landscapes popular under the Second Empire.

Courbet's *Forest Pool* of 1862 (cat. no. 21) is a good representative work of the dramatic transition that took place in the 1860s in landscape painting. The light tonality, broad execution, and unromanticized depiction of the scene not only qualify it as a realist work but also point in the direction of the innovations of the Impressionists. Dating from later in the decade, Corot's dreamy landscapes, such as *Turn in the Road* (cat. no. 6), seem retardatory in their romanticism, but in technique they provided an example for the next generation. Corot's interest in a general visual rendering, rather than the depiction of minute physical detail, and his attention to patterns of pure pigment on the surface of the canvas were concepts that were to be expanded in the 1870s.

The earliest Impressionist landscape in the exhibition is Pissarro's *Pontoise, Road to Gisors in Winter*, dated 1873 (cat. no. 32). The choice of an ordinary suburban scene in the Île-de-France as a subject is typical of the Impressionists; it is also one of the reasons for which their paintings were slow to be appreciated. Just as the Barbizon artists had had to struggle against the former

academic regulations requiring a landscape to have a historical theme, so the Impressionists had to fight for acceptance of everyday scenes that did not have the nobility or romantic drama of the Barbizon paintings. The alienation of the public was increased by the Impressionist painting technique and palette. Whereas the Barbizon artists had set an example by painting sketches from nature, most of their finished canvases were completed and rearranged in the studio. The Impressionists, on the other hand, chose to paint entirely out-of-doors before the subject and to depict it without artifice, exactly as it appeared.

The paintings dating from the 1870s in the exhibition, such as Sisley's *Waterworks at Marly* (cat. no. 39), all show a concern for the rendering of atmospheric light using soft, nuanced palettes of pastel and neutral tones. In the 1880s the Impressionists were less unified stylistically, each artist seeking development in his own direction, although all of them shared a general tendency to use more broken brushwork. This technique is evident in Monet's sunstreaked *Meadow with Haystacks at Giverny* of 1885 (cat. no. 47).

In the late 1880s Monet's palette became more intense, and he traveled in search of unusual sites with challenging textures and color effects, such as the Ravine of the Creuse (see cat. no. 52). An important transition took place in his work at this time; the surface of the painting became more relevant, and the pattern of color and use of impasto more artificial and contrived. In his series paintings of the 1890s of, for example, Rouen cathedral (cat. no. 49) his point of departure was still the effect of sunlight on a specific site, but his means of conveying it had become increasingly arbitrary and personal. A stylistic parallel can be found in Van Gogh's *Houses at Auvers* of 1890 (cat. no. 63), which owes a great deal to the Impressionists in choice of subject, in palette, and in its forceful brushwork. As with Monet's late paintings, Van Gogh's work has become a subjective, expressive vehicle for the artist's emotions. For both painters, the picture as a two-dimensional object had an importance as great as that of the subject depicted.

It seems appropriate that the latest landscape in the exhibition, Derain's *Landscape: Southern France* of 1927 (cat. no. 68) should bring the stylistic evolution full circle, back to the classical style of Poussin and seventeenth-century Rome. With the exception of the early works of Corot and the landscapes of Cézanne, the major landscape movement in France in the nineteenth century had been away from classical precedents to those of the northern Dutch and English schools, and to a new naturalism. Derain, on the other hand, working after the turmoil of the First World War, was interested in permanence and in a balanced and structured style.

The six seascapes in the present exhibition provide an interesting overview of this genre between 1860 and 1895. During the late eighteenth and early nineteenth centuries romantic seascapes depicting storm-tossed boats and dramatic shipwrecks were popular. Within the naturalist tradition it was Boudin, born on the coast of Normandy to a seafaring family, who first began in the 1840s to paint the sea and coastal areas of France. His works are marked by calm rather than drama, reflecting an intimate knowledge of the sea and careful observation of its changing colors and moods, as is exemplified in *Port of Le Havre: Looking Out to Sea* (cat. no. 25), a late work dating from 1886. The same sensitivity to local color and reflected light on the water is apparent in Monet's paintings of southern coastal regions. The *Old Fort at Antibes* (cat. no. 45), painted in the brilliant pastels of the Mediterranean, is similar in range of palette and simplicity of composition to Boudin's *Venice: Santa Maria della Salute from San Giorgio* (cat. no. 24), executed when the artist was seventy-one years old.

In contrast, Ziem's *Venetian Coasting Craft* (cat. no. 23) is so vague in detail that it is more a fantasy work than a true seascape. It owes its inspiration, in large part, to the Italian eighteenth-century *veduta* painters Guardi and Canaletto.

One of the most surprising paintings of this group, both for its subject and for its style, is Millet's *Fishing Boat at Cherbourg* (cat. no. 17). Seascapes are relatively rare in his oeuvre, most of them dating from the last decade of his life. The freshness of the palette, reminiscent in its intense blue-greens of the works of Delacroix, and the vigorous use of small brushstrokes make it an important precursor for the Impressionist seascapes, for example, Monet's *Sea Coast at Trouville* (cat. no. 48), painted a decade later.

Another genre that grew out of the development of nineteenth-century landscape painting was animal painting. A direct result of the naturalist movement, its precedents were to be found in the Dutch seventeenth-century animal and hunt paintings, English sporting pictures, and the works of the great eighteenth-century animal painter François Desportes. There was a ready market for animal paintings among the French bourgeoisie, who were fond of country living with dogs, horses, and hunting. Troyon, who had studied the works of the seventeenth-century Dutch *animaliers* Cuyp and Potter in Holland in 1847, specialized in this type of painting. In the years between 1855 and 1865 he executed a number of large pictures of individual animals in landscape settings, such as *Fox in a Trap* (cat. no. 13), that were enormously popular with collectors.

The depiction of horses in violent movement by David and Géricault in the romantic paintings of the early part of the century had their own progeny. Delacroix's great *Lion Hunt* (cat. no. 8), with its tumult of horses and wild animals in combat, depends for its inspiration on these precedents as well as his memories from North Africa and Rubens. While this colorful struggle between man and beast is entirely different in mood and execution from Daumier's subdued and mysterious picture of three horses and two riders (cat. no. 12), they share romantic origins. This is in sharp contrast with, for example, Degas's *Race Horses at Longchamp* of 1873-1875 (cat. no. 35), a painting of a relatively new sport in French modern life in which the artist captures with dispassionate accuracy a seemingly random moment before the race begins.

The romantic movement was characterized, in part, by a love of the exotic and the mysterious. Oriental themes became an important expression of this fascination with non-Western cultures and customs. Trade

with the Far East had been active in seventeenth- and eighteenth-century France, especially in the areas of porcelain and lacquerware, and artists such as the Swiss painter Liotard had painted figures in oriental costumes. In the nineteenth century it was the military campaigns of Napoléon in North Africa and the uprising of the Greeks against the Turks in 1821 that focused attention on the Near East. The death in 1824 of the English poet Lord Byron, who had volunteered to help the Greek cause, sparked the French romantic imagination and resulted in a burst of artistic activity. Delacroix painted his famous *Massacres at Scio* in 1824, and Victor Hugo published *Les Orientales* in 1829; the French conquest of Algeria, which followed in 1830, led to a general interest on the part of a number of artists in the countries surrounding the Mediterranean.

Delacroix traveled to Algiers and Morocco in 1832, and the trip was to inspire many important paintings of North African themes until the end of his life; these works, in turn, were instrumental in spreading an interest in the Near East to other artists. Fromentin traveled to Algeria three times between 1846 and 1853, and he became a specialist in the depiction of Arabian scenes. Paintings such as *The Standard Bearer* (cat. no. 22) of the early 1860s enjoyed great critical and commercial success.

Part of the appeal of the Near Eastern paintings was the exotic contrast they offered to the industrialization and urbanization of France. Artists took considerable license with these *orientaliste* pictures, often treating them as imaginary scenes. Diaz, for example, never went to North Africa, and in fact rarely ventured beyond Barbizon and the Île-de-France. His painting *In a Turkish Garden* (cat. no. 9) is a theatrical fantasy in which he had little concern for historical accuracy. Even Gérôme, who went to great lengths to paint settings and costumes with exact detail, would westernize a composition, introducing a European bather into an authentic Egyptian bath (see cat. no. 27) because his patrons loved this blend of exotic archaeological detail with a traditional, slightly erotic European subject. After the 1870s the vogue for Near Eastern themes diminished in French painting, their place being usurped by the artistic exploration of local landscapes and contemporary urban life.

Perhaps the most complicated and revealing developments in nineteenth-century art were in the area of figure painting, both in interior scenes and in outdoor settings, paralleling the growth of naturalism in landscape painting. The gradual breaking away from academic rules, which admitted figures only when they appeared in a classical, mythological, or historical context, led to the burgeoning of genre and peasant painting. In the late 1840s and early 1850s Millet and Courbet began painting ordinary peasants occupied in simple daily tasks. Both artists had grown up in the country, children of prosperous peasants, so their paintings were, in part, an expression of their childhood experience. At the same time, they, like the Barbizon artists, looked to the Dutch seventeenth century for models in genre painting and transformed them through firsthand observation. Dating from the period of the French Revolution of 1848, and the triumph of the Republicans, who championed the cause of the common laboring man, these paintings and their artists were regarded as the embodiment of Republican ideals, and the public and critics instilled them with a political meaning that was not always intended by the artist.

Millet, in his peasant paintings of the early 1850s, infused his figures (*The Spinner* [cat. no. 15], for example) with an extraordinary dignity, no matter how menial their labor. The same can be said of his peasants in outdoor settings, such as the potato planters (see cat. no. 18), who are given monumentality as they dominate the landscape in which they work. After these paintings lost their revolutionary connotations in the 1860s, they were avidly purchased by bourgeois collectors who saw them as idealizing the work ethic, the guiding principle of the self-made men of the new rich middle class. At the same time, they were appreciated as an evocation of the rural life style that was vanishing from the French countryside.

Several artists, such as Lhermitte (cat. no. 60) and Julien Dupré (cat. no. 61), fell under the spell of

Millet's work along with that of the Impressionists. Their own version of the peasant painting, less powerful and monumental than Millet's, focused on anecdotal scenes of farm life, emphasizing the more attractive and charming aspects of rural living. They incorporated in these works a conservative interpretation of the light palette and atmospheric effects found in the paintings of Renoir and Monet, with a pleasing, if less original result.

The artist who was the true heir to Millet and Courbet, as well as to their Dutch antecedents, was Van Gogh. Painting in the 1880s, more than thirty years after Millet's first peasant paintings were executed, Van Gogh was pessimistic about the peasants' survival and saw them to be a trapped and suffering group, condemned to poverty and to obsolescence. His early Dutch peasant pictures, such as *The Weaver* (cat. no. 62), are charged with empathy for their indigent way of life.

A second trend in figure painting in the last half of the century, which depended on Dutch seventeenth-century domestic interiors, was that of the depiction of middle class women, and sometimes children, engaged in simple daily activities. The earliest picture of this type in the exhibition is Toulmouche's *Reading Lesson* (cat. no. 29) of 1865. Painted in the academic *fini* style, with great attention to the slick finish of the surface and precise details of setting, it is a slightly sentimental portrayal of maternal devotion. Paintings such as this one were enormously popular during the Second Empire, embodying the values and taste of the upper middle classes.

The Impressionists painted a number of works of this type, both in interior and in outdoor settings. Throughout his career Renoir depicted women and children in entirely natural and unself-conscious poses while engaged in various domestic activities, for example, *Girl Reading* (cat. no. 56) and his painting of his son Coco learning to play dominoes with his nursemaid (cat. no. 55). Degas was among the most innovative artists of the Impressionist group, not only in exploring new subjects taken from modern urban life, but also in designing highly original compositions for these works, such as *A Visit to the Museum* (cat. no. 36). Like Degas, Vuil-

lard displayed the ability to paint the essential movements and gestures of a woman absorbed in a specific task, oblivious to the artist's presence (see *Woman Sewing* [cat. no. 65]).

Portraiture was an extremely important category of figure painting in the nineteenth century, one that enjoyed enormous growth and considerable technical innovation. Members of the expanding middle classes were anxious to have their portraits painted, and many artists from Ingres and Delacroix to Couture, Manet, Degas, and Toulouse-Lautrec executed major works of this genre. Only a few have been included in this exhibition, however, and some of them are more figure studies than actual portraits. An example is Cézanne's great painting *Mme Cézanne in a Red Armchair* (cat. no. 44) in which the sitter is treated as an object whose volume and color must be transformed into a classically balanced composition. The same objectivity and psychological distance are to be found in Manet's *Victorine Meurend* (cat. no. 33) and in Matisse's early *Carmelina* of 1903 (cat. no. 67). Each of these artists is primarily interested in the human figure as an object, the form of which presents a specific pictorial challenge.

In contrast, Degas's *Portrait of a Man* of the early 1860s conveys the inner character of the man without abandoning an objective representation of his features. Degas was a great portraitist who experimented in the late 1860s and 1870s with an expanded and unorthodox use of setting to reveal the nature and interests of the people he portrayed. Toulouse-Lautrec, who was profoundly influenced by the paintings of Degas, and who was a master draftsman, achieved the same degree of psychological penetration of his sitter's character in *Woman in a Studio* (cat. no. 64). It should be remembered that much of the innovation found in the portraits of Degas and Lautrec was possible because they were painting either a paid model or a family member or friend. Commissioned portraiture of this period followed far more conventional lines, the sitters usually demanding a flattering likeness and a traditional pose.

A type of painting that enjoyed a great increase in popularity in France after about 1850 was the still life. Objects that had been considered too lowly and humble

to be worthy of painting were, after the Revolution of 1848 and the ascendancy of naturalism and realism, suddenly acceptable. These works, the precursors of which may be found in the paintings of Chardin, Desportes, and the Dutch and Flemish seventeenth century, were collected as decorations for private homes. One of Fantin-Latour's earliest still lifes, *Plate of Peaches* of 1862 (cat. no. 37), painted with great sensitivity to the texture and color of the fruit, reflects Fantin's study of the works of Chardin. Still-life painting was popular among many of the Impressionists, often providing diversion on stormy days when it was impossible to paint out-of-doors. Sisley's *Grapes and Walnuts* of 1876 (cat. no. 41), rare in his oeuvre, is executed in the bright colors and broken brushwork associated with his contemporary landscape style.

Cézanne's *Fruit and a Jug* (cat. no. 42) of the early 1890s, differs significantly from Impressionist still-life paintings. Emphasizing the two-dimensional surface of the canvas and the interlocking blocks of color on it, this cerebral approach to painting was seminal in the development of Cubism. Braque's *Still Life* dated 1921 (cat. no. 69), also based on a careful grouping of humble, everyday objects, owes its stylistic origins mainly to Cézanne. Pushing the concept of the painting as independent object even further, Braque departed from the rules of linear perspective and three-dimensional illusionism. He remained attached to real objects, but he freely interpreted their colors, textures, forms, and spatial relationships to create a balanced and harmonious canvas.

While the paintings in this exhibition represent a wide diversity of artistic activity during the century it encompasses, there are unifying trends to be discerned. The first is a movement away from works of art that are obscure in meaning or that require a profound knowledge of history, classical literature, or mythology in order to be understood. With the decline in state and church commissions and the growth of the industrial moneyed class of patrons came a democratization of art, paralleling the struggle for political liberty and economic equality carried on throughout the century. The growing esteem for the dignity of hard work and the

nobility of the proletariat was a direct result of these political changes and led to the introduction of a wide range of non-academic subjects in art. Pure landscape painting and depictions of common laboring peasants, animals, and still-life subjects, all easy to understand and pleasant to live with, are manifestations of this movement.

In the second half of the century there is a further development in the treatment of formerly unworthy subjects with the Impressionist painting of the Paris suburbs, and weekend leisure activities such as boating, picnicking, and riding. At the same time there is an artistic exploration of urban themes, including train stations, cafés, brothels, the theater, and dance.

Just as important, however, is the new liberty in painting technique and the new emphasis on the significance of individual expression, which corresponds to the search for political liberty. From the vivid palette and free brushwork of Delacroix to the direct oil sketch technique taught by Couture in his independent studio, to the experiments with broken brushwork and the use of pure color by the Impressionists in the 1870s and 1880s, and the more scientific pointillism of Seurat, there was a development that led away from accuracy of drawing and illusionism to an increasing emphasis on the style and brushwork of the individual artist and the separate "life" of the surface of the two-dimensional canvas. Under the influence of Japanese prints and the new art of photography, there were experiments with the manipulation of space and unorthodox compositional arrangements. This freedom to distort the appearance of objects and space in order to achieve new pictorial effects led the artist to become more aware of the shape and limitations of the flat canvas.

The late works of Monet, Degas, Cézanne, Pissarro, and Van Gogh reveal the transition from the depiction of a transitory moment in nature to translating a personal expression of the artist, as the subject itself becomes less important. This gradual evolution away from picture-window illusionism toward an articulation of the artist's inner vision was fundamental for the development of both Cubism and expressionism in the twentieth century.

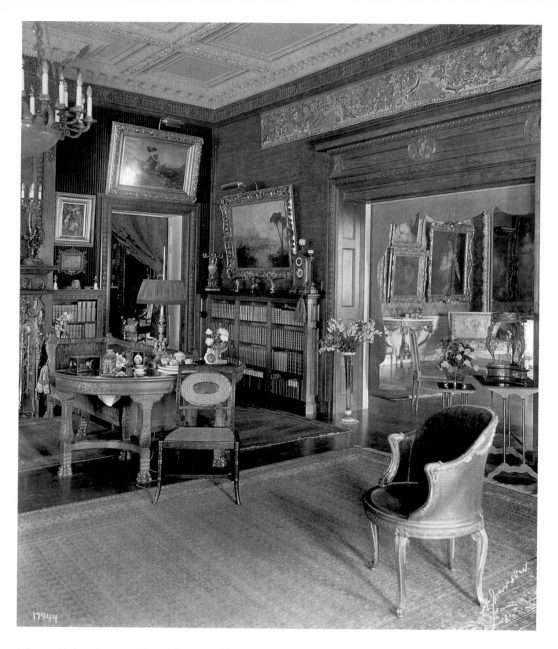

Library, Robert Dawson Evans Home, 17 Gloucester Street,
Boston, about 1910. Between 1875 and 1917, Evans and his wife
put together one of the most eclectic collections in Boston, reflect-
ing both the city's long-standing interest in French painting as
well as the turn-of-the-century taste for formal portraits by Eng-
lish and Northern masters. This view of the Library shows Fro-
mentin's Standard Bearer *(cat. no. 22) hanging over the doorway.*

French Paintings in Boston: 1800-1900

Concerned that rich Americans were rapidly carrying off the greater part of France's modern art patrimony, the French government in 1886 commissioned the art critic E. Durand-Gréville to tour America's private art collections in order to prepare a catalogue of all French paintings in the United States. Durand-Gréville's findings were summarized in two articles in the prestigious art journal *Gazette des Beaux-Arts*, and the editors must have been highly disturbed by his report. After a six-month tour of more than one hundred collections, Durand-Gréville exclaimed: "I would never have believed, had I not confirmed it myself, that the United States, so young a country, could be so rich in works of painting, especially works of the French school. It is not by the hundreds but by the thousands that one must count them."[1] About the only comfort Durand-Gréville could offer his countrymen was that Americans did indeed appreciate the French paintings they were buying so voraciously—they did not, as some angry critics had claimed, purchase paintings solely on the basis of their weight in gold, ostentatious frames included.

Perhaps what alarmed the French most about the thousands of French paintings in America was the extraordinary speed with which Americans had been able to dominate the contemporary art market. Nearly all the paintings seen by Durand-Gréville had come to the United States in less than thirty years; most, in fact, had been purchased since 1870. Americans, who, for much of the first half of the nineteenth century, had displayed so little interest in French painting, or any painting for that matter, did not make their first serious acquaintance with contemporary French art until 1850; within twenty years they were the major presence in the French art market, regularly outbidding even the wealthiest French collectors.

In spite of the fact that Durand-Gréville had given most of his attention to the collections of a small number of New York millionaires, nearly a third of the paintings he singled out for discussion were in Boston hands, or would be before the century was out (as was the case with a number of important New York paintings). Durand-Gréville explained his disproportionate interest in New York collections by pointing out that they were larger and more varied than those formed in other American cities. He could also count on the collections of New York millionaires to be better known to his French audience because of the uproar surrounding several celebrated sales: Rosa Bonheur's *Horse Fair*[2] went to a New Yorker despite a last-minute bid by the emperor, and, amid extraordinary journalistic distress, Ernest Meissonier's *Battle of Friedland, 1807*[3] was sold to another New Yorker, sight unseen, for the unprecedented sum of $60,000 (plus a tariff of $8,000 and a reputed $8,000 shipping bill). But while Boston had no single collection as large as Vanderbilt's (he owned 174 paintings in 1884) and certainly none as well publicized, there were more French paintings of quality in Boston than in any other city in the country. Most of them had never been seen by Durand-Gréville.

That Boston should have taken up nineteenth-century French painting so seriously was, to a certain extent, part of a national and international phenomenon, as Durand-Gréville's reports make clear. The United States had long had a special attachment to France as an ally during the American War of Independence; French literature and philosophy underlie many of the earliest American statements of political principle, while during the nineteenth century the works of George Sand were being translated for American audiences within a year or two of their original publication. Americans traveled to Paris in large numbers for study or pleasure both before and after the Civil War. French art enjoyed particular prominence throughout the world in the nineteenth century, and the passion for collecting painting and sculpture became an identifying feature of the international prosperity of the last half of the nine-

teenth century. But that Bostonians so vigorously collected the works of French artists little regarded by their fellow Americans and occasionally scorned even in Paris seems to be explainable only by factors that are uniquely Boston's.

For, when the American critic William H. Downes wrote about Boston's French painting collections in 1888, he made it quite clear that Bostonians went about their picture collecting very differently from New Yorkers: "Boston amateurs have never made such extensive, costly and showy collections as those of the Vanderbilts, Belmonts, and Stewarts of New York, or of Mr. Walters in Baltimore, but the number of good pictures modestly housed in the homes of 'the upper ten thousand' of the city is astonishing; and it is a significant fact in the history of art that there was a time when New York dealers who had a good Corot or Courbet were obliged to send it to Boston in order to sell it."[4]

Downes astutely pointed out several of the most significant points distinguishing Boston's painting collections from those being formed elsewhere in the country. Bostonians kept small collections of pictures purchased discreetly and cheaply, often directly from painters whom the collectors sought out themselves. Few owners of French paintings (and in most collections French paintings outnumbered all other schools) had more than twenty or thirty works and these were hung throughout their homes, not in specially designed semi-public galleries. Bostonians chose paintings they wished to live with, not paintings to flaunt. But most important, Boston's group of collectors was very large and, at any given time between 1850 and 1900, those collectors were generally two or three steps ahead of their countrymen in taste.

The typical Boston collector of the 1850s and 1860s was a broadly educated man of considerable but not conspicuous wealth, whose family was generally tied to the city by several generations of accomplishment, unlike many of the newly rich, vastly rich, collectors in New York, Baltimore, and Philadelphia who consciously used their painting collections to underline their wealth, social status, and taste. With fewer purposes to serve

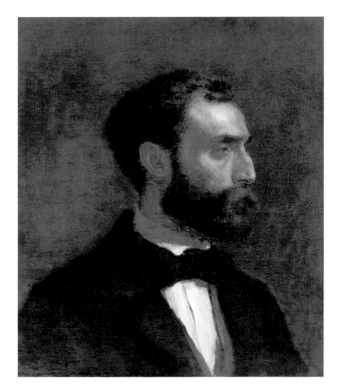

JEAN-FRANÇOIS MILLET, *William Morris Hunt*, ca. 1854. *After leaving Harvard in 1843, Hunt studied art in Rome, Düsseldorf, and Paris, working first with Couture and then Millet. Hunt formed a very close relationship with Millet, acting as his agent with many Boston collectors. When Hunt returned to Boston, he regularly quoted both Millet and Couture in his courses and recommended them as teachers for American pupils traveling to Paris. (Smith College Museum of Art, Northampton, Massachusetts)*

Facing page:
JEAN FRANÇOIS MILLET, *Harvesters Resting*, 1853. *Martin Brimmer spent several months in Paris after graduating from Harvard and before returning to Boston to practice law. While in Paris, he studied art and, through the intervention of William Morris Hunt, purchased a number of paintings. Harvesters Resting was the first Millet exhibited outside France when Hunt lent it to an Athenaeum exhibition in 1854. (Museum of Fine Arts, Boston. Bequest of Mrs. Martin Brimmer)*

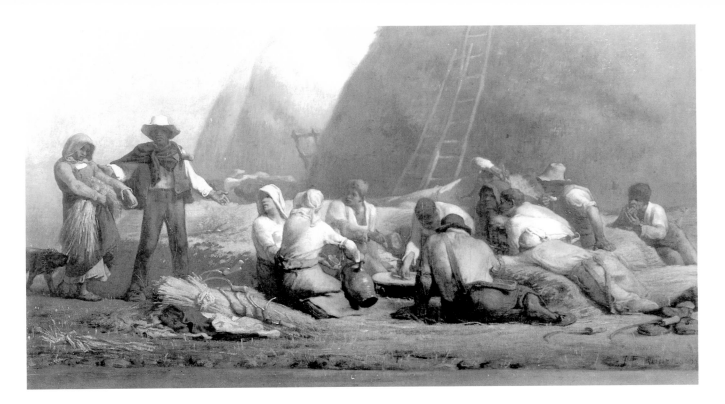

through their collecting, Bostonians were freer to indulge their personal tastes. In Boston, the art-collecting public was generally synonymous with the intellectual and financial elite of the city. Boston was probably unique in possessing a social milieu in which a large number of artists, writers, and amateurs, many professionally trained in Paris, moved quite freely. Both Washington Allston and William Morris Hunt, the leading Boston artists of the first and second halves of the century, respectively, married daughters of the city's most prominent citizens, something unlikely to have been permitted anywhere else in the world. Several of Boston's outstanding lawyers, doctors, and scholars of the 1860s and 1870s had studied in a Paris art studio during the 1840s and 1850s—or had longed to do so. More important for the specific direction its collecting took, Boston had, from the beginning of the century, provided the intellectual leadership that established an American literary-philosophical tradition: it identified the source of creativity with nature and the land, and

placed the highest value on those expressions of creativity that embodied a spontaneous, individualistic response to nature. From the very first pages of the very first issue of Boston's first major political and literary journal, *The Monthly Anthology and Boston Review*, in 1803, art in its broadest connotations was defined and justified with terms and images taken from nature and landscape painting.[5] And, surprisingly, throughout the 1850s and 1860s, when collecting became so popular in the city, Boston lacked either a major art school or an art journal that might have defined or prescribed standards and taste. Consequently, Boston's professional artists and the amateur artists among the lawyers and bankers enjoyed a considerably greater and freer role in directing collectors' interests than they did in New York or Philadelphia, both of which had had academies of design since early in the century. When an artist such as William Morris Hunt or Lilla Cabot Perry, both well born and well married, introduced the peasant scenes of Millet or the exuberantly painted landscapes of Monet

to their Boston friends, those friends were culturally equipped to appreciate the work of artists so much of the world found difficult to understand, and wealthy enough to collect it on a significant scale. Thomas Gold Appleton bought paintings by Diaz and Troyon in the late 1840s and 1850s; Martin Brimmer bought Millet in the 1850s; Henry Sayles bought Rousseau and Daubigny in the 1860s; Henry C. Angell bought Corot in the 1870s; and Peter Chardon Brooks bought Monet in the 1880s, all favoring naturalistic, rural themes and landscape paintings. Ahead of the broader taste in Boston, these collectors all helped introduce generally unknown artists to the greater collecting public through generous loans to the large numbers of exhibitions held in Boston during the 1860s and 1870s. There were few blockbuster pictures here such as the *Horse Fair* or *The Battle of Friedland, 1807*, and only one collection, that of Thomas Wigglesworth, with his Bouguereaus and Alma-Tademas and Merles among the Coutures, Courbets, and Corots, could rival the more famous New York collections in eclecticism. That is not to say Bostonians had no share in the general, late nineteenth-century interest in sentimental family scenes, gaudy history pictures, or mildly erotic "ideal" nudes. Probably every artist represented in New York collections could be found somewhere in Boston. But, as with Wigglesworth's Bouguereau, *Fraternal Love* (cat. no. 28), which hung alongside one of the first and most important Courbets to come to America, *Les Demoiselles de Village*,[6] the story paintings were surrounded by landscapes by the painters Bostonians came to call "The Men of 1830," the Barbizon masters who first received public notice following France's revolution of 1830. Naturalism, not sentimentality, was the rule in Boston.

Along with Bostonians' interest in naturalistic subject matter went an appreciation, and in some cases a passion, for the qualities of sketchiness and strong color that characterize much of the nineteenth-century painting most admired today. This was not a taste shared by their fellow collectors elsewhere, as is made clear in an article that appeared in the *Boston Post* at the time of the exhibition of two Boston private collections in New York in 1889: "that a sketch is very often more acceptable than a finished picture, because of its greater freedom, looseness, purity of color and spontaneity, is a statement which may seem superfluous in Boston, however shocking it may be to New York. The comments of some of the metropolitan art critics [regarding the Warren and Capen collections] betray a narrowness of spirit which is surprising, for in recent years they have had abundant opportunities of seeing and studying all phases of modern art and of growing far away from the standards of that New York amateur who boasted that in his whole collection there was not a single picture which showed a brushmark."[7]

The astounding variety of Barbizon landscapes, the unmatched numbers of works by Millet and Monet in the Boston Museum of Fine Arts, came almost entirely from private purchases between 1850 and 1900. Unlike larger painting collections elsewhere in the country, few of Boston's collections were broken up at auction. Most stayed in the hands of the original owner or his or her family, frequently to be given or bequeathed to the Museum over a number of generations. More than one-third of the European paintings in the Museum's collection are works of the French nineteenth century. Of that number, more than ninety percent were brought to this country before 1900 and the greatest part were presented to the Museum by the original owner or a family member. In 1978 alone, three paintings by Monet, all of which had entered Boston collections in the late 1880s and early 1890s, within a few years after they were painted, were given to the Museum by direct descendants of the collectors who first brought them to Boston.

The apparent triumph of French painting that greeted Durand-Gréville in 1886 had been hard won and was still subject to challenge. Although works of French art appear in Boston's earliest collections, for much of the first half of the century influential critics had singled out the French school of painting for abuse, and the works so popular in 1886 had been decried as "impure,"[8] "morbid,"[9] vicious,"[10] or "contemptible"[11] as recently as 1878. Even in 1884, when a number of art students began a public subscription to purchase Henri Reg-

nault's *Automedon with the Horses of Achilles* for the Museum, a considerable debate raged in the newspapers over the suitability of such a picture for a public collection. The exuberance of the paint handling and the strong, bright colors that had so impressed French critics when the painting was first exhibited in Paris met a small but vocal resistance in Boston. One teacher of drawing and design at Harvard denounced it as "about the most pernicious thing that could be placed before young students of painting."[12]

The thousands of nineteenth-century French paintings accumulated in Boston between 1850 and 1900 provide a striking contrast to the fewer than one hundred French paintings of all periods included in the annual exhibitions of the Boston Athenaeum (Boston's only regular exhibiting institution prior to the establishment of the Museum of Fine Arts in 1870) between 1827 and 1850. The history of the collecting of French painting in Boston during the nineteenth century is a highly reliable measure of the history of taste in the city, pointing to the problems and triumphs shared by all collectors before the mid-century and the gradual achievement of preeminence for French painting later in the century. The success of French painting was intimately entwined with the development of American painting in Boston and the rise of an aesthetic criticism independent of New York, then seen by many as the art capital of the country.

A Bostonian who wished to see a French painting in 1800 had only two choices: to visit the Columbian Museum of natural curiosities and art works, and, possibly, to search out one of the few Catholic churches in the city. That he should wish to see a French painting at all may be a rather ingenuous hypothesis, for the notion that paintings other than portraits had any useful purpose to serve in the new republic was not a widely accepted one. As Neil Harris points out, "the legitimization of artistic energies in America was a lengthy and articulate process."[13] Throughout the late eighteenth and early nineteenth centuries, Americans were asking themselves whether in fact artists were needed in the new society being created, and whether or not painting could prove a productive rather than a corrupting influence. Art and the problems of ostentation and wasteful consumption that came in its wake posed a serious challenge to a nation seeking an active definition of democracy as well as material progress. In the next few decades, as calls were raised in Boston as well as elsewhere for both institutional and private support for art of all kinds, but especially for painting, the proselytizers felt compelled again and again to answer arguments about the corrupting force of art and to suggest means to protect the American spirit from that force. French paintings in particular, perhaps because of the frivolity and eroticism that had characterized much recent (i.e., eighteenth-century) French painting, were singled out for criticism.

Nonetheless, in 1800, Boston did have one collector who probably provided a few French paintings for the curious or admiring viewer: Daniel Bowen, operator of the Columbian Museum. Founded in or about 1791, the Museum began as a collection of wax works, expanding to include minerals and stuffed animals as well as paintings. By 1803, it had become noted as "a fashionable resort."[14] Destroyed by fire, rebuilt twice, and reassembled again soon thereafter, the Museum enjoyed considerable longevity, which must have reflected substantial popularity. It was finally absorbed into another such undertaking in 1825. Prior to the first fire, visitors could have seen a picture of Belisarius (a Roman general whose virtues had attracted a number of late eighteenth-century French artists) as well as portraits of American heroes, Shakespearean scenes, and views by "Asiatic, European and American masters." Reopening after the fire, the new collection featured the *Battles of Alexander the Great*, copied from LeBrun, the first paintings specifically identified as French (at least in inspiration) on public display in Boston. Along with a *View of Hyde Park, London*, and a *Venus and Cupid*, one could study "the last family interview of the late King of France." At least fifty paintings (possibly including engravings) were on view. A number of similar establishments, all combining works of art with curiosities of various kinds, are noted in Boston throughout

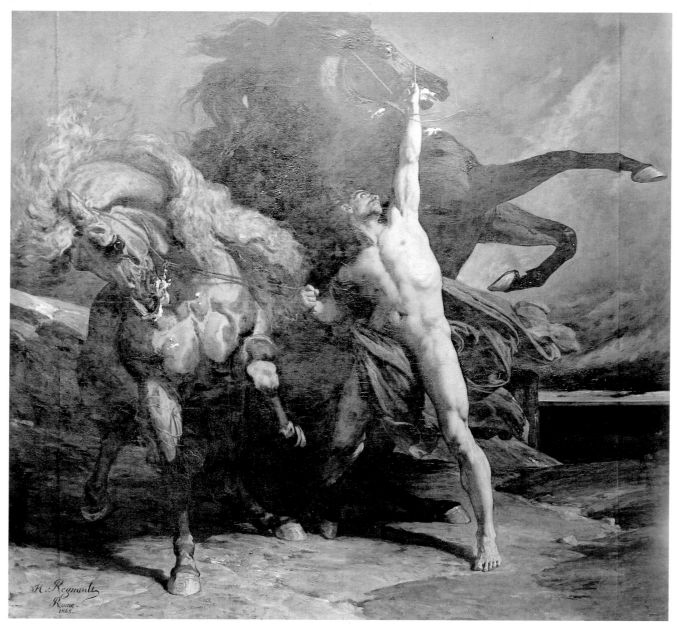

A. G. Henri Regnault, *Automedon with the Horses of Achilles,*
1868. When Boston art students launched a subscription cam-
paign to purchase the large Automedon *for the Museum in 1884,*
they encountered substantial opposition from a number of art
teachers and critics. The strong coloring and bold, loose execu-
tion of the painting, widely praised by French critics, was consid-
ered by some Bostonians as far too "raw" for young students to
emulate. (Museum of Fine Arts, Boston, Gift by subscription)

the first half of the century, but what paintings they may have offered are unknown.

Similarly, whether any French paintings adorned Boston's first Catholic churches presents an intriguing problem. The Catholic population of the city during the early nineteenth century was negligible, but the terrors of the French Revolution brought a number of Royalist Frenchmen to the city. Many of the fleeing Frenchmen who chose more welcomingly Catholic cities such as Baltimore did bring paintings as easily transported assets with them, often selling or leaving them behind when they returned to a calmer France. If this was also the case with Boston's immigrants, it might explain the otherwise untraceable origins of several religious paintings in early collections. Boston was still strongly Puritan in 1800, and could be expected to be disdainful if not intolerant of such images, but it was a Puritanism muted by the easing of daily life brought about by the growth of wealth that had characterized the eighteenth century. Religious pictures such as *Saint Anthony*, *Saint John*, and a *Holy Family* were tolerated in the Columbian Museum and, by the time of the first Boston Athenaeum exhibition in 1827, several of Boston's most staunchly Unitarian and Congregationalist families were able to lend decidedly "Catholic" religious pictures as well as the more expected family portraits.

Beyond the Columbian Museum, however, the known opportunities for picture viewing were few. In 1810, *The Monthly Anthology and Boston Review* published the first of what would become a regular series of arguments for the establishment of public and private collections. In an address for the Phi Beta Kappa Society at Harvard, William Tudor lamented: "Galleries of paintings and collections of statues, for the double purpose of exciting taste in the publick, and furnishing models to the artists are yet to be created. The common excuse for this neglect is that we are not rich enough. Alas! the poverty is not in our purse, it is in our taste.... Let us hope that this spirit may be awakened; that the time is not remote when we may cease to drive our artists to seek protection in other countries on which they confer honor."[15]

The fact that a number of American artists, despairing of adequate appreciation in their own country, had fled abroad, and that among them Copley, West, and Allston were applauded and regarded by Europe as her own, was a bitter blow to those who would establish an American school of painting. Such a blot on national pride was regularly called up whenever an individual or institution pleaded the cause for an art school or gallery. Tudor himself, five years after his Harvard address, tried to enlist supporters for the purchase of casts of the major sculptures in the Louvre as well as copies of the most noteworthy paintings (casts and copies because it was felt originals of great quality were not to be had) by arguing that such a collection with its attendant possibilities for exhibition might induce Allston to make his home in Boston.

Tudor did not raise his goal of $30,000, although he found a number of interested and generous contributors. Boston's slowly developing concern for art received a strong boost, however, when Washington Allston did settle in Cambridge in 1818, thereby doubling Boston's population of internationally known artists (Gilbert Stuart being the other). Allston, with his great unfinished masterpiece *Belshazzar's Feast*[16] begun in London and continued in Cambridge for thirty years, became a source of fascination to the Boston community, well known to a privileged few who frequented his studio, and much talked about by a great many more. As a deep admirer of Italian Renaissance painting, Allston had little direct effect on the collecting of French painting, but with his international reputation and imposing presence, he quickly became a symbol around which an active circle of art lovers developed in Boston for the first time. The wide range of his own work provided opportunities for patronage of modern art (other than portraits) that had not previously been available; the attention and assistance of a number of wealthy merchants who felt a public obligation to help the artist out of his regular financial difficulties established a precedent for strong merchant support of Boston's artists and art institutions that would continue well into the 1860s, when the art public expanded greatly.

Until the Boston Athenaeum began regular loan exhibitions in 1827, Bostonians seldom saw more than a few works of art together at any one time. What they knew of contemporary painting depended on the irregular visits of traveling exhibitions of a single spectacular painting, usually of great size, displayed with considerable pomp and advertisement in any local hall of sufficient scale. Although these paintings were generally by American artists, Bostonians were able to see occasionally such major French paintings as Jacques-Louis David's *Coronation of Napoleon* (the replica by David and studio, Musée de Versailles), which was shown for several weeks in 1827 at Faneuil Hall Market. For twenty-five cents visitors viewed what was billed as the largest picture ever painted (750 square feet of canvas, as the catalogue pointed out), and studied the carefully identified principal participants in a historic event still of great interest in Boston. Although no records of attendance exist, one may safely speculate that the exhibition was quite a success: David was one of the few artists whose name was likely to be recognized by the cultured public, while Napoleon seems to have fascinated the whole of the city. As book auction records attest, books on Napoleon, whether paeons or diatribes, were among the most popular and widely distributed volumes in Boston during the first two decades of the century. This widespread Napoleonic interest was responsible for the inclusion of two life-size portraits of the emperor and a large number of miniatures in Boston's earliest picture collections. Among art collectors he seems to have been more popular than George Washington.

In 1832, Bostonians were offered the opportunity to see a very different type of French painting, *The Temptation of Adam and Eve* and *The Expulsion from Paradise* by Claude Marie Dubufe. Painted two or three years earlier, for Charles x, the pictures featured life-size nudes. The paintings had been shown in London and after Boston went on to New York, Philadelphia, Baltimore, Atlanta, and New Orleans. The nudity caused a great commotion in American newspapers, bringing out many of the charges of sensuality and lasciviousness that would plague French paintings for decades. But

after considerable discussion, the newspapers generally judged the paintings wholly suitable for viewing by the family and even by unaccompanied women, for they were chaste, sublime, and necessarily true to biblical teachings.[17] The newspaper commentaries on the paintings, now known only through engravings and replicas painted by Dubufe for a second tour, thirty years later, make clear that the issue of sensuality in painting was an especially complicated one for American critics. Although nudity always raised questions of morality, the charge of sensuality was most often directed at those paintings in which the literary or moral content was subordinated, in the critic's view, to the artist's excessive interest in color or exuberant brushwork. Dubufe's paintings were finally acceptable, in spite of the very naked Adam and Eve, because of the idealized, highly finished manner in which they were painted.

A year later, Bostonians had a chance to get some idea of a true masterpiece of modern French art when G. Cooke's copy of Géricault's *Raft of the Medusa* was exhibited at Harding's Gallery. Something of the picture's importance would have been known to readers of the *Monthly Anthology*, in which it had been mentioned previously. Throughout the 1850s and 1860s, Boston art critics regularly granted Géricault a prominent place in the world of art, no matter how they might damn French painting in general, partly, no doubt, because some of them were strongly impressed during their youth by their encounter with the French master's most famous painting, even in a copy.

The most puzzling painting to visit Boston for a money-making special exhibition was *Cain Meditating on the Death of His Brother Abel*, shown at 19 Tremont Row for five weeks in 1838. The advertisement gave the painter's name simply as David, which at that time could have meant only the well-known French master Jacques-Louis David. But no work of that title is known among David's paintings. It would be most valuable to know the actual artist (and whether the entrepreneurs were really trying to deceive the Boston public) as well as to have some idea of what the painting looked like, for *Cain and Abel* is one of the few specially exhibited

paintings known from a firsthand account to have been well received and apparently profitable.[18] Even more important, its success inspired the young Boston artist William Rimmer to attempt his own version of the theme, for he felt certain he could do it better.

The 1820s and 1830s marked the high point for such traveling exhibitions. By 1840 they had to compete with regular Athenaeum exhibitions, special artists' auctions, and other showings of paintings, but tours of noteworthy paintings continued throughout the century and, in this way, Bostonians were able to view several of France's most famous or infamous pictures, including Rosa Bonheur's *Horse Fair*. Bostonians missed Delaroche's *Marie Antoinette on her Way to Execution*, which was prevented from coming to Boston on its 1856 tour because customs officials would not waive the thirty percent tariff on "works of art for luxury," as had been done in New York, even though the painting was not to be sold. Fanny Kemble, in a letter of 1860 to the English artist Frederick Leighton, who wished to exhibit his own work in Boston, gives some idea of the fanfare attached to these profitmaking tours: "Here people exhibit their pictures at a shilling a head, i.e., put them in a room hung round with black calico, light up a flare of gas above them, and take a quarter of a dollar from every sinner who sees them. —Pictures of very high pretentions are exhibited like scenes in a theatre, by gaslight, advertised in colored posters all over the streets."[19]

By the late 1820s, such short-term traveling exhibitions, which seem to have begun around the turn of the century, were no longer the only opportunity for picture viewing in Boston. The first recorded paintings auctions in Boston were held in 1821, 1825, and 1827. Although the standard assumption among historians has been that these early sales were rife with fakes and forgeries, the catalogues of the first three sales suggest a serious attempt to present paintings attributed within the standards of current European auctions.

The most important and interesting of these sales was planned for 1821, although a second catalogue suggests that it may not have taken place until several years later. The 164 "Works of the Great Masters from the 13th Century to the Present Times" were exhibited for a month prior to the sale at Doggett's Repository of the Arts, a frame, print and stationery shop that occasionally housed traveling exhibitions. Admission to such presale viewing was by numbered catalogue only, and some measure of the popularity of these exhibitions may be gained from the single extant copy of the catalogue for another sale that year. Issued to Miss Bunstead, the catalogue is annotated N. 1086.[20]

The catalogue for the 1821 sale was carefully compiled, giving brief information on each artist and descriptive commentaries for nearly all the paintings. Despite the sale's grandiose title, the pictures were nearly all from the seventeenth and eighteenth centuries, and generally attributed to masters of the second rank. The titles and descriptions suggest that most of the attributions were wholly reasonable if sometimes inflated. There were none of the Leonardo da Vincis that would plague Boston auction houses in the 1840s and 1850s. The most important French works included paintings of cupids and courtship scenes attributed to Boucher, Watteau, and Raoux; formal portraits attributed to Van Loo and Rigaud; and an imperial portrait of Napoleon described as by "Little David." The works were undoubtedly too generously attributed in many cases, but the full descriptions suggest perfectly genuine period works in each instance. A very large number of the paintings show up in a later painting auction, the executor's sale for Nathanial Devaltooth, held in 1825, implying either that the 1821 sale was never held or that many of the pictures went unsold. The former may well be the case, as the only known information about Devaltooth (presumably the entrepreneur behind the sale) is that he was an English native who died in Havana in either 1821 or 1822. At the 1825 sale, however, a considerable percentage of the paintings did find purchasers, as many of them turn up in the collections of prominent Bostonians over the next several years, and a number of them were shown in the early Athenaeum exhibitions.

Only one painting auction is recorded for Boston during the 1830s, that of the collection of Thomas Jefferson,

which had been exhibited at the Athenaeum. A number of the paintings passed into private hands, and the Athenaeum purchased the portrait of Franklin, then believed to have been painted by Greuze but now, on the New York art market, identified as a work of Duplessis.

It is in the 1840s, in nearly all the eight picture auctions, that the problem of deliberate fakes, forgeries, and misattributions becomes acute. Although disdainful remarks about the genuineness of works being sold in auctions and privately had already been made in the 1820s, Franklin Dexter, in the *North American Review* for January 1828, dismissed many of the doubts, indicating that he felt few of the pictures were fakes. "Junk does not find a market here," he claimed, and went on to point out that pictures were generally purchased for their quality and not for the name attached to them.[21] But by the 1840s, several Leonardo da Vinci paintings, a flock of Raphaels, and a veritable studio full of Guido Renis began to appear in Boston sales. The *Boston Transcript* alternately poked fun at the foolish people willing to believe they had purchased great bargains and complained about the effrontery of the sellers. On one occasion, tongue in cheek, the newspaper offered advice on how to appear as an expert on works of art with just a few select phrases committed to memory: "Wait until you hear the name of the painter. If its Rubens or any of them old boys, praise, for its agin the law to doubt them." But with a modern work, the viewer should be more discerning: "He don't use his grays enough, nor glaze down well; that shadder wants depth; the general effect is good, though parts ain't."[22]

In the flush of interest in Old Masters, few French paintings turned up in these auctions. Art criticism was beginning to appear in Boston publications such as the *North American Review* and the short-lived *Dial*, and it focused on explaining and praising the great Italian masters with theories and phrases uncomfortably combining German and English art writing of the period. More modern works were of little interest.

Only one modern painting sale was organized in Boston during this time, and the artists included are generally unknown today. They were hardly valued in 1842 either, for in a sale of nearly two hundred works, only three paintings achieved prices above $20, and most fell between $5 and $15. Nonetheless, the accounting of the sale indicates that nearly all the pictures were sold, so a market, however weak, did exist. The paintings were primarily small genre scenes of the late eighteenth and early nineteenth centuries, by artists of all nationalities. Watelet, a landscape painter, is the only generally known Frenchman among them.

From the founding of the Boston Athenaeum as a private lending library and literary society in 1807, a number of its sponsors had hoped that it might serve as the missing patron of the arts they felt Boston so badly needed. With Washington Allston's return to Boston in 1818, the agitation for an exhibition gallery increased. But it was only with the donation of a large collection of plaster casts of famous works of sculpture and the acquisition of expanded premises that the Athenaeum could open the first of nearly fifty annual exhibitions in 1827. Although laments about the lack of Boston collectors that were first voiced in the *Monthly Anthology* in 1810 had been repeated frequently and loudly by others in the intervening years, the organizers of the first exhibition were able to gather 310 items. Several individuals, particularly Thomas Handasyd Perkins and C. R. Codman, provided numerous loans. The exhibition included a significant number of works by living American artists, most working in Boston, as well as Old Masters. Since a large percentage of the Old Master paintings (other than the family or historic portraits) can be traced to one of the two auction sales of the preceding years, it is clear that Boston's collecting habit was just beginning to take root; however, it is equally clear that as soon as paintings were made available for purchase, Bostonians welcomed them.

The first exhibition contained about a dozen French works, most of which—the Bouchers, Watteaus, and possibly the Poussins—came from the Devaltooth sale. One of the most intriguing pictures, a portrait of Napoleon, attributed to Lefèvre and belonging to the unknown T. K. Jones, may conceivably be the life-size portrait of the emperor attributed to the mysterious

Little David in the Devaltooth sale. The two copies of LeBrun battle pieces may have come from the Columbian Museum, which in 1825 changed hands and sold much of its contents. The authenticity of these works, as with most of the Old Masters, is impossible to judge, but the unusual quality of the two eighteenth-century works still known today tempts one to speculate that a few treasures may have lurked behind the grandiose attributions. *Le Négligé* by Greuze and *A Female Head* by an unknown artist were lent by Thomas Dowse, a

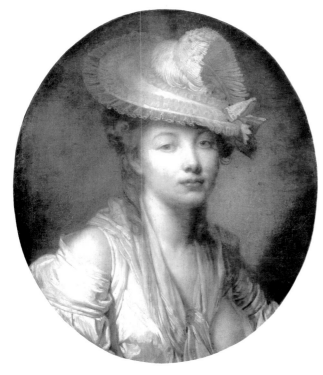

JEAN-BAPTISTE GREUZE, *The White Hat*, ca. 1775. *Very few significant works of French painting found their way to Boston during the first half of the nineteenth century. Of the small number that can still be traced today,* The White Hat *is both one of the first to enter a Boston collection as well as one of the loveliest. Greuze's painting displays many of the same characteristics that would appeal to collectors buying more modern works later in the century: free, confident brushwork and subtle, striking color effects. (Museum of Fine Arts, Boston. Jessie H. Wilkinson, Grant Walker, Seth K. Sweetser, and Abbott Lawrence Funds)*

Cambridge leatherdresser who later left the paintings to the Athenaeum. The Greuze now belongs to the Boston Museum, and the Grimou, as the other is now called, was recently on the art market. Both are lovely eighteenth-century paintings, striking in the freedom of handling and color; their presence in Dowse's small collection is hard to explain, as Dowse is not known to have traveled abroad and neither of the paintings appears in any earlier Boston sale or collection record. One can only guess that he acquired them directly from a recent immigrant or from a collection formed during the troubles in France that turned so many important paintings onto the market in a short period. Such possibilities would seem to account for the presence of another unlikely painting in the next Athenaeum exhibition, *The Whaffle* by LeNain. It would be fascinating to know what the LeNain painting looked like, for although the attribution may be wrong it is nonetheless a highly unusual and sophisticated guess, given the general ignorance of the LeNains' work at this period. Four putative LeNains had been part of the Jumel collection, which had been formed in France about 1820 and broken up in New York in 1821. A number of the Jumel paintings, many of which were French, had been included in the Devaltooth sale of 1825 (*Joseph Interpreting the Dreams of Pharaoh* by Gerard Lairesse and a portrait of Madame DuClos by Largillière being the most interesting) and it seems reasonable to assume that others may have made their way to Boston. If the limited number of art auctions held in the United States in the 1820s and 1830s is a fair indication, Boston was certainly viewed as a better market than New York.

The organizers of the succeeding Athenaeum exhibitions established a policy of not repeating their selections and by the fourth annual exhibition they seem to have exhausted local collections, for they turned to two collectors further afield, William H. Vernon of Newport and Mrs. R. W. Meade of Washington. The paintings in both collections are similar to those that appeared in previous Athenaeum shows. What is striking about the exhibition is the inclusion of a catalogue commentary with the listing of paintings. It is unusual to find admi-

ration expressed for the sketchy quality of two works by Oudry, lent by Vernon, whose "effect produced by such freedom and boldness of touch is astonishing. Every dash of the pencil has its true place and operates with surprising power to produce the end the painter had in view."[23] These anonymous remarks are the first instance of appreciation for the exuberant, painterly qualities that Bostonians would come to look for in the art they admired.

Generally, the French paintings shown at the Athenaeum exhibitions before 1850 are attributed to seventeenth- and eighteenth-century masters and many seem of doubtful authenticity. While there is the expected complement of idealizing Poussins and LeBruns, there are also many Bouchers and Watteaus, suggesting that Boston collectors were already establishing their preference for the more freely painted, more colorful pictures currently being damned as sensual.

An important exception to the generalizations that can be made about the early Athenaeum exhibitions, however, is a painting presented to the Athenaeum in 1837 by Thomas Handasyd Perkins, a merchant of considerable wealth and the owner of one of Boston's larger collections. The painting, *Count Eberhardt Mourning over the Body of his Dead Son*[24] by Ary Scheffer, was the first truly contemporary French work of distinction to be publicly exhibited in Boston and is a harbinger of the debate over modern French art that would dominate art collecting and writing during the 1840s and 1850s.

It is highly unlikely that Perkins could have purchased the picture in Boston during the 1830s; it was probably commissioned during a trip to Paris made by Perkins in 1835. The subject, an illustration for a Schiller ballad, is typical of the medieval themes gaining currency in French painting in the decade of the 1830s. It was a wholly appropriate choice for Boston's first modern work of European painting, as the vogue for Schiller and German Romanticism in general was central to the literary and intellectual life in Boston at that time. The painting's special significance in the history of American collecting is that it was the first work in this country by the artist who would be held up as the official stan-

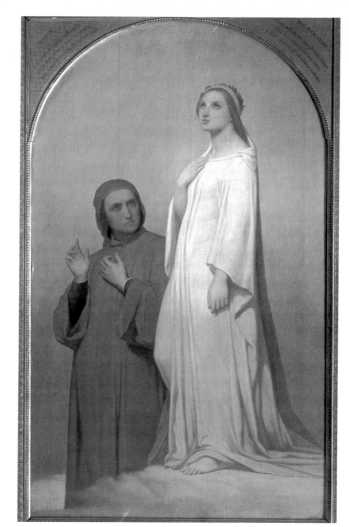

ARY SCHEFFER, *Dante and Beatrice*, about 1852. *Scheffer was one of the first modern French painters to become widely known in this country, chiefly through popular engravings after his paintings. Throughout the 1850s and 1860s,* Dante and Beatrice, *then owned by C. C. Perkins of Boston, was widely admired for its careful drawing and subdued, idealizing spirit. Many critics found it preferable to the less sentimental works by Millet that were then being introduced by Boston artists. (Musum of Fine Arts, Boston. Purchased, Seth K. Sweetser Residuary Fund)*

dard of modern French art for twenty years, in opposition to those artists Boston would come to prefer.

The Scheffer was not followed by other such gifts, unfortunately, and the Athenaeum preferred to use the receipts from its exhibitions to purchase American paintings and dubious Italian Old Masters. Boston's only other instance of direct patronage of contemporary French painting in the 1830s was of a much more personal kind. John Lowell, Jr., heir to a substantial textile fortune, having lost his wife and two young daughters within two years, attempted to ease his sorrow in 1833 with an extended trip through Egypt, the Middle East, Italy, India, and elsewhere. In the manner of a number of wealthy eighteenth-century European travelers, Lowell stopped first in Paris, hiring the young painter Charles Gleyre to accompany him to record the sights and characters they encountered. The Lowell-Gleyre relationship was a stormy one, and the painter and patron parted in Egypt, but the two hundred watercolors that remain from the trip are of archaeological as well as artistic interest.[25] Gleyre recorded a number of Greek and Egyptian antiquities prior to the ravages of vandals and archaeologists; he also produced a masterful series of costume studies made primarily in Turkey, which include a study of Lowell in elaborate Middle Eastern costume.

Most of the French paintings in Boston prior to 1850 were isolated examples in small, very mixed collections. However, late in the 1840s Boston gained a collection that intrigued and apparently slightly scandalized the prominent citizens who came to know it. Peter Parker, a wealthy Boston merchant, built a large house as a gift for his daughter and new son-in-law, Mr. and Mrs. Edward P. Deacon. Although the funds seem to have come principally from Parker, the furnishing of the Deacon House was supervised by Parker's son-in-law, who hung a suite of paintings by Fragonard in the reception room and a collection of cupids by both Boucher and Fragonard in what was called the Marie Antoinette Boudoir. Dozens of other paintings, nearly all from the eighteenth century, hung throughout the house, amid paneling and furnishings of the same period, all purchased in Paris. The most famous paintings were a large pair of market scenes by Boucher that had once belonged to the Duc de Richelieu, hanging in the dining room. Deacon purchased them in Paris in 1852, perhaps with his father-in-law's funds, for when the contents of the house were sold in 1871, the paintings reverted to the heirs of Peter Parker, who presented them to the Museum of Fine Arts. These exceptionally fine examples of French painting were the second and third pictures to enter the Museum's collection.

As the *Boston Transcript* reported in 1849, "Art is becoming fashionable in our community now . . . we wish some means could be devised to raise the standard of taste."[26] In fact, something was being done to raise the standard of taste, although its effects would not be noticeable until the middle of the next decade. By 1849, several young Bostonians had been studying in the art studios of Paris for a number of years. Although not the first Boston artists to seek out Paris for their artistic training, William P. Babcock, William Morris Hunt, Edward Wheelwright, and their friends Thomas Gold Appleton and Martin Brimmer would have a profound effect on Boston's ideas about art and painting when they returned to the city during the 1850s. In addition to their newly acquired skills, they brought back some of the most advanced paintings of the century as well as new attitudes toward suitable subject matter and the techniques of painting. Although their taste for the Barbizon landscape masters and Millet would ultimately triumph, they faced an uphill battle. For while they worked in Paris, an unusually strong and occasionally vicious onslaught was being waged against French painting back home.

As both the *Transcript*'s wistful hope for a rise in taste and the rash of auctions in the 1840s make clear, art collecting was beginning to become a serious business in Boston, but the problems of collecting in a city that lacked either public museums or accessible well-known private collections were manifest. Whereas in the past critics had advised collectors to purchase good copies of well-known works, in the belief that originals of value

could no longer be had, those same critics were now urging collectors to buy contemporary works, in order to protect themselves against forgeries and to secure a sound investment. When the Boston painter George Loring Brown sought funds to finance a study trip to Italy, he straddled this change in the direction of collecting by advertising for commissions to paint either copies of important Italian works or original compositions of his own choosing.[27]

The advice to buy modern works came primarily from critics fostering the development of an American school of art. Although the large numbers of modern American paintings in the annual Athenaeum exhibitions between 1840 and 1860 suggest that the campaign had had considerable success, the ascendancy of American art was by no means assured; it was in part the result of accessibility. Modern European painting was not readily available in Boston until Americans began to travel abroad regularly in the 1840s and until touring European dealers brought large sale-exhibitions of English, German, and French works to Boston late in the 1850s. Once foreign works became easily available, the hegemony of American painters was severely threatened. Fearing that there would not be enough money to go around, American artists and their supporters began a campaign to raise import duties on foreign works of art, and failing that, to discredit foreign paintings in the eyes of potential collectors.

For many years, protests had been raised against the numbers of American artists who went abroad to study. William Wetmore Story, in the Harvard Phi Beta Kappa address of 1844, exclaimed, "An American art would never be born of seeds sown in foreign soil,"[28] and Augustine Duganne, in a book entitled *Art's True Mission in America*, drew on a firm American tradition in proclaiming, "It is here, in our fresh, healthy land, that the new and sublimer advent of Art may be looked for."[29] During the 1840s and 1850s, the protests were extended to condemn the effect of imported works of art on the impressionable minds of young American artists.

America's two major early art journals, the *Bulletin of the American Art Union* and *The Crayon* (both published in New York), aided by sympathetic journalists in other periodicals, began a campaign to define and encourage the unique character of American art and to protect it against corrupting influences from abroad. "Untrammeled nature could best be painted by an American 'not merely because there happens to be more wilderness here than in Europe, but because the strongest feeling of the American is to that which is new and fresh —to the freedom of the grand old forest—to the energy of wild life!"[30] Nature, carefully observed and truly painted, was to be the touchstone and source for American art, and French painting soon came to be seen as the single greatest threat to the realization of American potential. For as a critic for the Art Union *Bulletin* said of an exhibition of French works organized by the French dealer Goupil in 1848 (shown in New York, possibly also shown in part in Boston), "the collection of these gentlemen is faulty both in its moral tone and in point of technical merit. On every account the French School, as it has developed since the late Revolution, is the last which we should desire to influence American art. We infer from the statements of intelligent writers that the day of Vernet, of Delaroche, of Scheffer is on the decline. That attention to Form and Expression which distinguished these artists has given place now to the study of Color and Effect—of the sensual rather than the spiritual elements of art."[31] What might happen to American painting was pointed out in the course of art in its downfall and degradation "as seen in its most contemptible shapes in France, until in the orgies of universal license and revolutionary anarchy it assumed the features of a demon."[32] As the strength of the criticism directed at French painting suggests, it was French art that was most feared, for French painting was becoming increasingly popular and France was attracting most of the American students going abroad to study.

These frequent criticisms, which castigated French painting for its license, its sensuality, its uncontrolled individualism and its disdain for nature—all qualities antithetical to the concept of an American art being promulgated by *The Crayon* and the Art Union—are especially noteworthy because they were made at a time

when so little French art was actually available in this country. In spite of the boom in collecting, in the early 1850s most of what Americans and their art critics knew and thought about art (as admitted by the Art Union critic quoted above) depended upon what they read, and what they read or had served up to them was the English critic John Ruskin. One of the world's most facile and beautiful writers on art, Ruskin was eminently quotable. But he could also be one of the most diabolically opinionated and inconsistent critics to put pen to paper. Nonetheless, he was the most prominent author writing on art matters in English and his strongly stated views provided a gospel and prescriptions that served the programs of the supporters of American art. Much of the abuse hurled at French painting during the 1850s and 1860s is taken from Ruskin more or less directly. His repeated emphasis on the precise study of nature and the moral significance of art established the basic criteria that most Americans used in judging a painting. A measure of how blindly many critics followed Ruskin can be found in the surprised and sheepish reviews published by a number of Ruskinian writers after their first direct contact with French art.

One of the few dissenters from the Ruskin gospel was a Boston art critic, Franklin Dexter, who said of Ruskin's *Modern Painters* as early as 1848, "It is difficult to believe it to be done in good faith."[33] Dexter's analysis of the damage that might be wrought by Ruskin was especially perceptive: "In Europe where the works of the old masters continually speak for themselves, such a book can do no lasting harm; but here, where these works are unknown except to those who see them abroad, unfrequently or at long intervals, there is danger that the effect may be more permanent."[34] Dexter's criticism of Ruskin marks the beginning of the divergence in the art criticism of New York and that of Boston. For the second half of the nineteenth century, New York was indisputably the art capital of the United States, with American artists flocking there from across the country and most major exhibitions and sales taking place there. Boston was one of the few cities to cut out a special, articulate role for itself in American art

consciousness, a role that would increasingly come to be equated by New York critics with "the morbid French manner."

Ironically, in view of the turn Boston's collecting would take later in the 1850s, the only modern French master to whom *The Crayon* gave its wholehearted support, Ary Scheffer, was best represented in Boston. Boston had had what may have been America's first work by Scheffer since 1837, when T. H. Perkins presented the *Count Eberhardt* to the Athenaeum; in 1853, Perkins's grandson, who had studied under Scheffer in the 1840s, commissioned America's most famous work by Scheffer, *Dante and Beatrice* (now in the Boston Museum). Charles Callahan Perkins was one of the first of the many Boston art students who would bring their taste home with them, but unlike the students who followed him, Perkins took a generally conventional view of French painting. *Dante and Beatrice* came to be seen by many Americans as one of the few saving graces of French art. "The charm of *Dante and Beatrice*," as *The Crayon* explained, "and the hold this design has upon us, proceeds from its being a new ideal, as well as from the excellence of its Art Scheffer, in embodying Dante's creation, has put an old Christian idea in a new shape"[35] Scheffer's work, although not specifically applauded by Ruskin, as was that of Rosa Bonheur, Ernest Meissonier, and Édouard Frère, could easily be reconciled with Ruskin's demand for an art that honored drawing and idealism. So often throughout the 1850s and 1860s was *Dante and Beatrice* held up as an example to uninterested American artists more intent upon assimilating the lessons of other French painters that Henry James commented somewhat petulantly, "Among the contemporary classicists, Mr. Hamerton [an English critic] . . . mentions Ary Scheffer, of whose too familiar *Dante and Beatrice* he gives still another photograph."[36] But James was writing in 1868, after Boston had given its heart to another kind of French painting; at the time of Scheffer's death in 1858, another critic could comment, "No painter of this age has made so deep an impression on the popular mind of America as Ary Scheffer . . . engravings [from his works] are not only

familiar to every person of acknowledged taste and culture, but are dear to the hearts of many who scarcely know the artist's name. Young maidens delight in their tender pathos, and the suffering heart is consoled and elevated by their purity and lofty religious aspiration."[37]

Such was the level of familiarity with modern French art at the time when C. C. Perkins's friends began to return from their Parisian art studies, bringing with them the paintings of their masters and the other artists they had come to admire. Unlike Perkins, who entered the studio of the widely respected Scheffer (a choice perhaps suggested by his grandfather's early patronage of the artist), Winckworth Allan Gay, William P. Babcock, William Morris Hunt, Edward Wheelwright, and most of the other Bostonians who followed them to Paris in the 1850s and 1860s were forced to cast about more widely for masters willing to take them on as pupils. Most, like Hunt and Babcock, had not even had formal drawing training in Boston and, unlike many of the better prepared New York students in Paris who sought out such officially sanctioned masters as Picot, the Bostonians were obliged to seek their training outside the intensively competitive Ecole des Beaux-Arts and the studios allied with it. But while it may have been a lack of formal preparation that first led the Boston artists to such less demanding masters as Couture, Troyon, and Millet, the bonds the Boston pupils formed with the French painters and their unconventional methods were strong and fast; even after considerable experience the Bostonians did not move into the official French circles.

Hunt entered the studio of Thomas Couture in 1846; a year later Babcock was also receiving instruction there. Although the two students would switch their allegiance to Jean-François Millet by 1849, greatly angering their first master, they had both been strongly influenced by Couture and his unorthodox teaching. In time Hunt would become famous and infamous as the American apostle of Millet, but it was the lessons he learned from Couture that most profoundly formed his own painting style and that underlay his highly influential teaching in Boston during the 1860s and 1870s,

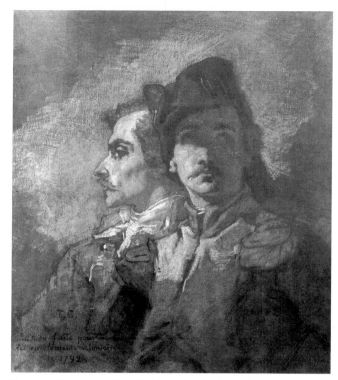

THOMAS COUTURE, *Two Soldiers: Study for "The Volunteers of 1792," ca. 1848. William Morris Hunt studied with Couture in Paris during the 1840s. When Hunt returned to Boston, he frequently quoted his French master during his own teaching, and recommended Couture as teacher for Boston students traveling to Paris. Several of Couture's former Boston pupils contributed to the subscription to purchase this study for the Museum collection. (Museum of Fine Arts, Boston. Gift by contribution)*

lessons that would be one of the single most important forces shaping Boston's thinking about painting.

Couture had been widely celebrated by all Paris for his *Romans of the Decadence*, exhibited in 1847, but his teaching methods, emphasizing free and direct painting without preliminary drawing, were notoriously opposed to the formal training available at the Ecole, which stressed the necessity of several years of drawing practice before a student turned to painting. The importance Couture attached to strong, pure color and to contemporary subject matter was carried back to Boston by

Hunt, and reinforced by a number of Bostonians who studied with Couture in succeeding years.

Unlike Hunt and Babcock, Gay began his studies with Constant Troyon, an animal painter who frequently worked in the small village of Barbizon, in the Fontainebleau Forest, the village that gave its name to the school of landscape painting that Gay, Hunt, Babcock, and others from Boston admired so deeply. In 1848, Babcock left Couture's studio to work with a friend of Troyon's, Jean-François Millet, then Paris's most notorious "democrat" painter, whose picture of a tired, dirty winnower[38] had been a *succès de scandale* in the revolutionary Salon of 1848. Babcock followed Millet to Barbizon, and shortly afterward Hunt joined them, donning peasant garb to work beside Millet. (That Hunt kept up a finer style of life in Paris, complete with expensive horses, must be noted, not to call attention to its irony, but to underline the fact that most of Boston's Paris-trained artists were men of wealth, and, as in Hunt's case, had at least part of a Harvard education.)

Hunt was not only Millet's pupil but also his friend and patron. With Babcock, who was Millet's regular evening dominoes partner, he served as a witness to Millet's wedding. From his first acquaintance with the artist, when Hunt purchased the well-known *Sower* (now in the Boston Museum), he frequently acquired Millet's work or interested his Boston acquaintances in doing so. The strong personal ties that developed between the Boston artists of this generation and their Paris and Barbizon masters were strengthened as the Bostonians regularly introduced their own American patrons to the Frenchmen or recommended the French artists as teachers for younger students.

One of Hunt's acquaintances, Martin Brimmer, who would later become the first president of the Museum of Fine Arts, was in France during the early 1850s, following his graduation from Harvard. Before returning to a law practice, he briefly studied art in Paris and was introduced by Hunt to Millet. Between them, Hunt and Brimmer purchased all Millet's Salon paintings of 1853, beginning for Brimmer a lifelong interest in the artist that would eventually result in the gifts of six Millet

paintings and pastels to the Museum by Brimmer and his wife. Brimmer returned to Boston in 1854, followed shortly thereafter by Hunt himself. One of Brimmer's Millets, *The Harvesters Resting* (now in the Boston Museum), became the first work of the artist to be publicly shown in this country, when it was included in an Athenaeum exhibition in 1854.

Babcock remained in Barbizon for the rest of his life, an erratic and uneven painter whose work had little to do with Millet in spite of their close ties. But as a constant Boston presence in Barbizon, he frequently acted as host, guide, and negotiating agent for visiting artists and collectors alike.

Another Bostonian in Paris, Edward Wheelwright, a member of Hunt's Harvard class, studied first with Eugène Ciceri, a lesser-known artist of the Barbizon circle. Wheelwright returned briefly to Boston in 1853–1854, and one of the landscapes he had purchased from Ciceri, *In the Gorge aux Loups, Forest of Fontainebleau* (now in the Boston Museum), was the first Barbizon landscape exhibited in Boston; it was shown at the Athenaeum exhibition in 1853. In 1855, Wheelwright returned to Barbizon with an introductory letter to Millet from Hunt, and he convinced the reluctant Frenchman to take him on as a pupil for several months. During that time, Wheelwright also befriended Diaz and Jacque, two other members of the Barbizon circle. Wheelwright did not continue as a serious painter beyond the 1860s but, as an art critic for the *Atlantic Monthly* during the 1870s, he reinforced the interest in French painting that was being promoted by Hunt and others.

Also purchasing modern French works in Paris during the early 1850s—for in fact it was only by traveling abroad that Bostonians could secure such pictures until later in the decade—was Thomas Gold Appleton, a slightly older friend of Hunt's, an amateur artist in his own right, and the wealthy, socially prominent owner of the most significant collection in Boston prior to the Civil War. Appleton became a friend of the animal painter Troyon, and may have become an informal pupil of the artist. Three of the several Troyon landscapes

that Appleton owned eventually came to the Boston Museum, after having been lent to the exhibitions of the late 1850s and 1860s that introduced Troyon and the other Barbizon painters to Boston. One of Appleton's most widely exhibited Barbizon paintings, *The Turkish Café* by Diaz (now also in the Boston Museum), which he purchased in 1852, appealed to the collector as a French Rubens, with just a touch of Spanish in it.

The years 1857 and 1858 mark the turning point in Boston taste that the *Transcript* writer had longed for in 1849. Hunt had returned and was teaching in nearby Newport, where his pupils included John La Farge, one of Boston's most celebrated artists at the end of the century; Henry James, whose art criticism of the 1860s and 1870s would be among the most sensitive if not always the most progressive appearing in American journals; and Thomas S. Perry, who, with his wife, would become Monet's strongest advocate in Boston during the 1890s. In 1862, Hunt moved back to Boston with his wife, the former Louisa Perkins, granddaughter of the prominent early collector Thomas Handasyd Perkins. Hunt became an extremely successful portraitist and teacher, and he was the first artist elected to the exclusive Saturday Club. Following the much earlier example of Washington Allston, he became the center of art affairs in Boston, and having all the platforms from which to preach new attitudes toward painting, he made good use of them. His success was not immediate, however, and he occasionally complained about Boston's insensitivity to the truly important in art. His leading critic, who in several instances prompted Hunt to debate in newspaper columns, was the New York journalist Clarence Cook, who in one early mild article charged: "William Morris Hunt translated Couture and Millet into Bostonese. . . . He paints these pictures deliberately, and a certain set in Boston just as deliberately pretend to admire them, and so, actually buy them."[39] Later, Cook would become acrimonious, calling Bostonians foolish sheep who followed a wayward shepherd into the barren pastures of French painting. But the ire of Cook seemed only to solidify Hunt's position, and it is not hard to imagine that part of the success

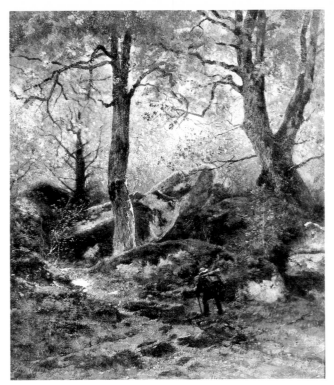

EUGENE CICERI, *In the Gorge aux Loups, Forest of Fontainebleau, 1852. This charming little painting, showing an artist with canvas and pack on his back, approaching one of the favorite sites of Fontainebleau Forest, near Barbizon, was the first work by a member of the Barbizon School to be exhibited in Boston. Edward Wheelwright, who had studied with Ciceri in 1853, one of the first Americans to work with a Barbizon master, brought the painting to Boston. (Museum of Fine Arts, Boston. Bequest of Mrs. Edward Wheelwright)*

that French painting achieved in Boston was the result of an effort to rise above the tastes of New York.

Hunt's return had coincided with the first visits of the Belgian dealer Gambart, who brought a wide range of French paintings to New York and Boston in 1857 and 1859. His exhibition-sale included Ruskin's favorite French artists, well received in New York, Rosa Bonheur, Ernest Meissonier, and Édouard Frère (whom *The Crayon* described in Ruskin's words as uniting "the depths of Wordsworth, the grace of Reynolds, and the holiness of Angelico"[40]) as well as the less well-known

artists Lambinet, Troyon, and Breton. His second visit brought at least one work by Courbet. The only pictures known to have been acquired by Bostonians, a Lambinet and a Troyon, were both purchased by artist-collectors among Hunt's friends.

In 1858, the annual Athenaeum exhibition consolidated the official exposure of the Barbizon artists and their American followers, including works by Ciceri, Decamps, Diaz, Millet, and Troyon, as well as Hunt, Gay, and Wheelwright. All the French paintings belonged to the American painters or their close friends, and reaction to them was slow and confused. Millet, primarily because of the notoriety he had already achieved in Paris, was usually the only artist singled out for comment. As could be expected, *The Crayon* dismissed *The Knitting Lesson* (belonging to Brimmer; now in the Boston Museum) as "an earnest, though affectedly feeble peasant group," and branded one of Hunt's paintings with the oft-quoted judgment "a clever picture, one of the morbid manner so popular in France."[41] But another writer, discussing the current work of French artists shortly after the 1858 exhibition, was clearly familiar with the Millets then in Boston and much impressed by them: "With yet greater skill and deeper pathos does the peasant Millet tell the story of his neighbors. The washerwomen, as the sun sets on their labors, and they go wearily homeward [see cat. no. 16]; the digger at his lonely task, who can pause but an instant to wipe the sweat from his brow; the sewing-women bending over their work, while every nerve and muscle are strained by the unremitting toil . . . such are subjects of his masterly pencil. Do not all these facts point to a realization of Christian Democracy?"[42]

To a certain extent the sentimentalization imposed on Millet by such writers sprang from an effort to equate him with Édouard Frère, whose more appealing peasant paintings were so popular in New York. But Hunt, who continued to serve as agent for Millet in the way that he had begun with Brimmer, swept aside such effusive moralizing criticism, and claimed for Millet simply the greater accomplishment of an honest man who chose to paint other honest men who had work to do. With

Wheelwright, Hunt constantly defended the work of Millet and advised or arranged the purchase of a large number of Millet's paintings and drawings. Before 1890, nearly 150 paintings and pastels by Millet had entered Boston collections, including such major works as *The Sheepshearers* belonging to Peter Chardon Brooks, *Waiting for Tobias* in the collection of Henry Sayles, Brimmer's *Harvesters Resting*, and Hunt's own *Sower*.[43] Millet's most famous painting, *The Angelus*, would have come to Boston in the collection of Thomas Gold Appleton had the artist not been so tardy in completing the picture that Appleton simply abandoned the commission.[44]

In 1872 Hunt made his most important convert to Millet-collecting when Quincy Adams Shaw, whom Hunt had apparently introduced to the artist some twenty years earlier, commissioned his first work from Millet during a visit to the artist in Barbizon. Within little more than ten years, Shaw, whose extraordinary interest in Millet has never been adequately explained, built the largest privately owned group of Millet's work to remain intact, twenty-six paintings and twenty-seven pastels, all given to the Museum by Shaw's heirs in 1917. Shaw had made his fortune from mining interests in the Midwest and had none of the farming or rural ties that help explain many other Bostonians' interest in rustic Barbizon themes. Although he presented Corot's large Salon painting *Dante and Virgil Entering Inferno* to the Museum in 1875, Shaw owned very few French paintings apart from his Millets. His collecting was otherwise directed toward Renaissance art such as the sculpture of Donatello and paintings by Veronese. Among the Millets he owned were *The Sower*, purchased from Hunt, *Planting Potatoes*, and *Noonday Rest*, the pastel copied by Vincent van Gogh.

In addition to forming one of Boston's larger collections, Shaw's group of Millets has a special importance as one of the city's few self-conscious collections. Whether Shaw was deliberately collecting for posterity or not, he carefully built up a full representation of the artist's entire career, commissioning works from Millet directly, talking him out of early works that the artist

had retained for years, and seeking out earlier Millet patrons, from whom he purchased prized works. Shaw's collection ranged from such typical early works of the 1840s as *The Spinner* (cat. no. 15) to the unexpectedly pre-Impressionist work of the 1870s, such as *Fishing Boat at Cherbourg* (cat. no. 17).

The other French artists introduced to Boston by Hunt and his friends captured the city's heart somewhat more slowly and less dramatically than did Millet, but during the 1870s and 1880s the appeal of the Barbizon landscape masters was even more widespread than that of Millet, who, in spite of the large number of his works in Boston, required something of a specialized, sophisticated taste. But the quiet rural landscapes of Daubigny, the animal pictures of Troyon, and the orientalist themes of Diaz, Decamps, and Delacroix gained such general admiration that it is possible to draw a profile that will fit nearly any Boston collection of the period: a group of paintings by American artists working in a Barbizon landscape mode, around a core of paintings that included Corot, Daubigny, Decamps or Delacroix (their high prices usually precluded the presence of both in one collection), Diaz, Jacque, Lambinet, and Troyon, with a selection of works of other schools and more conventional French artists. The more sophisticated collectors also owned Théodore Rousseaus, Courbets, and Boudins, while some of the most sentimentalized works of the German and French schools enjoyed a sustained popularity in the city as well.

Whereas Millet was brought to Boston almost entirely through the agency of one man, Hunt (assisted by Wheelwright, whose lengthy reminiscences of the artist published in the *Atlantic Monthly* in 1876 remain one of the principal sources of information on Millet's methods and intentions), the ascendancy of Barbizon landscape painting here was the result of a combination of many forces.

Hunt and Wheelwright had a hand, of course, in introducing the other artists of the village of Barbizon to Boston. Both of them lent pictures by the Frenchmen to the earliest exhibitions of such works. But they shared their apostolic role with younger artists such as Thomas Robinson, Albion Bicknell, and J. Foxcroft Cole, all of whom had worked in Paris or Barbizon in the 1850s and 1860s, and with several dealers, notably the Frenchman Cadart and the Providence-Boston dealer Seth M. Vose. And they were aided throughout by Boston's special predilection for landscape painting.

Perhaps following the example of the Belgian dealer Gambart, who had visited Boston in the 1850s, Cadart, primarily a print dealer, brought to New York and Boston two touring exhibitions of the works of the French artists he sponsored, including paintings and drawings as well as prints. At the close of the 1867 Boston exhibition, the pictures were sold at auction, and a number of paintings, including works by Jacque, Bonheur, Boudin, and Brissot de Warville, were acquired by Bostonians. The most famous painting of Cadart's exhibitions, a large hunting scene, *The Quarry*, by Courbet (now in the Boston Museum) had been purchased the year before by a group of young artists who were members of the Allston Club, for the impressive sum of $5,000, raised in a matter of days.

Courbet's painting had first been seen in the Cadart exhibition by Albion Bicknell, a recently returned art student who had worked under Couture in Paris. He called Hunt's attention to the picture and both agreed that it was equal to or better than anything by Veronese, the Italian Old Master whose skill as a colorist had made him one of Boston's favorite artists for several generations. After its purchase by the Allston Club, the painting served as the centerpiece for two consecutive exhibitions, in 1866 and 1867, in which works by the Americans Hunt, Bicknell, Gay, R. H. Fuller, and J. Foxcroft Cole hung among paintings by Millet, Couture, Frère, Lambinet, Troyon, Jacque, Diaz, Rousseau, Dupré, and Daubigny. The long roster of French artists

GUSTAVE COURBET, *The Quarry*, ca. 1857. *When* The Quarry *was exhibited in 1867 by one of the first French dealers to visit Boston, several Boston artists in the Allston Club immediately raised the substantial price to buy the picture. The painting was proudly exhibited in a special showing in their studio building and was the centerpiece in the two exhibitions of American and French paintings organized by the Club. (Museum of Fine Arts, Boston. Purchased, Henry Lillie Pierce Fund)*

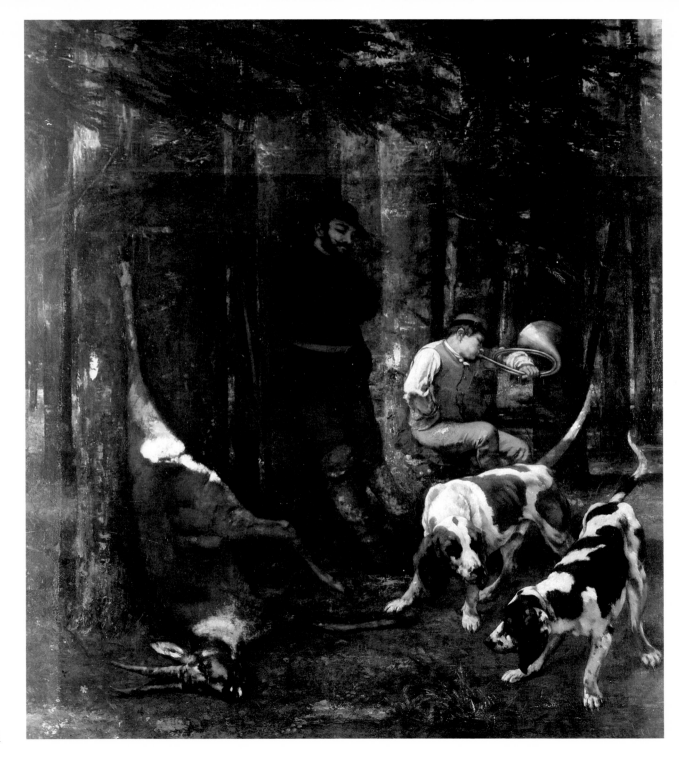

might suggest that these artists were already well accepted in Boston, but nearly all the paintings had been lent by a small group of owners, including the Boston artists and their circle of friends in Boston and Providence.

It is significant that a number of paintings were lent from Providence collections, since from 1860 on the history of French collecting in Boston would be closely entwined with that in nearby Rhode Island, mainly because of the devotion of the dealer Seth Vose, whose efforts on behalf of the French landscape painters contributed as much as the Boston artists to their popularity. Precisely how Vose, who began as a dealer in artists' supplies in Providence in 1850, came to know of the works of these artists is unclear, but it may have been through the Providence painter Thomas Robinson, who studied in Paris in the 1850s and 1860s. In any event, using both Robinson and J. Foxcroft Cole (who had studied with Lambinet as well as Jacque and Troyon) as agents, and occasionally buying on the advice of Hunt, Vose built up the most impressive holdings of nineteenth-century French landscape painting in the country, displaying and selling them from galleries in both Providence and Boston. The amazing Wall and Brown collections in Providence (outside the scope of this essay) were formed almost entirely through Vose's advice, as were the Capen and Warren collections in Boston, whose paintings had so offended New York critics when shown there in 1889, much to the amusement of the Boston press (see note 7 above). At least half the pre-Impressionist French paintings in the Boston Museum's collection were originally imported by Vose, handled by his firm, or bought on his advice. Although not the only Boston dealer carrying French paintings—he had competition from Doll and Richards, Williams and Everett, and Blakeslee and Noyes—his close relationship with a number of the Paris-trained artists, as well as his own considerable faith in the works in which he had invested so heavily, made Vose the most effective and respected salesman for the Barbizon School. William Downes's comment, quoted early in this essay, that New York dealers with a Corot or a

Courbet they could not sell in their own city would turn to Boston was a veiled reference to Vose, who frequently took paintings that Samuel P. Avery, one of New York's prominent dealers in French painting, could not convince New Yorkers to buy.

Vose made the paintings available and Hunt, Cole, Robinson, and others acted as either official or unofficial agents, encouraging their friends to purchase them. Henry C. Angell, a friend of both Hunt and Robinson, formed one of the earliest, largest, and most unusual collections of French painting in Boston, buying through Vose and other Boston dealers, from Robinson or Cole directly, and from French artists and dealers whenever he traveled abroad. His first French paintings came from Cadart's first visit to Boston in 1866; by 1870 he had at least ten modern French landscapes, including works by Boudin, Daubigny, and Bonheur, and as many similar American paintings. He continued to make frequent purchases until after the turn of the century, often trading early acquisitions for later works he thought better. He is of particular interest for his consistent choice of sketches and small, unfinished paintings. Although Angell was openly delighted to make a bargain on his purchases, it does not seem to have been cost that dictated his interest in this kind of painting, for he readily paid very substantial sums for major works that he admired. Rather, he seems to have taken a genuine enjoyment in the free paint handling and strong coloring often found in sketches and the late works of the Barbizon School. Even in finished works he sought the same kinds of freedom and painterly display. Angell was undoubtedly Boston's strongest supporter of Corot and Daubigny, owning at one time or another at least thirty-four paintings by the former and eighteen paintings and twelve drawings by the latter.[45]

Henry Sayles, whose collection was formed mainly in the 1860s and 1870s, with the help of Vose and Cole, represents a special kind of Boston collector. Although not an artist himself, he seems to have been a member of the Allston Club (Boston is noted for a series of artist's associations in which artists were frequently outnumbered by amateurs and collectors) and he bene-

fited from the advice of the club's members in his purchases. It was Sayles who ultimately purchased Courbet's *Quarry* when the Allston Club broke up. He owned one of the first works by Théodore Rousseau in Boston, one of the few Barbizon artists not generally well represented in the city, and paintings by Corot, Daubigny, Couture, Decamps, Barye, Courbet, Harpignies, and Michel.

Thomas Wigglesworth is a more enigmatic Boston collector, for although several of the paintings in his collection were well known during his lifetime, how he acquired many of them remains a mystery. The important early Bouguereau, *Fraternal Love* (cat. no. 28), entered his collection sometime before 1869; by 1879, he owned one of the most important Courbet paintings in the country, the early *Demoiselles de Village*. His collection was probably the most eclectic and far-ranging in Boston, including works by Breton, Corot, Diaz, Lambinet, and Rousseau, as well as genre and history paintings by Merle, Escosura, and Pils, artists not generally found in the company of the Barbizon masters in Boston.

Boston's interest in Barbizon art held up throughout the rest of the century and well into the next. Mrs. S. D. Warren put together one of the most important such collections late in the 1880s and 1890s,[46] and both the Jordan and Evans collections were formed primarily after the turn of the century. Mrs. Warren worked closely with Vose in building her own collection, which included a significant representation of Barbizon painters, as well as in periodically purchasing paintings that were given directly to the Museum. These included both Corot's *Portrait of a Man* (cat. no. 1), which Avery had been unable to sell in New York, and the major Corot landscape *Forest of Fontainebleau* (cat. no. 3), imported by Vose in the 1880s and included in the first Corot exhibition held in this country.

Far more than earlier collectors, Mrs. Warren, Eben Jordan, and Robert Evans combined Old Master paintings with their nineteenth-century works, a response to the renewed interest in Old Master collecting that spread throughout the country in the early twentieth century. And all of them also sought out the nineteenth-century history painters Gérôme, Meissonier, and Vernet, whom earlier Boston collectors had scorned, often buying up the gems of New York collections at the auction sales that dominated the 1880s and 1890s. But for each collector, a principal interest was nineteenth-century landscape painting. Mrs. Warren's Diaz, *Bohemians Going to a Fête* (cat. no. 10), Jordan's Corot, *Turn in the Road* (cat. no. 6), and Evans's Rousseau, *Pool in the Forest* (cat. no. 14) all entered the Boston Museum collection as bequests in the early twentieth century.

The Sayles, Wigglesworth, and Warren collections were among the largest in Boston prior to 1900. Boston also had very many smaller collections, some with fewer than ten paintings, but nearly all boasting at least one work by the "Men of 1830," the Barbizon masters and their friends. Although the presence of interested American artists working themselves in a similar manner, and the rise of a group of dedicated dealers with a substantial stake in the success of nineteenth-century French painting in Boston, goes a long way to explain the popularity of these paintings in the city between 1850 and 1900, that does not wholly complete the explanation. Nineteenth-century landscape painting, rather than history or genre painting, became the prevailing taste of Boston because of the city's long and enduring attachment to nature, dating to the writings of Emerson and Thoreau during the 1830s and 1840s. As transcendentalist thought, which believed that man's most significant accomplishment lay in his appreciation of and union with nature, became generalized and detached from its original sources, it spawned a great deal of nature writing in the city at the time the French landscapists were first being introduced. Added to the generalized interest in nature was the specific, continued effort among many critics to establish landscape painting as the unique and vital expression of American art. But the transcendentalist writers and the earlier American landscape tradition, nurtured by *The Crayon*, had supported a precise, literal depiction of identifiable aspects of nature, linked to ideas of national symbol or

JEAN-LÉON GÉRÔME, *L'Éminence Grise*, ca. 1874. *Gérôme's carefully detailed history pictures and Édouard Frère's sentimental rustic scenes were among the most popular French paintings in New York during the 1860s and 1870s. Boston never took much interest in Frère's work—it was considered too banal next to that of Millet—and Gérôme did not win a following in the city until the 1880s. L'Éminence Grise was purchased by a Bostonian when the famous Stebbins collection was sold in New York in 1889. (Museum of Fine Arts, Boston. Bequest of Susan Cornelia Warren)*

religious ideal. In the competitive prosperity of the last decades of the century, a period of expansion as well as intellectual retrenchment throughout the country, the hold of such symbols began to fail. As Joshua Taylor has pointed out, what Americans sought and found in the Barbizon landscapes was a certain air of mystery, a vague nature, both humble and exotic, lacking the grandiosity of vision that characterized much American landscape painting, but with enough elements of familiarity to be acceptable to the Boston mind, "to the imagination that looked for a new Forest of Arden without the trappings of Shakespeare."[47] Hunt himself expressed the same idea when defending the mistiness and lack of polished definition in the works of Corot: "Corot's painting is poetic . . . because it is not what people call a finished painting. There is room for imagination in it. Finish up, as they call it, make everything clear and distinct, and anybody sees all there is in about a minute. A minute is enough for a picture of that sort, and you never want to look at it again. . . . But see how beautiful that is—how vague and indistinct. He knows the worth of mystery and of hiding the appearance of hard work."[48] But having been taught to find the mystery and the dream in the lack of finish that typified Barbizon landscape, Bostonians were about to be challenged to find the science and the ultimate reality there as well. For even as Corot and Daubigny gained favor in the 1880s, another style of still more startling French landscape was making its way into Boston collections, a style anticipated in the writings of one of Boston's best nature writers some thirty years before. In a book on the White Hills of New Hampshire, Thomas Starr King, a writer for the Boston *Transcript*, suggested that his readers "observe the hues and harmonies of a landscape at different times of day and under widely different conditions of air and cloud and light" for to do so was sure to bring "a purer delight in art and an intelligent patronage of it."[49]

The triumph of Monet, who almost alone meant Impressionism in Boston, came very quickly. Although no paintings by Monet can be documented in Boston collections prior to 1889, three years later the Saint Botolph Club sponsored the first non-commercial one-man showing of Monet's work held anywhere, with twenty paintings lent by Boston owners. And the catalogue author assured the public that it would not have been hard to find twenty more within the city, had the gallery been large enough to accommodate them. Shortly after Monet's death in 1926, the Boston Museum sponsored a retrospective exhibition of the master's work that was unrivaled by any public or private institution in France. Today, the Boston Museum owns the largest collection of works by Monet to be found anywhere outside Paris, and a significant number of Boston families still own paintings bought from Monet by their grandparents and great-grandparents seventy and eighty years ago. That Monet was so well appreciated in Boston during the 1890s was due in large part to the efforts of the painter Lilla Cabot Perry and the writer-collector Desmond Fitzgerald. But both Perry and Fitzgerald were praising Monet in an atmosphere already made receptive to his work by the debates that had surrounded the works of Millet and earlier French painting, and by the slow, almost unheralded entry of Impressionist painting into the city's art life.

One of the very first Boudins sold at public sale anywhere was purchased in Boston from the French dealer Cadart by Henry C. Angell in 1867; in 1874 or 1875, Angell acquired a painting by Pissarro, purchased for him in France by the painter J. Foxcroft Cole. In 1880, in one of the last of the touring exhibitions of spectacular paintings that had brought so much contemporary art to Boston in the first half of the century, Boston's art public was offered the opportunity to study a much more difficult and challenging painting than David's *Coronation of Napoleon*, shown in 1827. Édouard Manet's *Execution of Maximilian*, which had been banned from exhibition in Paris (or so its exhibitors claimed), was brought to New York and Boston by a young woman singer, a friend of the artist. The painting atttracted a great deal of interest in the Boston press, since Manet was frequently cited as the leader of the Impressionist band in Paris. Although judgments were ultimately critical, they were surprisingly thoughtful: after dis-

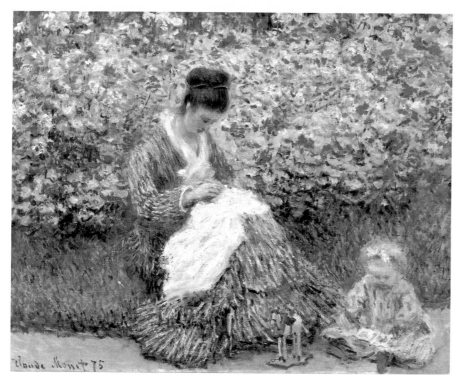

CLAUDE MONET, *Madame Monet and a Child in a Garden*, 1875. *Madame Monet was the earliest painting by Monet in the large collection of Desmond Fitzgerald, one of Boston's first and most influential supporters of Monet. When the painting was sold at auction in New York, following Fitzgerald's death, it was purchased by another Boston collector, in whose memory it was recently given to the Museum. (Museum of Fine Arts, Boston. Anonymous gift in memory of Mr. and Mrs. Edwin S. Webster)*

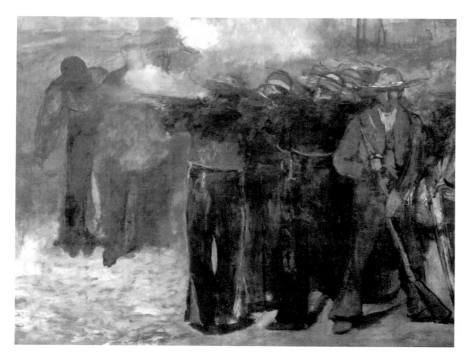

ÉDOUARD MANET, *Execution of the Emperor Maximilian*, ca. 1867. *This full-scale first version of Manet's famous history painting came to Boston at the suggestion of the painter Mary Cassatt, who encouraged a Boston collector to buy it in Paris. When the final version of the picture toured Boston in 1880, most critics were impressed by Manet's originality, but one writer dismissed the picture as an "example of the ultra slap-dash school." (Museum of Fine Arts, Boston. Gift of Mr. and Mrs. Frank Gair Macomber)*

cussing the painting at great length and attempting to explain its merits as well as its failures, the reviewer for the *Evening Transcript* concluded, "With all its crudities and inaccuracies the work is singularly powerful and striking in its originality and its unconventional effects."[50] With one exception the critics took the painting seriously: the *Saturday Evening Gazette* dismissed it as a "coarsely executed example of the ultra slap-dash school."[51] The picture stayed in Boston only a week and was poorly advertised, with no hint of its subject in the small notice. With all the attention it received from the press, however, it might have had a substantial success had its exhibition been better organized.

In 1883, the Foreign Exhibition held in Boston included an art section with a number of loans from the Impressionists' dealer, Durand-Ruel. The frontispiece for the catalogue was a creditable engraving after Manet's *Dead Christ with Angels*. Also included in the exhibition were a portrait by Manet, three landscapes by Monet, six landscapes and figure paintings by Pissarro, three paintings by Renoir, and three by Sisley. In the eyes of the press Impressionist paintings had been nearly lost among the paintings more familiar in the city, but what criticism the works received was once again serious, if circumspect—unlike the scornful, open mockery that met the Impressionist exhibition held three years later in New York. And, as William Downes pointed out with more gentle humor than irony in his study of Boston collections, by 1888 "it is not altogether impossible to find extremists who already avow openly their admiration for those mad outlaws, the Impressionists."[52]

Although Lilla Cabot Perry is generally credited with bringing the first Monet to Boston in the fall of 1889, a view of Etretat, it seems quite probable that the city already housed a few works by the master when she arrived. A painter herself, married to a writer and amateur painter, she had worked in Giverny near Monet during 1889, and over the next ten years she became quite close to Monet, filling much the same role that Hunt had held for Millet: apostle, interpreter, and source of introductions for visiting collectors. Perry's

published reminiscences of Monet are one of the most reliable sources on the master's working methods and his own attitudes toward his painting. During a visit to Boston in 1894, she addressed the Boston Art Students' Association, explaining Monet's method and his palette, and stressing the importance of noting the subtle color differences wrought in nature by changing sunlight, using much the same language Monet himself chose in discussions of the same problems. Several of the earliest Monet paintings in Boston and Providence collections belonged to members of Mrs. Perry's and her husband's families.

Desmond Fitzgerald, successful engineer and art writer, may well have owned one of the first Monets in the city, although the documents on his collection are unclear and most of his paintings by Monet date from the 1890s. In any event, he was certainly one of the "extremists" to whom Downes referred in 1888 (see note 52 above). Fitzgerald was loud and frequent in his praise for Monet and he provided the catalogue essays for several Monet exhibitions in this country and abroad. At the time of his death, his own collection of Impressionist paintings included nine works by Monet,[53] and he acted as adviser to a number of Boston's collectors of Impressionism. The most notable of these was the Edwards family, whose many gifts to the Boston Museum included twenty Impressionist paintings, among them nine by Monet (see cat. nos. 49 and 50).

Other than Angell and Denman Ross (one of Boston's most wide-ranging collectors), most of the Bostonians buying the works of Monet and his followers were new to collecting. Unlike most of the Barbizon collectors, few of Monet's fans even came from collecting families and the taste for Impressionism was strongest among new Bostonians. An exception was Peter Chardon Brooks, who had owned one of Millet's most important paintings, *The Sheepshearers*, and whose father had been a prominent Boston collector. Brooks built up a large collection of Impressionist works, defining the term more loosely than is done today, including minor works along with his Monets. He seems to have the strongest claim to owning the first Monet in Boston, a

snowy view of the village of Argenteuil, which appears to have been purchased in 1888 or 1889, and was given to the Boston Museum by his grandson in 1978. Certainly his Monets were the best-known early group of Impressionist works in the city.

Most of Boston's Barbizon collectors kept a distance from the new paintings. As a brother-in-law of Quincy Adams Shaw reported during a trip to Paris in 1901, both he and Shaw felt the same way about Impressionist paintings: that "the only way to have them is about a mile off—then they are superb."[54]

An unusual number of women were prominent among the collectors of Monet's work: Mrs. David P. Kimball, Annette Rogers, Hannah Marcy Edwards, and her sister Grace. The sudden interest in collecting by women may be a result of the large numbers of women who studied under Hunt in the 1860s and 1870s, including several who traveled abroad for further art instruction, a relatively new phenomenon in nineteenth-century Boston.

As strong as was Boston's appreciation of Monet, it did not embrace all the Impressionists equally. The less talented followers of Monet, painting similar types of land and sea views, were more strongly represented in Boston collections than was Renoir, whose Impressionist figure paintings found little welcome until the twentieth century, when the Edwards family collected his work in earnest (see cat. nos. 56, 58, and 59). Even Monet's figure paintings were shunned; the major Monet figure piece of the 1870s, *La Japonaise*, was a Museum purchase. The same lack of interest in figure and history painting applied to the work of Degas and Manet, who found their strongest supporters not in nineteenth-century collectors, but in Robert Treat Paine and John T. Spaulding in the 1920s and 1930s. The only paintings by Manet to enter Boston collections prior to that time, *The Street Singer* and *The Execution of Maximilian*, were both brought to the city through the influence of the American painter Mary Cassatt, who encouraged Mrs. Montgomery Sears to purchase the first and Frank Gair Macomber the second. When Cassatt learned that Macomber had in fact acquired the *Maximilian*, which she had taken him to see during a visit to Paris, she sent a short note congratulating him and explaining "it has been one of the chief interests of my life to help the fine things across the Atlantic."[55]

At the same time that Monet was reaching such popularity in Boston, one of the city's grander acts of patronage of French painting occurred when Puvis de Chavannes was prevailed upon to accept the commission for the mural decorations in the grand stairwell of the new Public Library. Although this tribute to the idealizing Puvis seems incongruous in view of the city's collectors' interest in more realistic French painting, Puvis was acknowledged as one of the world's greatest masters of decorative painting, and a number of his works had found their way into Boston collections. Such an act of formal patronage seems a fitting close to a century in which the unceasing struggle to secure an appreciative audience for French painting in Boston had often gone unrewarded. Especially fitting are the remarks made by the French critic, Gustave Geffroy, when once again the French raised a cry of protest over important French paintings leaving Paris. Discussing the panels for the Library stairwell (see cat. no. 26), which had been exhibited at the Salon of 1897, Geffroy said, "We have already heard it said, and shall hear it again, that it is a great shame to see these beautiful paintings leaving for the Boston Library, for America so far away. It is true that many among us will not see them again. But on reflection, this departure is admirable. Art crosses the world, going beyond the ocean, to a new people . . . and America, after taking the paintings of our artists, will give us, in order that we might go to see them, aerostats and *pyroscaphes*, that we will be able in a few hours, to cross the ocean and find once again our thoughts, if ever we lose them."[56]

NOTES

1. E. Durand-Gréville, "La Peinture aux Etats-Unis" in *Gazette des Beaux-Arts* 36 (July 1887), p. 65.

2. Now in the Metropolitan Museum of Art, New York.

3. Now in the Metropolitan Museum of Art, New York.

4. William Howe Downes, "Boston Painters and Paintings, VI" in *Atlantic Monthly* 62, no. 374 (December 1888), p. 781.

5. Anonymous untitled editorial in *Monthly Anthology and Boston Review* 1, no. 1 (November 1803), p. 4 .

6. Now in the Metropolitan Museum of Art, New York.

7. P. M., "Art in New York" in *Boston Post*, March 2, 1889.

8. Anonymous, "The International Art-Union" in *Bulletin of the American Art Union* 2 (November 1849), pp. 14-15.

9. Anonymous, "Boston Athenaeum" in *Crayon* 2, no. 2 (July 11, 1855), p. 24.

10. [A. H. Everett], "Exhibition of Pictures at the Athenaeum Gallery," in *North American Review* 31, no. 69 (October 1830), p. 337.

11. James Jackson Jarves, *Art Hints* (New York: Harper and Brothers, 1855), p. 41.

12. Charles H. Moore, "To the Editors of the Boston Daily Advertiser" in *Boston Daily Advertiser*, February 15, 1884.

13. Neil Harris, *The Artist in American Society: The Formative Years 1790-1850* (New York: George Braziller, 1966), p. vii.

14. Caleb Hopkins Snow, *A History of Boston, the Metropolis of Massachusetts*, 2d ed. (Boston: Abel Bowen, 1828), p. 336.

15. William Tudor, Jr., "From Boetia to Attica" in *Monthly Anthology and Boston Review* 9, no. 11 (September 1810).

16. Now in the Detroit Institute of Arts.

17. Kendall B. Taft, "Adam and Eve in America" in *Art Quarterly* 23, no. 2 (Summer 1960), pp. 174-176.

18. Unidentified contemporary source quoted in Truman H. Bartlett, *The Art Life of William Rimmer* (Boston: James R. Osgood, 1882), pp. 11-12.

19. Quoted in Martha A. Shannon, *Boston Days of William Morris Hunt* (Boston: Marshall Jones, 1923), p. 19.

20. Copy in the collection of the American Antiquarian Society, Worcester, Massachusetts.

21. [Franklin Dexter], "Fine Arts" in *North American Review* 26, no. 58, n.s. 33 (January 1828), pp. 213-214.

22. Anonymous, *Boston Transcript*, February 17, 1848.

23. Anonymous, *Fourth Exhibition in the Gallery of the Boston Athenaeum* (Boston, 1830), p. 2.

24. Now in the Boston Athenaeum (a replica of a painting now in the Louvre).

25. Now in the collection of the Lowell Institute, Boston, on deposit with the Museum of Fine Arts, Boston.

26. *Boston Transcript*, November 2, 1849.

27. *Boston Transcript*, June 10, 1840.

28. William Wetmore Story, *Nature and Art* (Boston: Charles C. Little and James Brown, 1844), pp. 37-38.

29. Augustine Duganne, *Art's True Mission in America* (New York: George S. Appleton, 1853), p. 28.

30. Lois Fink, *The Role of France in American Art, 1850-1870*, unpublished Ph.D. dissertation, University of Chicago, 1970, pp. 3-4, quoting in part "The National Academy of Design Exhibition" in *Literary World* 10 (May 8, 1852), p. 331.

31. Anonymous, "The International Art-Union" in *Bulletin of the American Art Union* 2 (November 1849), pp. 12-13.

32. James Jackson Jarves, *Art Hints* (New York: Harper and Brothers, 1855), p. 41.

33. [Franklin Dexter], "Modern Painters" in *North American Review* 66, no. 138 (January 1848), p. 111.

34. Ibid., p. 112.

35. Anonymous, "Facts and Thoughts about Ary Scheffer" in *Crayon* 6, part 11 (November 1859), p. 342.

36. [Henry James], *North American Review* 106, no. 219 (April 1868), p. 721.

37. Anonymous, "The Life and Work of Ary Scheffer" in *Atlantic Monthly* 4, no. 23 (September 1859), p. 269.

38. Now in the National Gallery of Art, London.

39. Clarence Cook, *New York Daily Tribune*, August 2, 1867.

40. Anonymous, *Crayon* 5, part 7 (July 1858), p. 204.

41. Anonymous, "Boston Athenaeum" in *Crayon* 2, no. 2 (July 11, 1855), p. 24.

42. Anonymous, "The Life and Works of Ary Scheffer," in *Atlantic Monthly* 4, no. 23 (September 1859), pp. 271-272.

43. The *Sheepshearers* is now in a private collection in Boston; *Waiting for Tobias* is in the collection of the Nelson Gallery-Atkins Museum, Kansas City, Missouri; *Harvesters Resting* and *The Sower* are both in the Museum of Fine Arts, Boston.

44. Now in the Louvre, Paris. For a discussion of the problems surrounding the original commission for the painting and the subsequent changes in its ownership, see *Jean-François Millet*, exhibition catalogue by Robert Herbert (Paris: Grand Palais, 1975), pp. 105-106.

45. Angell's Corots ranged from small sketches such as the *Old Beech Tree* (now in the Boston Museum) to large, finished landscapes such as *The Orchard* (current whereabouts unknown). The Daubignys included both *The House of Mère Bazot*, a composition the artist repeated several times, as well as the large, unusually bold and sketchy *Sunset on the Seine* (both in the Boston Museum).

46. At the 1889 sale of the James Stebbins collection, Mrs. Warren purchased Gérôme's *Eminence Grise* (now in the Boston Museum), one of the artist's best-known works. Although Gérôme was extremely popular in New York as early as the 1860s, the *Eminence Grise* was his first major work to enter a Boston collection.

47. Joshua C. Taylor, "Introduction" in Peter Bermingham, *American Art in the Barbizon Mood*, exhibition catalogue (Washington, D.C.: National Collection of Fine Arts, 1975), p. 10.

48. Henry C. Angell, *Records of William M. Hunt* (Boston: J. R. Osgood & Co., 1881), pp. 2-3.

49. Thomas Starr King, *The White Hills* (Boston: Isaac N. Andrews, 1859), p. 72.

50. Delta, *Boston Evening Transcript*, December 16, 1879, p. 6.

51. Anonymous, "Art Notes" in *Saturday Evening Gazette*, January 4, 1880.

52. William Howe Downes, "Boston Painters and Paintings, VI" in *Atlantic Monthly* 62, no. 374 (December 1888), p. 782.

53. When the Fitzgerald collection was sold in New York in 1927, many of the French works were purchased by Bostonians. Fitzgerald's earliest Monet, *Madame Monet and a Child in a Garden*, was recently given to the Boston Museum in memory of its second Boston owners, who purchased it at the Fitzgerald auction.

54. Quoted without source in Walter Muir Whitehill, *Museum of Fine Arts, Boston: A Centennial History*, vol. 1., (Cambridge, Harvard University Press, 1970), p. 335.

55. Copy of undated letter from Mary Cassatt to Frank Gair Macomber in files of Painting Department, Museum of Fine Arts, Boston.

56. Gustave Geffroy, "Salon de 1896" in *La Vie Artistique*, 5th series (Paris, 1897), pp. 148-149.

List of Artists and Titles

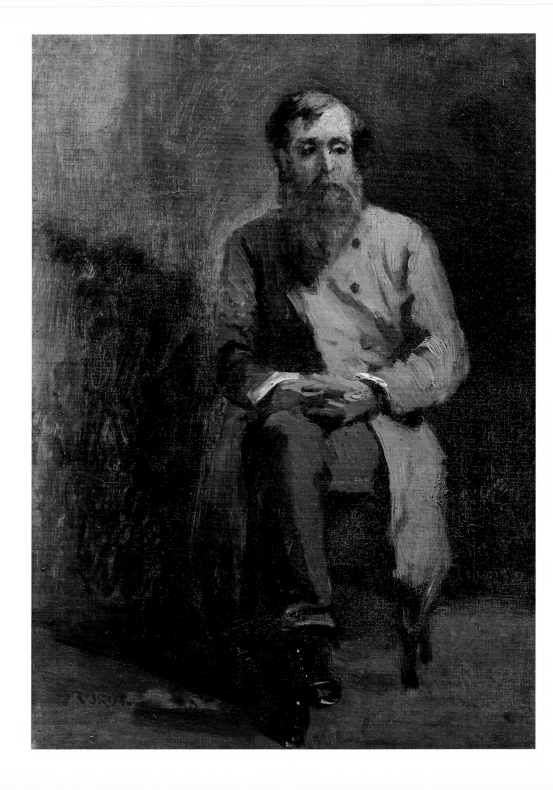

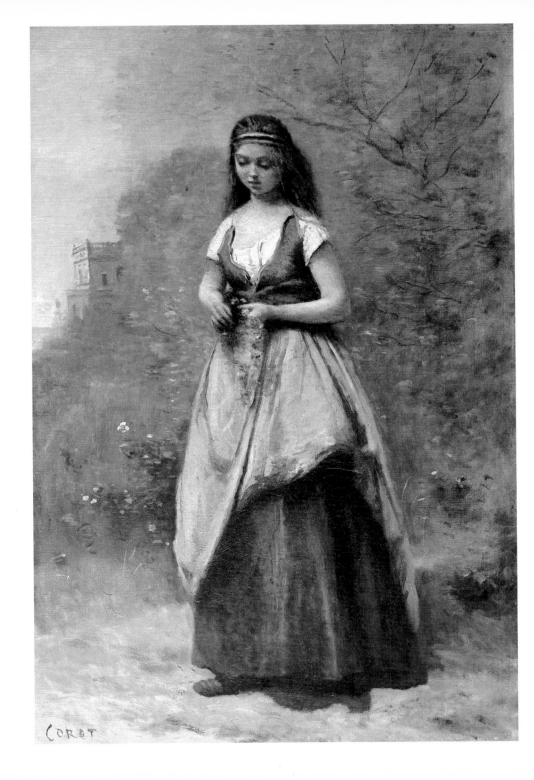

JEAN-BAPTISTE-CAMILLE COROT (1796-1875)
Young Woman Weaving a Wreath of Flowers
Oil on canvas, 27⅞ x 18½ in. (70.8 x 47 cm.)
Signed at lower left: *COROT*
Bequest of David P. Kimball in memory of his wife,
 Clara Bertram Kimball. 23.511

With few exceptions (see cat. no. 1) Corot abandoned portraiture after 1850, turning instead to a series of figure paintings of professional models whom he dressed in exotic costumes and posed in the studio. These were primarily paintings of single women depicted as Greeks, Italians or gypsies, in dreamy, completely inactive poses. Lacking the revelation of individual character found in Corot's portraits of the 1830s, these works are imbued with a touching quality of melancholy and poetic nostalgia that parallels the mood of his late landscapes (see cat. no. 6). Some of the figure pictures are half-length and recall the Italian High Renaissance portraits of Leonardo or Raphael, both in format and in pose. Others, such as *Young Woman Weaving a Wreath of Flowers*, represent the model standing full-length in a landscape setting, reminiscent in their introspective reverie of Giorgione's paintings.

This group of pictures seems to owe its inspiration to Corot's early years of study in Italy. During the three trips he made there between 1825 and 1828 and in 1834 and 1843, he executed a number of studio paintings of young Italian peasant girls. It has been suggested that the female figures done at the end of his life (and the majority of them date from after 1856, when he was sixty years old) represent his personal sadness at the transience of beauty and youth. The paintings are a kind of nostalgic souvenir of the pleasures of the past. Corot conceived these works entirely for himself, and, although they are today highly esteemed, they were virtually unknown during his lifetime. The only one he ever exhibited was *Woman Reading in a Landscape* (Metropolitan Museum of Art, New York), shown at the Salon of 1869. It was not well received or understood by the critics. Hippolyte Flandrin, a student of Ingres, was one of the few contemporary artists

to express some appreciation of Corot's figure paintings when he said: "That devil of a man puts something into his figures that even our specialists in that line have never put into theirs" (quoted and translated in Jean Leymarie, *Corot* [Geneva, 1966], p. 94).

Between 1866 and 1870 frequent attacks of gout made it impossible for Corot to travel, and he spent most of his time in his studio in the rue du Paradis-Poissonnière, devoting himself primarily to figure painting. *Young Woman Weaving a Wreath of Flowers* was probably executed during these years. The young girl depicted in the painting has a small, round face and an extremely elongated form. She stands quietly, slightly turned to her right, and looks down in a sort of reverie. Corot probably used a local model, transforming her to suit his personal pictorial intentions. This young girl, dressed as an Italian peasant, her skirt tucked at her waist, her blouse open and her hair long to her shoulders, held by a gold band, exudes a sensual yet melancholy charm. She is placed in a hazy, dreamlike landscape of pale greens and grays with a sketchily indicated flowering bush behind her. Rising in the right background is a filmy tree, the branches of which seem almost penciled in on the surface in thin gray pigment. Glints of light blue and green indicate individual leaves that shimmer against the soft generalized mass of foliage. In the left background the Villa Medici appears against a blue sky with gray-white clouds. The entire canvas is unified with a delicate balance in the gradations of hue and tone, creating an atmosphere of Elysian fantasy.

JEAN-BAPTISTE-CAMILLE COROT (1796-1875)
Forest of Fontainebleau
Oil on canvas, 35½ x 50¾ in. (90.2 x 128.8 cm.)
Signed at lower left: *COROT*
Gift of Mrs. Samuel Dennis Warren. 90.199

The struggle for the establishment of pure, unidealized landscape painting as a major art form took place in France primarily in the years between 1830 and 1848. Advances had been made in the early part of the century when, in 1817, landscape painting was designated as one of the official categories for the Prix de Rome competition. The first winner of that prize, the neo-classical landscape artist Michallon, was Corot's teacher. From the beginning of the century sketches made directly from nature were exhibited at the Salon, but they were always carefully listed as studies. A finished landscape required a historical or mythological theme in order to be worthy of exhibition.

During the 1830s and the 1840s, conforming to this tradition, the majority of Corot's Salon paintings represented either Italian sites or classical or religious subjects; however, in 1831, 1833, 1834, and 1846 he exhibited views of the Forest of Fontainebleau. These pictures were admitted by the Salon juries because they were large studio landscapes, based on earlier studies made from nature, rearranged and somewhat idealized by the artist. This *Forest of Fontainebleau,* the only one of four canvases submitted by Corot that was accepted for the Salon of 1846, is a large composite of earlier studies made in the Apremont region of Fontainebleau in 1834. It created quite a mixed reaction among the critics, receiving an enthusiastic review from Champfleury, who expressed his appreciation of Corot's fidelity to nature. Shortly after the Salon, in July of 1846, Corot was awarded the Legion of Honor, at last receiving official recognition of his talents. He was exactly fifty years old.

The Forest of Fontainebleau was one of the first outdoor sites where Corot had painted as a student with Michallon in the summer of 1822; he returned there repeatedly throughout his life. Unlike the Barbizon artists who would later be drawn to the shadowy interiors of the forest, Corot was attracted by the massive outcroppings of rock, the architectonic aspects of the terrain, and the forms of the trees. It is interesting to compare this Salon picture of 1846 with Rousseau's *Pool in the Forest* dating from the 1850s (see cat. no. 14), for these two artists were the most important figures in the development of landscape painting in the first half of the century. Both works depict a clearing in the forest bordered on the far side by large trees, a pool in the center, and a scattering of cows with one milkmaid. In fact, this became a very popular type of composition with many of the Barbizon artists (see cat. no. 11). But whereas Rousseau emphasized the contrast in dark and light areas between the foreground and the meadow beyond, Corot boldly depicted his clearing as open and enveloped in an even, soft diffused light. While Rousseau painted every tremulous detail with great sensitivity, Corot's application of paint is broad and smooth with finely modulated tones, giving the canvas a serene clarity and harmony. In Corot's painting there is a luminous balance in the use of color, with the dark areas shaded in dark grays, rather than black, and creamy whites in the lightest areas—the clouds, the rocks, and the cows. The middle tones are soft gray-greens, beiges, and grays, carefully blended.

Corot wrote about the synthetic working method exemplified in *Forest of Fontainebleau* in one of his notebooks: "We must always keep in view the mass, the whole that has caught our eye, and never lose the first impression which quickened our emotion. The design's the first thing to get, next come the values— relations of forms and values. These are our starting point. Then come the colors, and, lastly, the execution. I am never in a hurry to get down to details; it's the masses and the general structure of the picture that interest me primarily. Only when I've seen it clearly as a whole do I turn my mind to subtleties of form and color. I go back to it again and again, without letting anything stop me, and without any system" (quoted and translated from *Carnet 68* in Jean Leymarie, *Corot* [Geneva, 1966], pp. 65-66).

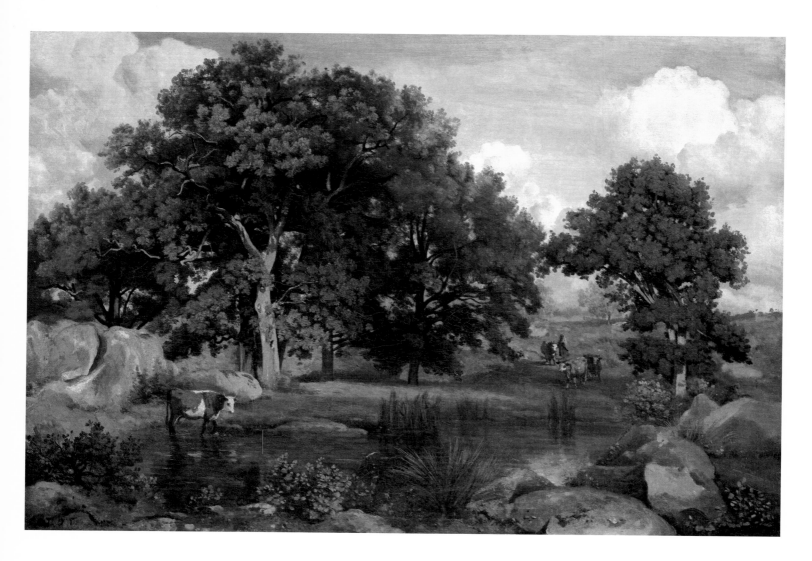

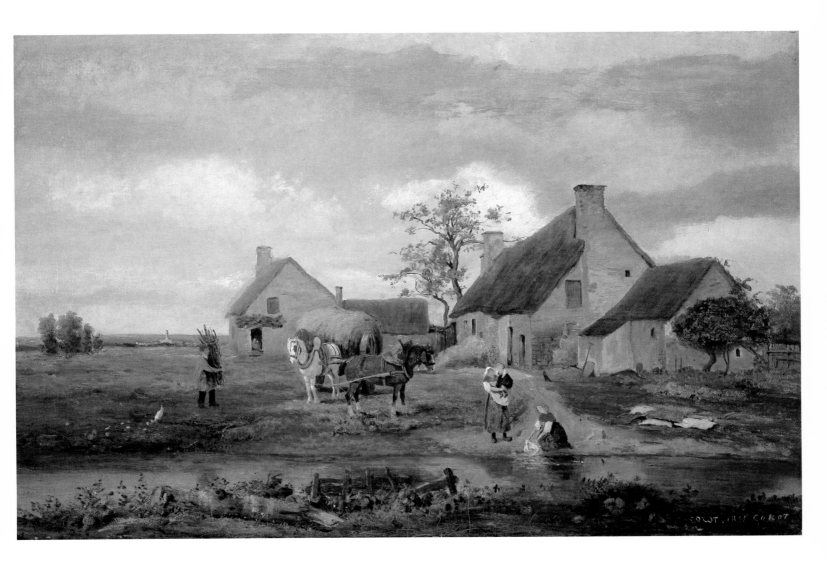

4 JEAN-BAPTISTE-CAMILLE COROT (1796-1875)
Farm at Recouvrières, Nièvre
Oil on canvas, 18½ x 27⅝ in. (47 x 70.3 cm.)
Signed at lower right: *COROT. 1831* (incised) /
COROT
The Henry C. and Martha B. Angell Collection.
 Gift of Martha B. Angell. 19.82

Corot's life spanned the first three quarters of the nineteenth century, and the development of French landscape painting during that time was profoundly affected by his art and his personality. The son of a Paris merchant, he served as an apprentice draper for eight years before devoting himself full time to painting in 1822. He first studied with Michallon, a classical landscape artist whose painting style was in the tradition of Valenciennes. Following Michallon's sudden death in 1822, Corot worked with Bertin, from whom he learned to paint directly from nature, with an emphasis on compositional structure and precision in drawing. After discovering the *plein-air* oil sketches of the English artists Bonington and Constable at the Salon of 1824, Corot went to Italy in 1825. For three years, he traveled in the region around Rome and in central Italy, making numerous drawings and oil sketches directly before the scene. While Corot considered these works to be nothing more than sketches for later reference in composing formal landscapes, they are regarded today as some of his most beautiful and important paintings. Characterized by a broad painting style with an underlying sense of geometric construction, they are bathed in a clear, warm light and have an extraordinary balance of tonalities. These works were to have an important influence on later artists such as Derain (see cat. no. 68), who was drawn to Corot's fresh interpretation of the classical landscape.

When Corot returned from Italy in 1828, he established a working pattern that would remain unvaried until the end of his life. He spent the summer months traveling extensively in France, and sometimes abroad, seeking new motifs that he drew and painted directly from nature. He then returned to his Paris studio during the winter and, using his studies, composed larger formal pictures for submission to the Salon. Following the same pattern, the young Théodore Rousseau made a trip to Auvergne in 1830, returning to Paris with some colorful and bold landscapes that caused a sensation in the Paris studios that winter. Corot may have been inspired, in part, by Rousseau's Auvergne canvases in deciding to make an extensive trip throughout France the following year. *Farm at Recouvrières*, dated 1831, was executed in the Nièvre region of central France, not far from Auvergne, during that journey.

The farm represented in this picture, with its thatched roofs, stone buildings, and its wide expanse of flat, green fields, low horizon, and cloudy gray sky, recalls Dutch seventeenth-century landscape paintings by, for example, Adrien van de Velde or Ruysdael. Dutch paintings were an important source of inspiration for the romantic landscape artists, particularly Rousseau, and Corot was clearly aware of their works in the early 1830s. But whereas Dutch painting would have a continuing importance in the development of Rousseau's style, it was of only minor significance in that of Corot. Although his ultimate choice was to continue in the classical vein of Poussin and Valenciennes, paintings such as this were greatly enriched by his early exposure to the works of the northern landscape artists.

The composition of *Farm at Recouvrières* reflects the lessons learned during Corot's Italian studies and classical training. While the light is different from that of Italy, Corot adapted the technique of his Mediterranean canvases to this northern scene. Relying on close direct observation for his color tones, Corot eliminated unnecessary detail, using a generous broad brushstroke to create a creamy, smooth surface. The horses, hay wagon, and figures seem to be later additions made in the studio, and their integration into the scene seems somewhat forced and artificial. The anecdotal or genre quality they give to the painting is again reminiscent of Dutch prototypes.

JEAN-BAPTISTE-CAMILLE COROT (1796-1875)
Twilight
Oil on canvas, 19⅞ x 14½ in. (50.3 x 37 cm.)
Bequest of Mrs. Henry Lee Higginson, Sr., in memory
 of her husband. 35.1163.

At the same time Corot was exhibiting Poussinesque classical landscapes at the Salon and doing vivid studies from nature during the 1840s, he gradually developed an entirely different, romantic type of small easel painting, which was inspired chiefly by the poetic landscapes of Claude Lorrain. These paintings were characterized by delicate light effects, frequently representing atmospheric scenes at dawn or dusk. They were often peopled with nymphs and creations of Corot's personal mythology rather than identifiable historical figures.

Corot's friend and biographer Théophile Silvestre wrote of the artist's lack of interest in literature or antiquity: "One has wanted at all costs to make of Corot a classicist saturated with antiquity, he who practically never reads anything. What he knows best, I think, of our literature, are the two or three hundred first verses of *Polyeucte* [a tragedy by the French seventeenth-century playwright Corneille]; he has begun them again every year for the past twenty years without ever being able to reach the end of the tragedy, and he excuses himself each year by saying 'this year however, I must finish *Polyeucte*'" (translated from Silvestre, *Histoire des artistes vivants: français et étrangers* [Paris, 1856], p. 96).

Twilight is an early example of Corot's romantic landscapes dating from about 1845-1850. It has a wider range of tonal contrasts and is more solid in composition and execution than his pale, filmy later works of this genre (see cat. no. 6). The trunks of two trees serve to frame the picture, their brown-black shapes providing a strong linear pattern in the shadows, and the graceful upper branches recalling their Roman prototypes in the sunset canvases of Claude.

Many of the nineteenth-century French landscape artists, all of whom were preoccupied with the rendering of light at different times of day, were particularly intrigued and challenged by the depiction of twilight. Millet's *Washerwomen* (cat. no. 16), as well as many of his other paintings, represents this magic moment with an entirely different range of colors and style. In contrast to Millet's picture of common French women nobly laboring on the banks of a river, Corot's painting has a poetic lyrical quality lent by the Italianate young girls who are gathering fruit from the tree at the right. The standing girl, posed like a dancer, with both hands raised above her head to pick the fruit, and the girl kneeling over a basket of fruit at the right repeat, with few variations, the poses of two female figures in the left background of Corot's painting *The Concert* (Condé Museum, Chantilly), exhibited at the Salon of 1844.

Alfred Robaut, Corot's biographer, suggested that *Twilight* was among the nine paintings the artist exhibited at the Salon of 1848 that were described by a contemporary as: "consisting of sweet morning or twilight impressions, wet with dew or enveloped in shadow . . ." (Robaut, *Catalogue raisonné*, vol. 1, pp. 118-119). This date corresponds to the transitional style of the painting, elegiac in mood, pointing to later works, but still rather vigorous in execution.

The year 1848 represented a turning point for Corot. One of the results of the Republican victory in the Revolution of that year was the democratization of the Salon. It marked the triumph of naturalism in landscape painting and, for most artists, the demise of romanticism. Paradoxically, just as Corot's great *plein-air* paintings were receiving official recognition (he exhibited a direct study from nature for the first time in the Salon of 1849), his art took a different direction. Abandoning the powerful, immediate studies of earlier years, he evolved in paintings such as *Twilight* a misty romantic landscape style, increasingly imbued with silvery, light tones and a poetic Claudesque nostalgia. In time these works became more and more conceptions of the artist's imagination in the studio, with an ever-diminishing dependence on firsthand observation.

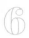

JEAN-BAPTISTE-CAMILLE COROT (1796-1875)
Turn in the Road
Oil on canvas, 24⅝ x 18⅞ in. (62.5 x 48 cm.)
Signed at lower left: *COROT*
Gift of Robert Jordan. From the collection of Eben D.
 Jordan. 24.204

Turn in the Road was painted around 1868-1870, and in
style and execution it is typical of Corot's late land-
scapes. In a review of Corot's works shown in the Salon
of 1869 Paul Mantz expressed the contemporary
critic's view of paintings such as this one: "Another
poet calls us. M. Corot takes advantage of the years to
continue to grow in serenity and tenderness. He had his
bitter moments, he understood drama.... But age came
with its softening and calming authority. M. Corot no
longer believes in storms, nature is no longer an enemy,
it is the great comforter, the good mother with the moist
smile who rocks us on her breast and who puts us to
sleep in a dream.... From the point of view of crafts-
manship, as it is usually understood, no form is exactly
defined.... It is clear that if M. Corot participated in
the famous "tree competition," he would be banished
from the empire. But what a poet, this ignorant man,
and what a charmer!" (translated from "Salon de
1869" in *Gazette des Beaux-Arts* 1 [June 1869], pp.
506-507). While this was the prevailing view of Corot's
paintings by the late 1860s, he still had his detractors.
Comte de Nieuwerkerke, director of fine arts during the
Second Empire, persisted in negating Corot's abilities,
saying: "He's an unfortunate who goes over the canvas
with a sponge that has been dipped in mud" (quoted
and translated from Robaut, *Catalogue raisonné*, vol. 1
[Paris, 1905], p. 242).
 Certain elements in *Turn in the Road*, which are
repeated with variations in many of Corot's other late
canvases, indicate that it was probably painted in his
studio, a composite of earlier direct outdoor studies
and of his own imagination. The vertical format of the
picture with its shallow foreground plane, through
which winds a curving dirt road, and a mass of trees on
one side with a smaller grouping of trees on the other,

are all popular compositional features of Corot's late
pictures. The five figures in *Turn in the Road*—the
woman collecting firewood, the standing woman hold-
ing a baby, the woman with a walking stick, and the
man on horseback riding away from the viewer—are
stock characters that appear in different combinations
in a number of the artist's canvases.
 Like Monet's late paintings of waterlilies (see cat.
no. 51), Corot's landscapes of this type are permeated
with his personal vision and emotions. Nature has be-
come the means through which the artist expresses his
nostalgia for the past and his sadness at growing old.
Individual forms are softened and enveloped in a shim-
mering cool, but sunny atmospheric light. The pigment
is thin, and the few linear touches in the tree trunks
and branches have become insubstantial wispy fila-
ments of gray paint. In *Turn in the Road*, as in all of his
paintings, Corot showed himself the master of nuanced
tones, with grays tying together the delicate yellows,
greens, and blues of the scene, and giving it at the same
time its dreamlike ambience.
 The imaginative late works were in part the result of
Corot's suffering from gout, which obliged him to stay
in the studio, and in part the product of a lifetime of
memories of the hundreds of sites he had visited and
painted. He boasted of his memory to Théophile Sil-
vestre: "I will paint ... a picture from that study; but,
if necessary, I could do without having it before me.
When a collector wants a copy of one of my landscapes,
it is easy for me to do it for him without seeing the
original again; I keep in my heart and in my eyes a copy
of all my works" (quoted and translated from *Histoire
des artistes vivants: français et étrangers* [Paris, 1856],
p. 95). During the last decade of his life Corot drew on
this rich visual storehouse, freely interpreting his
memories of Italy and France in an abbreviated and
extremely lyrical style.

JEAN-BAPTISTE-CAMILLE COROT (1796-1875)
Morning Near Beauvais
Oil on canvas, 14⅛ x 16⅜ in. (36 x 41.5 cm.)
Signed at lower left: *COROT*
Juliana Cheney Edwards Collection. Bequest of Hannah Marcy Edwards in memory of her mother.
39.668

The Exposition Universelle, a large world's fair held in Paris in 1855, marked an important new development in Corot's career. He showed six paintings there, all similar in style to *Morning Near Beauvais*, and when Napoléon III toured the exhibition, he was so taken with one of them (*Souvenir of Marcoussis* [Louvre, Paris]), that he purchased it. This acquisition was made over the objections of the comte de Nieuwerkerke, Napoléon's director of fine arts, who criticized Corot's paintings, saying that the color was "muddy" and the execution "cottony" (Robaut, *Catalogue raisonné*, vol. 1, p. 161). Corot was awarded a first class medal, and at the age of fifty-nine, he finally began to enjoy widespread popular success.

Even though Corot's paintings remained controversial and were misunderstood by members of the Academy and by conservative critics, he had a growing number of champions, including several Americans, who appreciated his works. For the first time in 1858 he held a public auction of his paintings, and they brought very high prices. The public found his hazy, Claudesque landscapes far more palatable than the powerful realist paintings by artists like Courbet. From this time forth Corot was to encounter an ever-increasing demand for his pictures.

Corot's working pattern remained unaffected by the new demand for his canvases. He continued to travel in the spring and summer months, painting directly from nature, and would return to his Paris studio to paint from his sketches during the winter. One of the places he frequented during the decade between 1855 and 1865 was Marissel, a town near Beauvais where a friend named Badin was director of the Beauvais tapestry factory. Corot often stayed with him, making

painting excursions in the environs. *Morning Near Beauvais*, which represents a site in the area in the direction of Pentement-Saint-Jean, was doubtless executed on one of these trips. A scene of early spring with the leaves just beginning to come out on the tall, spindly poplar trees that lined the stream, it is of an exquisite freshness and delicacy, and must have been painted directly before the motif.

The composition of *Morning Near Beauvais* contains a number of elements that typify Corot's later landscapes. Unlike earlier works in which he often painted a series of receding planes of deep space (see cat. no. 4), this picture has a single, relatively shallow foreground plane consisting of a flat, open meadow bordered by a stream on the right and a fence on the left. The block-like solidity of earlier forms dissolves into wispy trees, their trunks and branches painted with a thinned pigment in pale grays, blurring into a soft, indistinguishable mass of misty color in the background. Individual leaves and highlights are indicated with small flecks of white and yellow paint, a practice that was to become standard in the late landscapes.

It is easy to understand how paintings such as *Morning Near Beauvais* were important to the Impressionists. Corot's humility before nature, his sensitivity to the effects of light in a landscape rather than the objective depiction of physical detail, his technique of using small flecks of pure pigment, and his gradual elimination of the darkest range of colors from his palette in the late canvases were all of seminal importance to the formation of the young Impressionists. Corot set an example not only as an artist but also as a personality. His independent spirit and his determination to follow his own instincts in painting, along with his willingness to travel to find new motifs to paint from nature, were characteristics that were often sources of encouragement to the struggling Impressionists, particularly Pissarro.

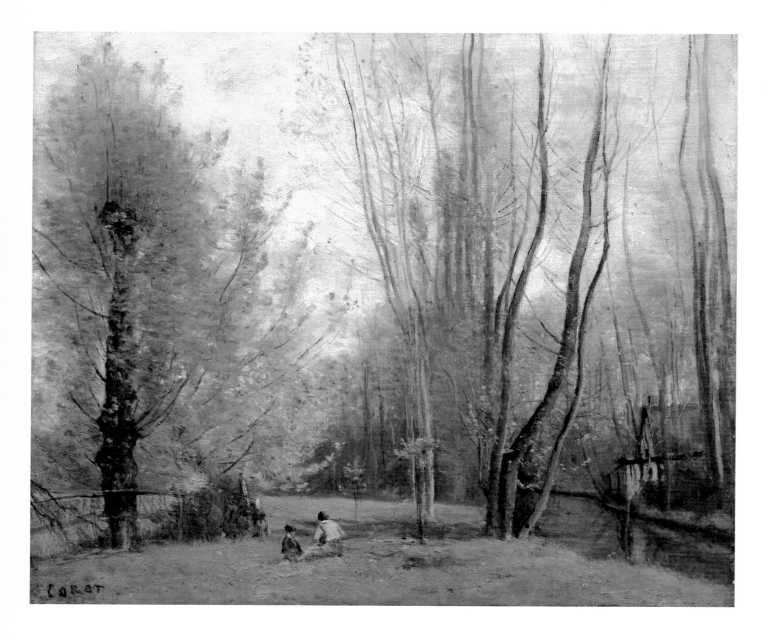

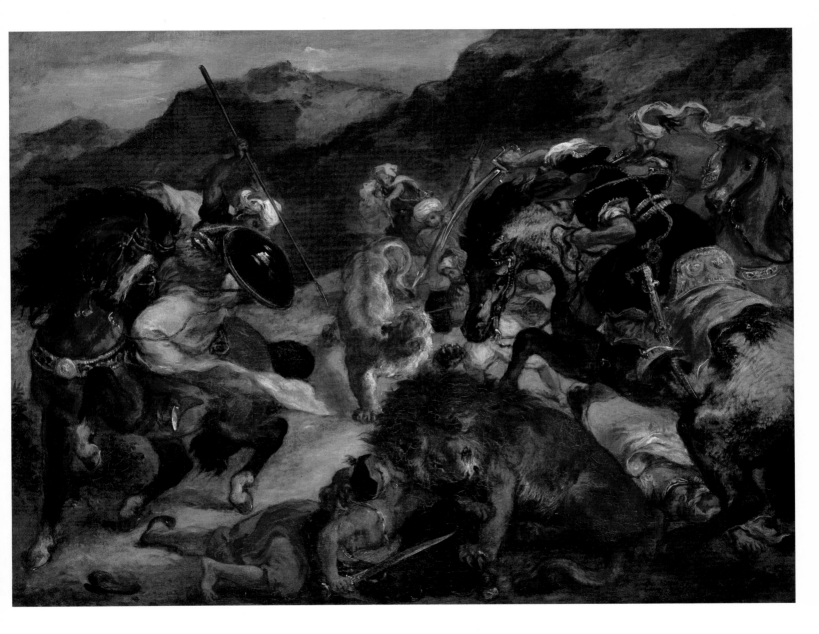

EUGÈNE DELACROIX (1798-1863)
The Lion Hunt
Signed and dated at lower right: *Eug. Delacroix 1858.*
Oil on canvas, 36⅛ x 46¼ in. (91.7 x 117.5 cm.)
S.A. Denio Collection. Purchased from the Sylvanus
 Adams Denio Fund. 95.179

The French conquered Algeria in 1830, and in December of 1831 comte Charles de Mornay was given the important diplomatic mission of establishing friendly relations with Abd er Rahman, the sultan of neighboring Morocco. Delacroix, then thirty-four years old and already a famous artist, accompanied the young diplomat to Morocco, Algiers, and Spain from January until the end of June of 1832. His correspondence and notebooks from the trip provide a detailed account of his enthusiastic reactions to the landscapes and people he encountered. The trip made a profound impact on his art, and it was to become an important source of inspiration for his paintings until the end of his life.

This *Lion Hunt*, the second of three variants of the subject, all of which were painted in the final decade of Delacroix's life, is dated 1858. It was executed sixteen years after Delacroix's return from North Africa, yet it is imbued with his fascination for the natives and countryside. The violent movement of horses hunting, fighting, and in military exercises had been the subject of numerous earlier studies as had the exotic and colorful costumes and weapons of the Arabs.

In the foreground a male lion and a fallen Arab hunter form a pyramid that provides structural stability. The pivotal point of the entire painting is the head of the lion. All swords, spears, horses, and hunters in the foreground of the painting are drawn to him as to a magnet. The lioness, dramatically foreshortened, penetrates the middleground and runs directly at the lion, pulling the hunters who chase her toward him. Delacroix balanced light and dark areas of the composition, serving to make it more legible, and placed the frenzied figures and animals against a simple landscape with a chain of low mountains that recede into the left background.

In 1854 Delacroix was commissioned by the State to paint his first *Lion Hunt* (now in the Musée des Beaux-Arts, Bordeaux, and partially destroyed by fire in 1870). When it was exhibited at the Exposition Universelle in 1855 it received a hostile critical reaction. The artist was accused of having created a chaotic and illegible composition. This negative response may have been one of the reasons Delacroix decided to execute a second variant of the *Lion Hunt* three years later. The Boston painting attains a magnificent integration of dramatic, swirling movement in a completely legible, almost classical composition.

As early as 1824 Delacroix was considered the leader of the romantic movement in painting, the antithesis of Davidian neoclassicism. An inspiration to the next generation, his oriental subjects prompted a sudden increase in the painting of exotic subjects by artists like Fromentin. The Impressionists, such as Cézanne and Renoir, admired and copied Delacroix's works for their freedom of brushwork and sense of color. Cézanne recognized the importance of Delacroix for his contemporaries when speaking before another painting inspired by North Africa, *The Algerian Women* (Louvre, Paris): "We are all in this Delacroix He remains the finest palette in France and nobody under our sky has possessed at once such calm and pathos, such shimmering color" (quoted by Bernard Dorival, *Cézanne* [New York, 1948], p. 111).

Even though the painting is based on firsthand observations of North Africa, it is ultimately a product of his romantic imagination, for Delacroix never witnessed a lion hunt. The primary source for the subject of the painting was the group of *Hunts* by the great seventeenth-century colorist Rubens, which Delacroix knew through prints. As early as 1847 Delacroix analyzed two of Rubens's *Hunts* in his journal (André Joubin, ed., *Journal d'Eugène Delacroix*, vol. 1 [Paris, 1822-1852], pp. 168-169). While filled with admiration for the drama and imaginative impact of Rubens's paintings, Delacroix was concerned with the formal composition and how it might be improved and given greater unity.

NARCISSE-VIRGILE DIAZ DE LA PEÑA (1807-1876)
In a Turkish Garden
Oil on canvas, 14⅜ x 11⅛ in. (36.7 x 28.2 cm.)
Signed at lower left: *N. Diaz.*
Bequest of Mrs. Harriet J. Bradbury. 30.501

Exotic Near Eastern themes figure prominently in Diaz's art from the early 1830s until the end of his life. For the most part, these pictures were of small format and often represented young women in an outdoor setting dressed in their native garb. These works enjoyed an enormous popular success, and Diaz painted them in great quantity, selling them easily for rather low prices. *In a Turkish Garden* is typical of these compositions. The same figures shown in this painting form the central group of a larger picture that was signed and dated 1864 (present whereabouts unknown), and so it too probably dates from that time.

By the 1860s Diaz, the recipient of several official honors, was a wealthy and famous artist. During the last fifteen years of his life he was as vigorous and prolific as ever, and he continued to execute as many figure paintings and fantasy paintings as before; however, due to the great importance given to landscape painting after 1848, the focus of public attention was concentrated on his landscapes.

Unlike Delacroix and Fromentin, Diaz never visited North Africa or the Near East. The inspiration for his paintings was found, rather, in the romantic theater, literature, and art that flourished in France in the 1830s. He was influenced, for example, by Victor Hugo's *Orientales*, a series of poems on the Levant that achieved immediate popularity when it was published in 1829. His biographer wrote: "He showed an amazing zest and productivity in painting Arabs, Turks, Odalisques, all the scenes that he saw only in pictures or across the lights of theaters, . . . the sumptuous clothing and sparkling arms of which attracted and fascinated him by . . . their magnificence" (translated from Théophile Silvestre, *Histoire des artistes vivants: français et étrangers* [Paris, 1856], p. 224).

One of the most important sources for Diaz's Near Eastern pictures was the North African paintings of Delacroix. The *Women of Algiers* of 1834 (Louvre, Paris) is a composition that is quite similar to Diaz's *In a Turkish Garden*. Both paintings show a group of women in the foreground who are richly dressed in colorful native costumes and jewelry. In both there is careful attention to the accoutrements of rugs, shoes, and the water pipe or *nargileh*. Above all, both artists delighted in painting the varied textures and colors of the materials and objects.

The tonality of Diaz's painting is more blond than that of Delacroix, with a more liberal use of whites and pale pastels. The picture has a dreamy quality, which is enhanced by the vacant stares and soft modeling of the languidly posed women. A feeling of theatricality is introduced by the incongruous contrast in the landscape setting between a Barbizon-like tree behind the women, its foliage dark brown and green, and the brilliant blue sky and sunny pink and beige buildings in the distance at the left. As in many of Fantin-Latour's fantasy paintings (see cat. no. 38), which reflect the influence of Diaz's works, the setting resembles a theatrical stage set more than any actual Near Eastern location.

The sweet shapes of the faces of the women and their smooth, delicately contoured bodies are closer to the women of Correggio and Prud'hon than to natives of Turkey or North Africa. The painting, never intended to be an accurate record of the actual life style of the women depicted, has a decorative charm that pervades all of Diaz's fantasy paintings. His training as a porcelain painter in 1823 brought him into contact with eighteenth-century depictions of *fêtes galantes* and fluffy mythological scenes, and his fantasy pictures constitute a continuation, with his own romantic variations, of that tradition.

The Impressionists were sensitive not only to the technical innovations of Diaz's paintings but also to his subject matter. Renoir, who had also been trained as a porcelain painter, was familiar with Diaz's Near Eastern fantasies, and his *Algerian Girl* (cat. no. 59) is created in the same spirit as *In a Turkish Garden*.

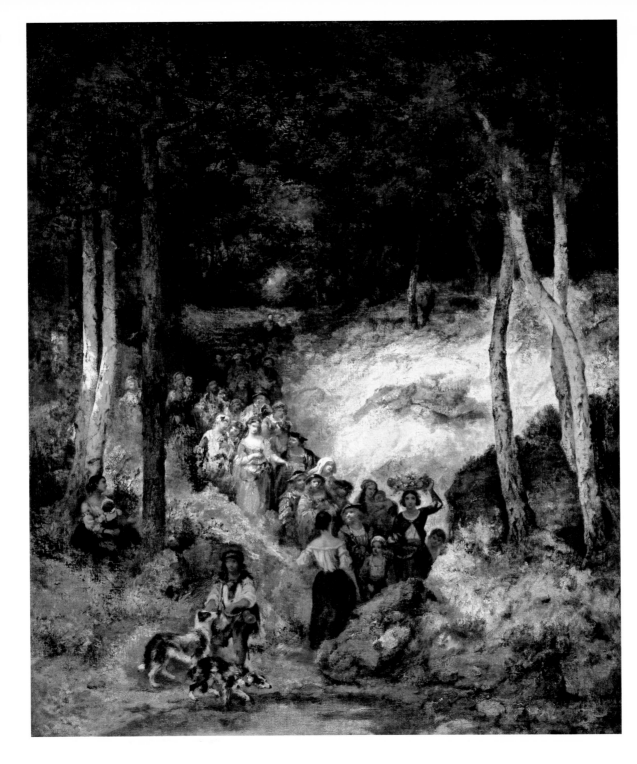

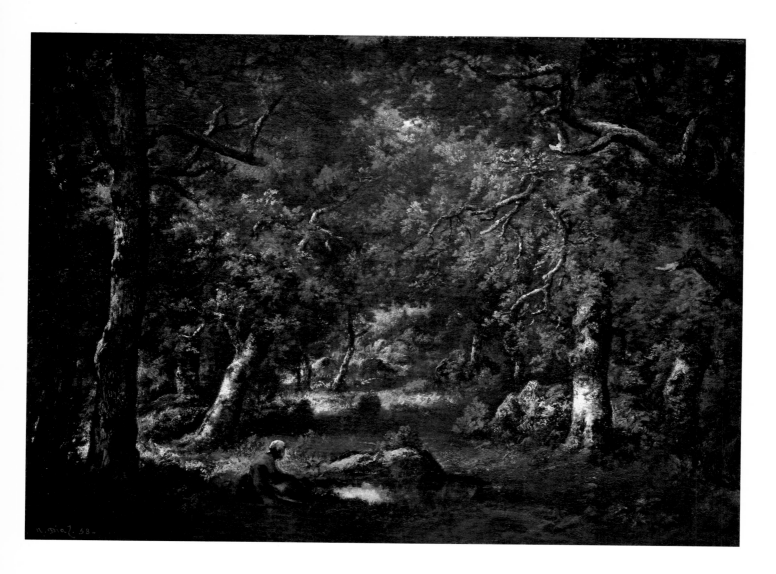

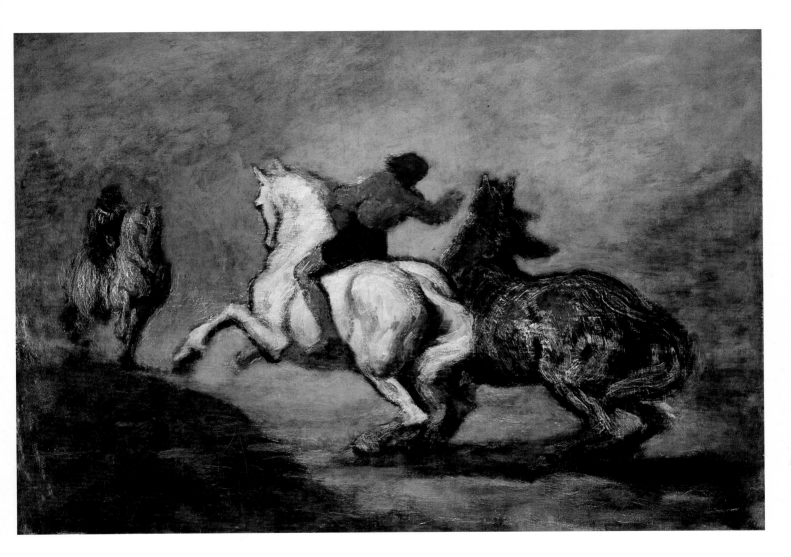

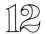

HONORÉ DAUMIER (1808-1879)
The Horsemen
Oil on canvas, 23¾ x 33½ in. (60.4 x 85.3 cm.)
Tompkins Collection. Arthur Gordon Tompkins
 Residuary Fund. 41.726

During his lifetime Daumier was known primarily as a lithographer, caricaturist, and illustrator. It was not until the end of the nineteenth century that his enormous talent as a sculptor and painter was appreciated by collectors and the general public. As an artist with a profound concern for the political and social issues of his time, his works centered on the human condition, particularly the urban scenes of Paris. Born in Marseilles in 1808, he came to live in Paris with his family at the age of eight. In about 1822 he began to draw under the tutelage of Alexandre Lenoir and developed a passionate interest in sculpture as well as the paintings of Rubens and Titian. He was then trained with the lithographer Ramelet, leading to the first publication of his political caricatures in 1830. His gifts as a draftsman and satirist were quickly recognized, and he became a regular and popular contributor to the daily newspapers. His illustrations were often highly controversial; one of his caricatures of Louis-Philippe led to his imprisonment in 1831. Through the practice of lithography Daumier developed an extraordinary ability to reduce a figure to a few evocative lines, and his mastery of sculptural modeling in simplified volumes led Balzac to say that he "had some of Michelangelo under his skin" (translated from Jean Adhémar, *Honoré Daumier* [Paris, 1954], p. 17).

From 1845 until 1863 Daumier lived on the Île Saint-Louis in Paris, where he joined a circle of artists that included several Barbizon painters, Delacroix, and Baudelaire. It was there, at a watering place for horses on the quai d'Anjou of the Île Saint-Louis, that Daumier became fascinated by the animals. In the late 1850s he studied them assiduously, and they became the inspiration for a number of canvases, among them the present picture, probably dating between 1855 and 1860. *The Horsemen* is a mysterious and romantic scene, however, removed from any identifiable place and time. The atmosphere is misty and other-worldly, not a space with which the viewer can identify. *The Horsemen* has been described as a *grisaille* painting, and it has also been called unfinished; close observation indicates that neither appraisal is accurate. The color range is subdued but richly varied. For example, the background area of the picture is a subtly scumbled matrix of blue-gray and beige pigment applied over a dark underpaint. This extremely subdued palette, the handling of lights and darks, and the drama conveyed by minimizing the setting and definition of detail, recall the *Tauromaquia* prints of Goya, an artist Daumier ardently admired.

The sophisticated painting technique of *The Horsemen* owes a great deal to Daumier's experience as a lithographer. The black and white horses in the foreground were painted in complicated layers of pigment. The black horse was painted over a white ground using a stiff brush and dry pigment, allowing forceful patterns of fine white lines to show through. A similar method was used to paint the horse walking in the background, while the white horse was brushed in using thick white paint with dark outlines for the contours of his form. The reduction of the bodies of the horses and riders to sculptural, simple masses also reflects Daumier's experience as a caricaturist, from which he learned to capture the most significant patterns of light and shade of his subject, eliminating extraneous detail.

As was often true of Delacroix's paintings of horses, there is a direct link to Baroque precedents in Daumier's *Horsemen*. The powerful rearing horses that ride away from the viewer diagonally into the picture space are strongly reminiscent of the great Baroque horse studies by Rubens, such as his superb *Struggle for the Standard* after Leonardo, which entered the collection of the Louvre in 1852. Daumier's horses, however, are transformed into a highly personal romantic composition, enveloped in a foggy ambience that is entirely different in feeling and execution from his seventeenth-century source.

CONSTANT TROYON (1810-1865)
Fox in a Trap
Oil on canvas, 36½ x 29 in. (93.5 x 74 cm.)
Signed at lower left: *C. Troyon.*
Gift of Julia C. Prendergast, in memory of her brother,
 James M. Prendergast. 21.8

Along with landscape painting, animal painting attained great popularity by the mid-nineteenth century in France. J. R. Brascassat had revived the genre early in the century with his romantic depictions of wolves and raging bulls. Wild animals were introduced into the violent North African hunting scenes of Delacroix (see cat. no. 8), and Barye specialized in bronze sculptures of animals, usually shown in a life-and-death struggle. However, it was Troyon who became the most powerful and influential animal painter of the time. He developed a style of painting profoundly influenced by the seventeenth-century Dutch *animaliers*, a style dependent not on a conflict between animals for drama, but rather on a penetrating, closely observed depiction of the individual animal in a natural setting.

The son of a porcelain painter from Sèvres, Troyon received his first artistic training there, and his earliest Salon paintings of 1833 and 1835 are landscapes of the Sèvres region. Troyon became a friend of Rousseau and Dupré, and, during the late 1830s and 1840s he frequently painted landscapes in the Forest of Fontainebleau near Barbizon, as well as in other areas of France. The most important event of his career, however, was a trip to Holland in 1847. While there he fell under the influence of the great Dutch animal painters, including Aelbert Cuyp and Paulus Potter, and following his return to France, he specialized in painting animals in landscape settings. Winning the medal of the Legion of Honor in 1849, Troyon was the first artist of the Barbizon group to attain public popularity. His works were exhibited extensively abroad, where he had many imitators and admirers.

It was during the last decade of his life that Troyon executed a number of large-scale paintings of hunting dogs that reveal his study of the eighteenth-century French animal paintings by François Desportes. *Fox in a Trap*, which closely resembles this series stylistically, must date from about 1855-1860. As in the *Pointer*, dated 1860 (also in the Museum of Fine Arts), the fox dominates the canvas and the setting, being placed in the center of the composition and shown full length. In both works a high degree of animation is introduced by showing the tail, back, and hindquarters of the animals facing the viewer with the muscular body curving into a diagonal thrust leading to the head, which is painted in profile. The paintings' vitality results from the fact that the animals are shown in a stable pose of potential action, like a coiled spring.

The background of *Fox in a Trap* is painted very sketchily and flatly in deep gray-greens, with only the edges of a few leaves highlighted. In contrast, the fox's fur is brushed in with thick impasto, each stroke imitating the length and direction of the pattern of the hairs. Softly lighted from the left foreground, the coat is painted a rich ocher with touches of gold, brown, and yellow. The muzzle of the face is white, accenting the cry from the open mouth as it is outlined against the foliage. This emphasis on the texture and color of the animal's fur, and the large scale of his form within the picture, give it the quality and emotional impact of a human portrait.

The closed landscape, with its screen of dense foliage, and with only a small patch of blue sky visible at the upper right, reinforces the sensation of the fox's being trapped and having no escape. His expression of pain, conveyed through the angle of his head, the flattened position of his ears, and his open mouth, is almost human. The position of the fox, his outstretched paw locked in the grip of the black steel trap, recalls famous images of human suffering such as Puget's great marble *Milo of Crotona* of 1671-1682 (Louvre, Paris), in which the figure, his hand caught in a tree trunk, screams in agony. The only evidence of human activity in the painting is the presence of the hunter's trap, but unlike hunting scenes by artists such as Courbet, Troyon here intended the viewer to sympathize with the animal, not the triumphant hunter.

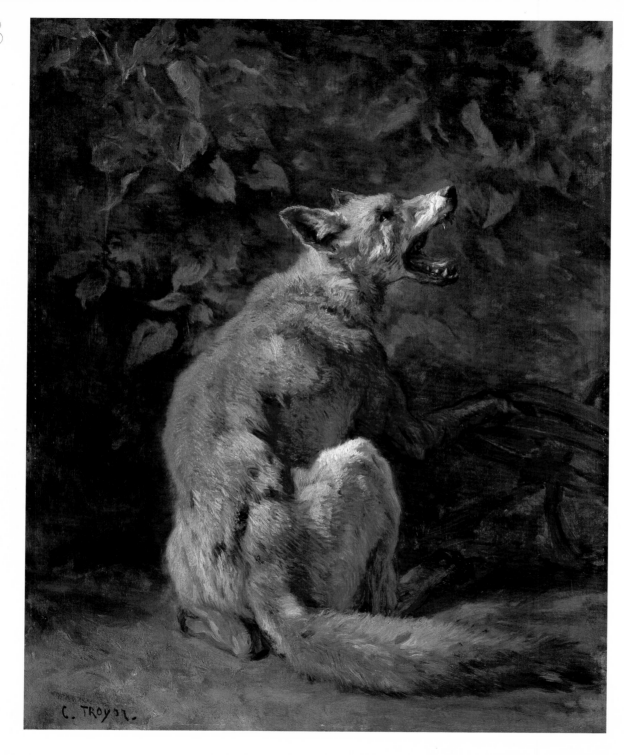

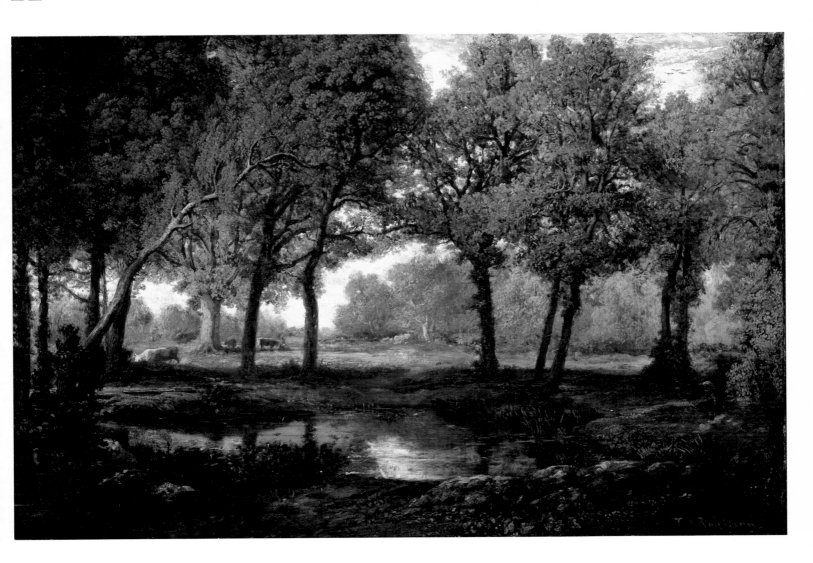

THÉODORE ROUSSEAU (1812-1867)
Pool in the Forest
Oil on canvas, 15½ x 22⅝ in. (39.5 x 57.4 cm.)
Signed at lower right: *TH. Rousseau*
Robert Dawson Evans Collection. Bequest of
 Mrs. Robert Dawson Evans. 17.3241

Rousseau is the most famous of the group of landscape artists who painted in the environs of the small village of Barbizon, located in the Forest of Fontainebleau, during the second and third quarters of the nineteenth century. His artistic training began at the age of fifteen, when he accompanied his cousin, the landscape painter Pau de Saint-Martin, on excursions in the region of Compiègne. His exceptional talent was so apparent that he was sent to study figure painting in Paris, first in the studio of Rémond, then in that of Lethières; however, Rousseau's only interest was in painting after nature. He first worked in the Forest of Fontainebleau in 1830, and was deeply affected by the beauty of its landscapes. The following year Rousseau made his debut at the Salon. His works of the early 1830s reflect the influence of the English artists Constable and Bonington, as well as the great Dutch seventeenth-century landscape painters.

Rousseau's career was plagued by continual vicissitudes of public acceptance and patronage. Despite his prodigious talent, he was refused admittance to the Salon from 1836 until 1848, leading to his being dubbed *"le grand refusé."* His fortunes changed after his appointment to the jury of the Salon of 1848. Until that year he had traveled widely in France, seeking new motifs to paint, but after 1848 Rousseau spent more and more time at Barbizon, where he formed a circle of friends who admired his work, including Jules Dupré, Diaz, Daumier, and Millet. Under the Second Empire his paintings gained public acceptance, and he was the recipient of a series of official honors, including a special room devoted to his and Decamps's paintings at the Exposition Universelle of 1855 and a medal of honor in 1867, the year of his death.

After working in a romantic style marked by dramatic subjects and free brushwork in the 1830s, Rousseau gradually changed his manner of painting in about 1850 to one of calmer landscapes with a tighter, and a more detailed application of paint. *Pool in the Forest* corresponds to this style of the early 1850s. Using a compositional device popular with Dutch artists such as Hobbema, Rousseau placed the foreground in shadow, contrasting it with an open, sunny clearing in the background. However, where Hobbema would have had a road or path to lead the viewer's eye into the picture space, and used trees only to frame the foreground, Rousseau closed the space surrounding the pool along its far edge with a screen of trees that reach above the upper limits of the canvas. This shadowy, dark enclave generates a feeling of quiet peace and intimacy, and the viewer is drawn into its mysterious, protective space as if it were an outdoor room. An impression of flickering luminosity is introduced by the gentle glimmer of reflected sunlight in the pool's rippled surface. The calm, bucolic mood is emphasized by the scattering of cattle and a milkmaid in the field beyond with the fringe of trees that border it, defining its limits.

In *Pool in the Forest* Rousseau displayed an extraordinary sensitivity to the physiognomy of the Forest of Fontainebleau, as well as to the season and time of day. Here he painted the forest in all of the golds, oranges, and greens of early fall, his preferred season. While Rousseau always sketched landscapes such as this one directly from nature, he usually returned to his studio to execute the finished oil painting, a method that links him to the practices of early nineteenth-century landscape artists. His direct response to nature and attention to seasonal effects of color and light, however, were fundamental to the development of the Impressionist style of landscape painting.

Like Corot, Rousseau exercised an important influence not only on the next generation of French landscape artists, but also on many nineteenth-century American painters. He was one of the first French artists to appreciate Japanese prints. After 1863 he collected them, and his late works, far brighter and looser in execution than *Pool in the Forest*, reflect their influence.

JEAN-FRANÇOIS MILLET (1814-1875)
The Spinner
Oil on canvas, 18¼ x 15 in. (46.5 x 38.1 cm.)
Signed at lower right: *J.F.Millet*
Gift of Quincy Adams Shaw, through Quincy Adams
 Shaw, Jr., and Mrs. Marion Shaw Haughton. 17.1499

In 1849 Millet left Paris, where he had been living for two years during the upheaval of the French Revolution of 1848. He settled permanently in Barbizon, a small village southeast of Paris where Rousseau, Troyon, and other landscape artists had been working for some time. He had disliked urban living, and his paintings of the 1850s reflect his joy in rediscovering nature in the environs of the Forest of Fontainebleau and the daily occupations of the peasants who lived there. *The Spinner*, dating from the early 1850s, is one of a number of small-scale works he executed representing a single figure engaged in a routine activity of country life. This picture reflects the influence of similar compositions by Chardin and is reminiscent of Dutch genre paintings of single women in interiors. Dutch seventeenth-century paintings that depict a woman spinning were evidently conceived as moralizing scenes illustrating the virtue of domestic industry, just as a sleeping maid in an untidy kitchen might represent the vice of sloth. The figure of the spinner personifies the virtue and dignity of hard work and demonstrates through her rhythmic pose the personal satisfaction derived from the labor of spinning by hand.

The young woman in this painting stands in a shadowy interior, her right hand on the crank of the spinning wheel, her left hand pulling off the spun yarn. Her form, reduced to broad, simplified areas of softly modeled color, is lit from an invisible source in the left foreground. She wears a brown skirt and a gray-beige apron, a white blouse and muted red vest with a gray kerchief on her head. Unlike Millet's later peasant figures, who often appear brutalized and broken by their work, this spinner is a graceful and attractive young girl who seems in complete harmony with her wheel and with her surroundings. The interior, as simplified in its descriptive detail as the figure of the girl, is painted in warm earth tones. Barely visible in the left background is a large wooden cupboard with a basket placed on top of it. The area is enveloped in deep shadow, which serves to throw the form of the spinning wheel into high relief. Under the wheel is a basket piled high with unspun wool, and in the right background two large gray sacks lean against the wall under a single wooden shelf on which a scale has been placed. The floor is of wide wooden boards, painted in a mellow gray-brown.

The composition is one of extraordinary unity and quiet. Millet succeeded in distilling the very essence of spinning, stripping it of all specificity of place and time, making it universal. The spinner and her wheel are contained in a pyramid of space, the triangular shape of which is echoed in the slanted angle of the legs bearing the weight of the front of the spinning wheel. Within this pyramid, however, there is a rhythm of circular motion and line that establishes the visual link between the woman and the wheel. A continuous movement flows from the rounded contours of her head through the smooth curve of her arm and hand to the yarn leading to the curve of the spinning wheel.

Such paintings of working peasants, all of whom Millet instilled with great innate dignity, were initially associated with Republican and artistic radicalism and social reform; however, within a few years they became popular with bourgeois collectors both in Europe and in America. They came to embody for these self-made men the work ethic of the industrial nineteenth century, while at the same time capturing a vision of a lost, bucolic world where man and nature were seemingly in complete accord. It is important to note that at the time *The Spinner* was painted spinning had already been mechanized and industrialized in western Europe, making Millet's painting a conscious anachronism, and evoking with nostalgia a rural activity that had already been eclipsed.

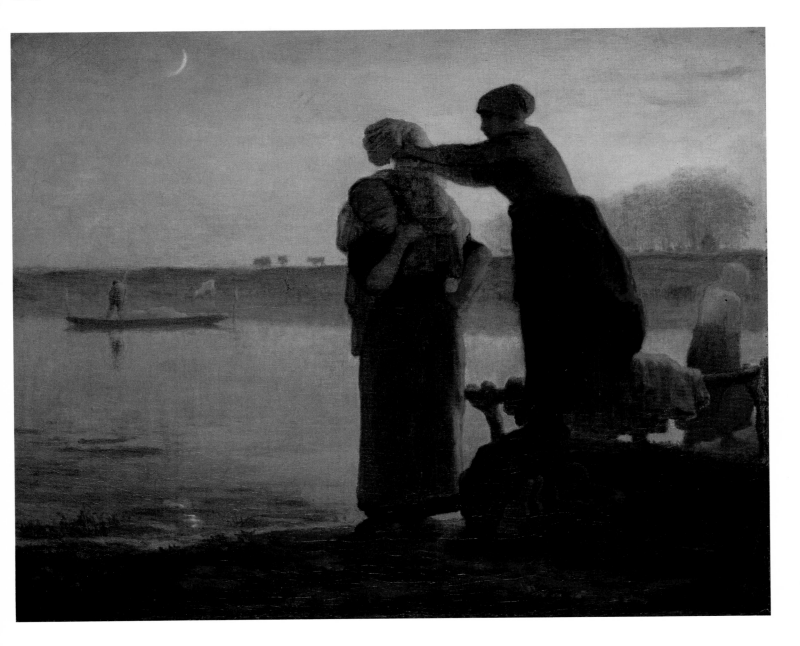

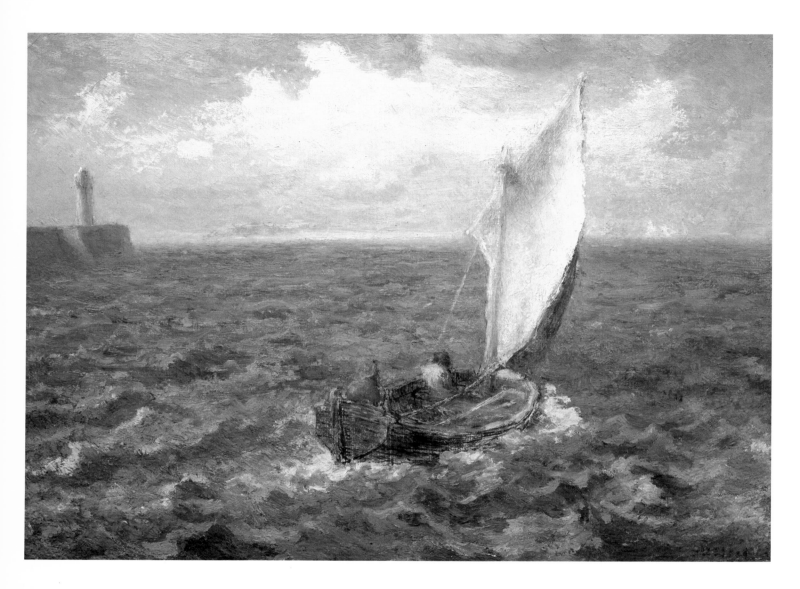

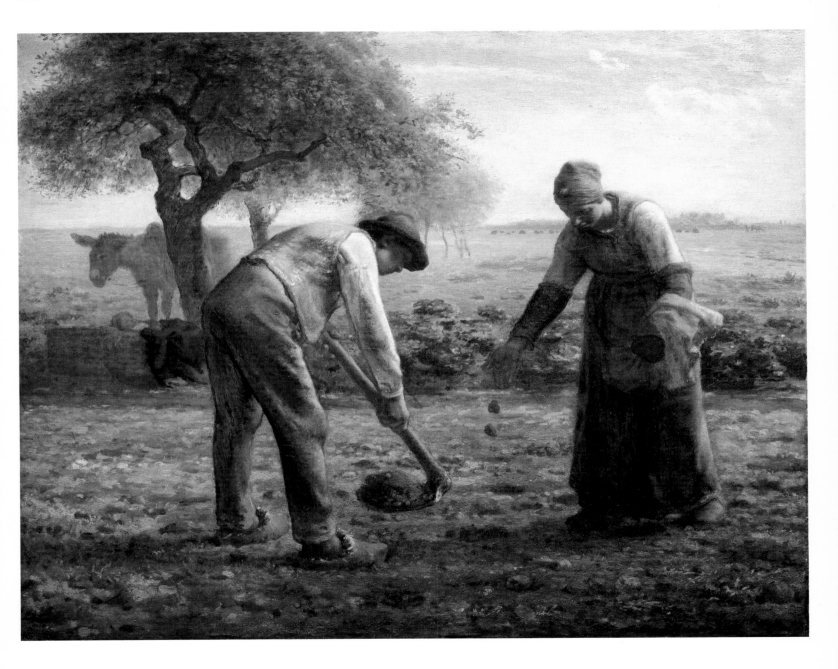

JEAN-FRANÇOIS MILLET (1814-1875)
Planting Potatoes
Oil on canvas, 32½ x 39⅞ in. (82.5 x 101.3 cm.)
Signed at lower right: *J. Millet*
Gift of Quincy Adams Shaw, through Quincy Adams
 Shaw, Jr., and Mrs. Marion Shaw Haughton. 17.1505

Planting Potatoes, executed in 1861 and 1862, is among Millet's most important large figure paintings. Representing peasants in a landscape setting, it is typical of the kind of painting most closely associated with Millet's public image from the time it was painted until the present. First exhibited in 1862 at the Cercle de l'Union Artistique in Paris, where it caused a sensation, it was subsequently shown at the Exposition Universelle of 1867. This second exhibition included a number of Millet's most famous works, such as *The Angelus* and *The Gleaners* (both now in the Louvre, Paris), for which he received a first class medal. It marked the firm establishment of Millet's importance as a leading artist of the time.

It was Millet's empathy with the working man, and his conviction that the peasant's daily life was as worthy of an artist's attention as religious or historical subjects, that served to advance the cause of realist art and to dissolve the academic hierarchy of subject matter. Millet and Courbet had been pioneers in this movement in the late 1840s, but the battle had been won by the late 1860s, and they became recognized masters not only for the new generation of artists but also among critics and patrons.

When *Planting Potatoes* received some sharp criticism from reviewers after its initial exhibition in 1862, Millet was encouraged by his friend Alfred Sensier to defend his painting in writing. As a result, Millet drafted an explanation of his work (unpublished during his lifetime) that eloquently reveals his point of view: "*A peasant and his wife planting potatoes* I would like to be able to render in a touching way the manner in which these two intimately associated beings work, and to make their two movements harmonize so well they become but one single motion.... Why should the work of

a potato planter or of a bean planter be less interesting or less noble than any other activity? It should be understood that there is no nobility or baseness except in the manner of understanding or of depicting things, and not the things themselves. How many examples could be cited in defense of this!" (translated from quotation in Etienne Moreau-Nélaton, *Millet raconté par lui-même*, vol. 2 [Paris, 1921], pp. 110-111).

From the time he moved to Barbizon in 1849, landscape was an important element in Millet's figure paintings, and he turned to the countryside in and around the village for their settings. In *Planting Potatoes* the potato field and vast plain that extends to the horizon represent the plain of Chailly outside of Barbizon, which was visible from the courtyard of Millet's house. This plain was the stage for some of his most important paintings, including *The Gleaners*.

Through the careful structure of the composition and the use of color Millet made the peasant family an integral part of the earth in which they labor. The couple work in a rhythmical cadence, as their outstretched arms and bodies form interlocking triangles. The hazy atmospheric light, which all but dissolves the haystacks and rooftops of the village in the distance, indicates Millet's close observation of the actual scene. The sensitivity to light, time of day, season, and palete evident in *Planting Potatoes* was to be admired and imitated by the Impressionists a decade later. It was paintings like this one that inspired Pissarro, Monet, and their contemporaries to explore new painting techniques in order to convey effects of light and weather out-of-doors.

In the early 1850s Millet had painted the four seasons, and one of the recurring themes of his art is the cycles of nature. *Planting Potatoes* is a springtime scene and a tribute to the renewal of life, with oblique religious overtones vaguely reminiscent of the Nativity. The two figures deposit the potato seeds, which will grow and multiply into a harvestable crop. There are tender green shoots of new grass in the plain and new leaves on the apple trees. The presence of the baby in the basket is also an indication of fertility and the creation of a new generation.

THOMAS COUTURE (1815-1879)
Woman in White
Oil on canvas, 18¼ x 14¾ in. (46.3 x 37.6 cm.)
Signed at lower left: *T C*
Gift of Mrs. Samuel Dennis Warren. 91.28

One of the most important artistic events in mid-nineteenth-century France was the exhibition of Couture's *Romans of the Decadence* (Louvre, Paris) at the Salon of 1847. It was received with universal acclaim by the critics and the public, catapulting the artist to fame. Couture had devoted four years to the completion of this vast canvas, and he was elated at its reception. It was particularly satisfying in light of earlier disappointments.

After moving to Paris from Senlis with his parents at the age of eleven, Couture began to study painting in 1829. He entered Gros's studio in 1831 and, meeting with rapid success, entered the École des Beaux-Arts. Between 1834 and 1839 he competed six times for the Prix de Rome, the coveted scholarship given to the best student each year, enabling him to study in Italy. In 1837 Couture was awarded the Second Grand Prix but, through what seemed an unfair political decision, was never given the first prize. Couture left the school and retained a bitterness toward the academic establishment for the rest of his life.

In an autobiography written in 1856 Couture described what followed his success at the Salon of 1847: "I thought I might as well take advantage of the public's infatuation by painting the many portraits I had been commissioned to do. In 1850 I exhibited a number of them thinking to prove to my dear colleagues that it was possible to please both the public and the art lovers by painting portraits in an artistic fashion. I obviously mistook the situation; both artists and critics alike were severe in their judgement of me" (translated and quoted in *The Second Empire/1852-1870: Art in France Under Napoleon III* [exhibition catalogue], Philadelphia Museum of Art, October-November 1978, pp. 277-278). *Woman in White* was probably executed during the early 1850s, when Couture's portraits were in greatest demand. The woman's hair style, parted in the middle, smooth and full at the sides, and pulled into a knot at the back of the head, was fashionable at that time. When works such as this fell from favor under the Second Empire, Couture still found a ready market among his American pupils and patrons.

In this portrait Couture painted his sitter bust length, in three-quarter profile, looking off to the right with a rather vague and dreamy expression on her face. A degree of spontaneity and animation is introduced into the picture by placing her off-center, and by showing her turned at a slight angle, the right shoulder lower than the left. The rather homely, yet sweet features of her face—her large brown eyes, nose, and cupid's-bow mouth—are deftly brushed on the canvas. The smooth creamy whites and pinks of the contours of her face and throat are contrasted with the filmy white material of the collar and bodice of her dress. Particularly in the collar, Couture used broad, free strokes of thick white, pink, gray, and green paint to brush in its ruffled form.

Profoundly influenced by Venetian sixteenth-century art and by the romantic paintings of Gros, Couture evolved a pictorial style of painting with emphasis on sureness of drawing, clarity of color, and freedom of brushwork. In portraiture he believed in painting one's immediate impression of the sitter directly on the canvas, and then working up and refining the *ébauche*, or oil sketch, into a more finished painting.

Couture's strong anti-academic stance and his belief in the spontaneous expression of the artist's individuality in his work were important for the development of other artists of the period. A born teacher, he founded an independent teaching studio in 1847 that continued until 1863. His most famous students were Manet (see cat. no. 33) and Puvis de Chavannes (see cat. no. 26), whose enormous talent and stylistic originality attest to Couture's nurturing of their individual abilities.

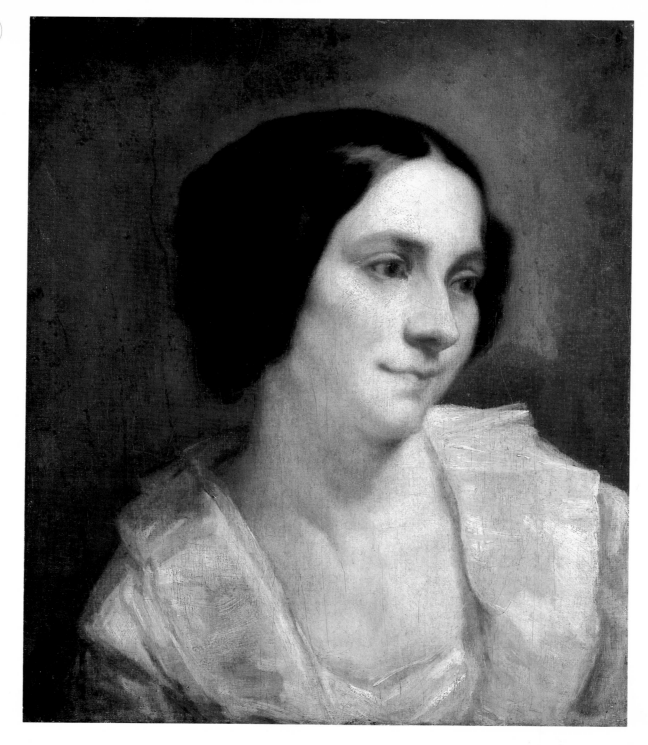

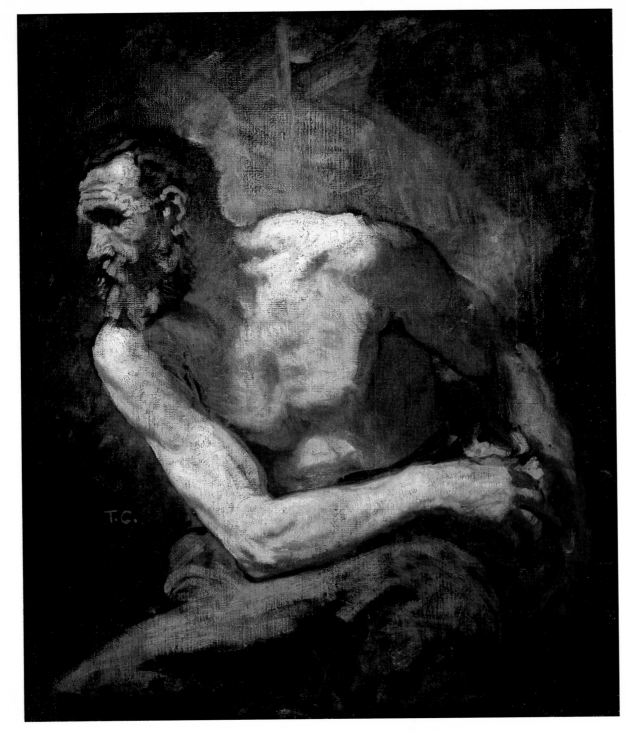

THOMAS COUTURE (1815-1879)
The Miser
Oil on canvas, 32 x 25⅝ in. (81.2 x 65.3 cm.)
Signed at left: *T.C.*
Bequest of Ernest Wadsworth Longfellow. 23.570

In the 1840s the battle between the romantic and classical schools of painting was still alive in France. Delacroix was the leader of the romantic movement, with its emphasis on color and dramatic expression and strong links to the seventeenth-century paintings of Rubens, while Ingres was the leading proponent of the classical school, rooted in the academic tradition of Greek and Roman art, stressing drawing, finish, line, and the tenets of Poussin. When Couture exhibited *The Romans of the Decadence* in 1847, he was hailed as having finally resolved the classical-romantic conflict.

Later that same year Couture founded a school for artists, and he continued teaching until the end of his life, playing an important role in the formation of many French and American painters. The announcement of the opening of Couture's school read: "His [Couture's] teaching is based above all on the *great art of ancient Greece,* the *Renaissance masters* and the admirable *Flemish school.* He believes that it is necessary to study all of these schools in order to reproduce the wonders of nature and ideas of our time, in a noble and elevated style" (translated and quoted by Albert Boime, *The Academy and French Painting in the Nineteenth Century* [London, 1971], p. 66). Couture thus espoused both polarities of the romantic and classical schools, at the same time stressing nature and contemporary subjects, leading in the direction of realism.

The Miser embodies many of the stylistic elements taught by Couture and revered by his students. Boldly and quickly painted directly on the canvas, the muscular, bearded figure of an old man is depicted against a scumbled dark reddish-brown background. The paint is dragged over the rough texture of the canvas, giving it a flickering, luminous quality reminiscent of the late paintings of Titian.

The pose of the figure, strongly lighted from the left,

recalls the male nudes of Michelangelo on the Sistine ceiling. More specifically, however, *The Miser*, seated in a twisted position with his head in profile, torso facing the viewer and arms thrust to the left side of his body, resembles the figure of Christ in Titian's great painting *Christ Crowned with Thorns* of about 1550 (Louvre, Paris). Since Couture encouraged learning through making free copies after the masterpieces of the Italian High Renaissance, it is not surprising to find that this study was apparently inspired by the figure in Titian's painting.

E. W. Longfellow, a Bostonian who donated *The Miser* to the Museum of Fine Arts in 1923, studied painting with Couture during the summers of 1876 and 1877 at the artist's home in Normandy. In an article about his teacher, Longfellow wrote: "Couture . . . received me warmly, and after rummaging about among a lot of old canvases, at which I longed to get a better look, produced a superb study of a man nude to the waist, which he had made years ago for the picture *L'Amour de l'Or.* This he set me to copy" (see E. W. Longfellow, "Reminiscences of Thomas Couture" in *Atlantic Monthly,* August 1883, p. 240). Apparently, after making his copy, Longfellow purchased Couture's oil study and brought it back to America with him.

The painting for which Longfellow claims *The Miser* is a study is *The Love of Gold* (Musée des Augustins, Toulouse), which won a medal at the Salon of 1844. Comparison of the study with the finished painting reveals that while the old man in *The Miser* grasps a sack, as does his counterpart in *The Love of Gold*, the two figures are otherwise entirely different. Moreover, the Toulouse canvas, executed when Couture was twenty-nine years old, is more tightly painted and anecdotal in quality, with none of the High Renaissance associations to be found in the oil sketch. It is more likely that *The Miser* was an exercise painted by Couture in the studio at a much later date as a demonstration sketch for his students. This supposition is reinforced by the fact that recent x-rays reveal a painting of a female nude underneath the sketch of *The Miser*, perhaps another painting used for demonstration purposes in the studio.

GUSTAVE COURBET (1819-1877)
Forest Pool
Oil on canvas, 61¾ x 44⅞ in. (157 x 114 cm.)
Signed at lower right: *G. Courbet.*
Gift of Mrs. Samuel Parkman Oliver. 55.982

Courbet was the most prominent artist in the realist movement in nineteenth-century France and its self-styled leader. The son of prosperous peasants, he was born at Ornans, a small village in the Jura mountains in the east of France. Having decided to become an artist, he went to Paris in 1839, studying for a short time in the studio of Steuben and later with Hesse. However, Courbet was of an extremely independent nature and chose to forgo traditional academic training, preferring to spend his time studying and copying Old Masters in the museums. His early works reveal the influence of the romanticism then current in France, but by 1848 he had evolved an individual, vigorous style characterized by the close observation of contemporary, untraditional subjects.

Courbet's large paintings *The Burial at Ornans* (Louvre, Paris) and *The Stonebreakers* (destroyed, formerly at the Dresden Museum), shown at the Salon of 1850, electrified the public, eliciting both intense admiration and extreme criticism of his startlingly realistic depiction of ordinary country peasants. These works were considered revolutionary not only because of the unorthodox nature of the subjects but also because of the stark, direct specificity of Courbet's style, devoid of any idealization or generalization.

Like Millet, Courbet became a champion of the common man and the liberal Republican cause; however, he differed from Millet in that he actively opposed the régime of Napoléon III. At the Exposition Universelle of 1855 he opened the "Pavilion of Realism," confirming his leadership of the movement, an event he was to repeat in 1867. Although Courbet's peasant subjects were the source of much controversy, his landscape paintings were generally well received.

In the spring of 1862 he accompanied his friend the art critic Castagnary to the region of Saintonge in the west of France, where they visited Étienne Baudry, a wealthy collector who owned the Château de Rochemont just outside the town of Saintes. From late May until early September Courbet was the guest of Baudry. *Forest Pool*, which closely resembles other landscapes that Courbet painted in the Saintonge region, must have been executed during the summer the artist stayed with Baudry.

The unusually large format and careful finish of *Forest Pool* make it the most significant landscape to date from Courbet's Saintonge period. Its composition is distinguished by a marked emphasis on verticality, which recalls the landscapes of Corot (see cat. nos. 5 and 6). In fact, Corot spent about twelve days at Rochemont, also a guest of Baudry, in August of 1862, during which time he and Courbet painted together. It is tempting to surmise that the unusual elements that appear in *Forest Pool* are due in part to the influence of the older landscape artist.

The general tonality of this painting is lighter and the palette brighter than in many of Courbet's Ornans landscapes. Patches of luminous blue sky are visible at the upper left and right corners of the canvas as well as in open areas between the trees. A rich variety of greens and yellow-greens, thinly applied in feathery strokes, was used to paint the foliage of the different species of trees caught by the sun, while the shaded areas of the canvas are brushed in in dense blue-greens and dark greens.

The artist created an extraordinary feeling of space and air through the funneling of perspective to the far end of the pool and by painting a dense bank of low trees and foliage behind the screen of tall trees. A sense of scale and animation is provided by the young buck who pauses on the right bank of the pool and turns to look directly at the viewer as though he had just heard a noise in this otherwise peaceful and quiet setting. Courbet's favorite sport was hunting, and he became an accomplished animal painter, often introducing wild animals into his landscapes.

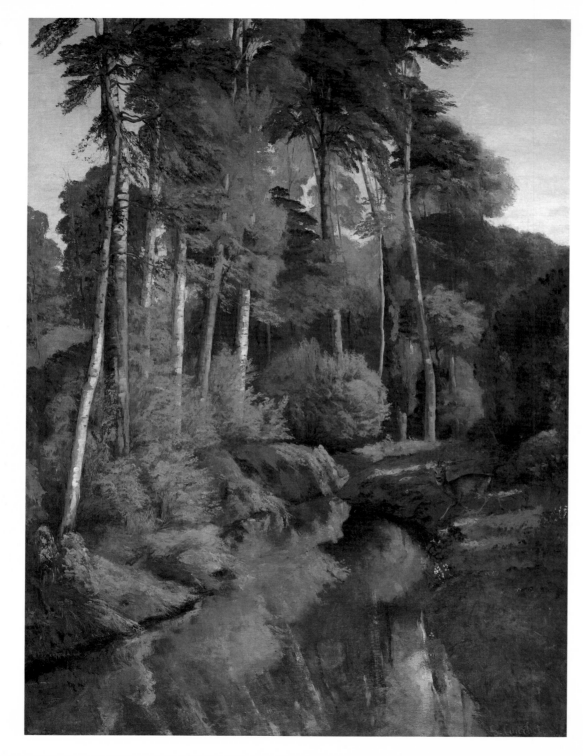

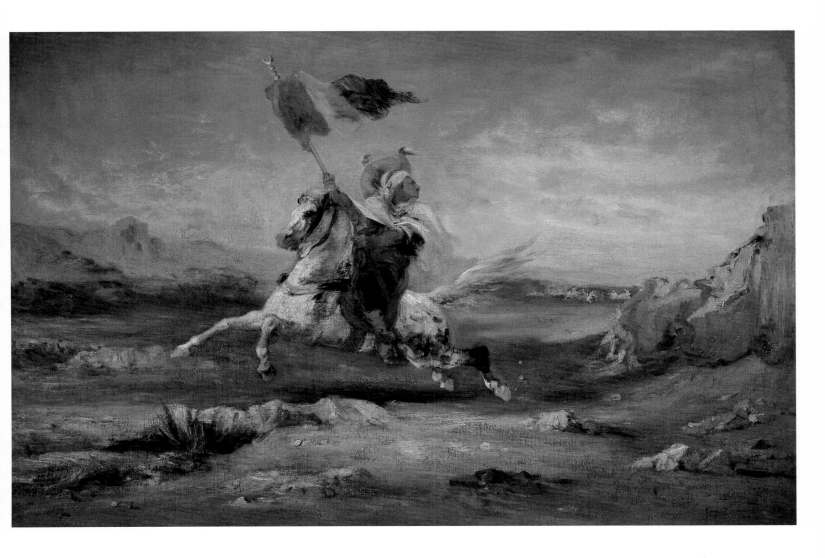

43

EUGÈNE FROMENTIN (1820-1876)
The Standard Bearer
Oil on canvas, 23¼ x 35⅛ in. (59 x 89.3 cm.)
Signed at lower right: *Eug. Fromentin.*
Robert Dawson Evans Collection. Bequest of
 Mrs. Robert Dawson Evans. 17.3254

Fromentin was not only famous as an artist who special-
ized in paintings of scenes from North Africa, but was
also a successful writer and art critic. A member of an
educated bourgeois family from La Rochelle, Fromentin
first studied law in Paris in 1840. He did not begin to
paint until 1843, when he entered the studio of Rémond.
He soon left in order to study with the landscape painter
Cabat, and through a friend, the watercolorist Charles
Labbé, he was introduced to the North African water-
colors of Delacroix, Decamps, and Marilhat. Fascinated
by these works, Fromentin accepted Labbé's invitation
to accompany him on a six-week trip to Algeria in 1846,
and the experience was to determine the direction of his
artistic and literary career. Two days after Fromentin's
arrival in North Africa he wrote, "Everything here
interests me. The more I study nature here the more
convinced I am that, in spite of Marilhat and Decamps,
the Orient is still waiting to be painted" (quoted in
Georges Beaune [translated by Frederick T. Cooper],
Fromentin [New York, 1913], p. 30).

Fromentin returned to Algeria and the Sahara twice,
once in 1847-1848 and again in 1852-1853. His notes and
sketches from these travels provided the basis for virtu-
ally all of his artistic production until the end of his life.
A regular contributor to the Salons, he was awarded a
second class medal in 1847 and a first class medal and
the Legion of Honor in 1859. Along with two books
written about his travels, *Un Été dans le Sahara* of 1857
and *Une Année dans le Sahel* of 1859, he wrote a famous
novel, *Doménique,* and published a critical study of
Flemish and Dutch art in 1875 entitled *Maîtres
d'autrefois.*

Although *The Standard Bearer* is undated, its subject
and style indicate that it was painted in the early 1860s.
The brilliance of the palette corroborates a date in the
early 1860s, when Delacroix and Marilhat were im-
portant influences for Fromentin. Subsequently, his
color harmonies would become more grayed and sub-
dued as a result of his study of the works of Corot.

After the Salon of 1861 in which Fromentin exhibited
Horsemen Returning from a Fantasia (now in the
Louvre, Paris), horses became increasingly important
in his work. Inspired by his sketches and memories of
events witnessed in North Africa, and based on life
studies after horses executed at his home near La
Rochelle, his scenes were full of drama and color.
Fromentin described the Arab *fantasias* in *Une Année
dans le Sahel*: "... imagine the most impetuous dis-
order, the most inconceivable swiftness, the utmost
radiance of crude color touched by sunshine; picture
the gleam of arms, the play of light over all those mov-
ing groups ... and perhaps you will catch a glimpse, .
amid the pell-mell of action, joyous as a festival, intoxi-
cating as war, of the dazzling spectacle called an Ara-
bian *Fantasia*" (quoted in Louis Gonse [translated by
Mary C. Robbins], *Eugène Fromentin, Painter and
Writer* [Boston, 1883], pp. 80-81).

The Standard Bearer reflects the influence of Dela-
croix's North African paintings such as *The Lion Hunt*
(see cat. no. 8) in its emphasis on the forceful, excited
movement of horse and rider in a landscape setting, and
in its extraordinary quality of exotic fantasy and ro-
manticism. However, Fromentin's painting is much
simpler and less ambitious in composition than that of
Delacroix. Instead of a complicated group of figures
and animals, a dappled white horse and his colorfully
costumed Arab rider are placed in the center of a rocky,
barren landscape. While the scene is clearly an Arab
fantasia, the exact nature of the drama is obscure.

Within the limitations of his *orientaliste* art, Fromen-
tin made an important contribution to the development
of nineteenth-century French painting. Romanticizing
his memories of scenes from his travels in North Africa,
while continuing the tradition of Delacroix, he perpetu-
ated the popularity of exotic Near Eastern subjects
through the third quarter of the century.

FÉLIX ZIEM (1821-1911)
Venetian Coasting Craft
Oil on canvas, 8½ x 12¾ in. (21.5 x 32.5 cm.)
Signed at lower right: *Ziem*.
Bequest of Lucy Ellis. 99.309

Ziem's artistic formation was outside the mainstream of French nineteenth-century art. Born in Beaune, he first studied at the Ecole des Beaux-Arts in Dijon in 1837, winning a prize in architectural drawing. After moving to Marseilles in 1839 and a period of informal study with Monticelli, he traveled to Italy in 1842, visiting Rome and Venice. He was so enraptured with Venice that he made it his second home, returning there to paint annually until 1892. Like many artists of his generation, Ziem was an inveterate traveler, visiting Russia, the Near East, various European countries, Algeria, Egypt, and even India.

In 1849, following several years of constant travel, Ziem returned to France and made his artistic debut in Paris at the Salon with a group of paintings and watercolors of Italian and Near Eastern subjects. He continued to exhibit at the Salon regularly until 1868, winning several prizes, including a first class medal in marine painting in 1852.

Ziem was an extremely prolific artist who achieved commercial success by the time he was forty. His early paintings, mostly landscapes and seascapes, reveal the influence of the Italian works of Corot. He gradually evolved a personal type of view painting depicting the exotic places he visited, particularly Venice. Purposely reminiscent of eighteenth-century Italian view paintings by artists such as Guardi and Canaletto, Ziem's works are usually done from a distant point of view, including a vast expanse of sky and sometimes sea, and often featuring a familiar architectural monument. The foreground often includes boats or small figures to provide scale and to add local color to the composition. These works had enormous appeal for his middle class French and American clients, either as souvenirs of their own travels or simply as mildly exotic decorative pieces for their homes.

Venetian Coasting Craft, although undated, is typical of Ziem's Venetian works of the 1860s. Painted in bright, highly keyed colors with rather free brushwork, it depicts two sailboats in the left foreground with a small rowboat drawn alongside. In the right distance, across an expanse of calm blue water, rises a group of buildings on the Venetian shoreline. The buildings glow in a warm pink-yellow light with a few touches of ocher. These tones are picked up and heightened in the brilliant yellow sails of the boats with their orange and ocher shadows.

It appears that the two domed buildings in the background are Santa Maria della Salute and the Dogana, and that the two-storied building on the water's edge is the Seminario Patriarcale. From their relative positions, the artist's point of view would have to have been from the opposite side of the Grand Canal, yet the distance from the buildings would not be as great as that depicted in the painting. Thus Ziem exercised considerable artistic license, and probably painted from memory.

During his lifetime Ziem executed hundreds of views of Venice. In a recent catalogue of his works more than one hundred fifty paintings that include the church of Santa Maria della Salute are listed (see Pierre Miguel, *Félix Ziem 1821-1911* [Maurs-la-Jolie, 1978]).

While based on firsthand knowledge of the city of Venice, the Boston painting has the quality of a prettified fantasy. It is vague in detail and generalized in technique, in complete contrast, both in execution and conception with, for example, the genre scenes of the Near East by Gérôme (see cat. no. 27). The orientalist movement in French painting manifested itself in many different subjects and styles, and in the works of artists of varying purpose and temperament. Ziem's paintings are colorful and decorative, but they represent a minor undercurrent in the overall view of French orientalist art.

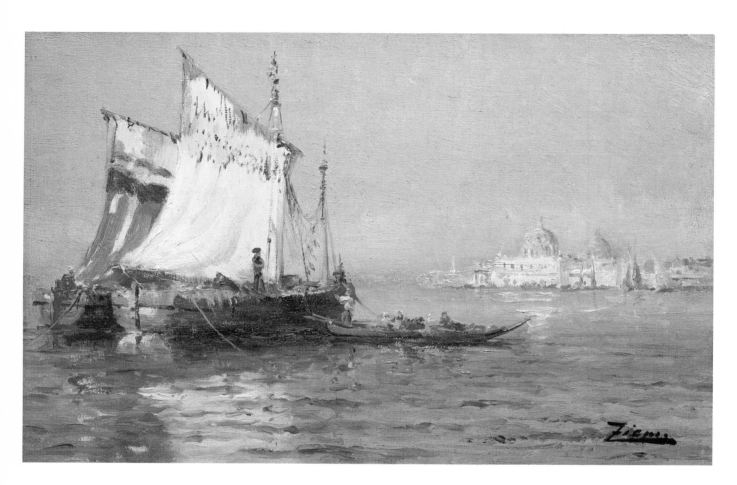

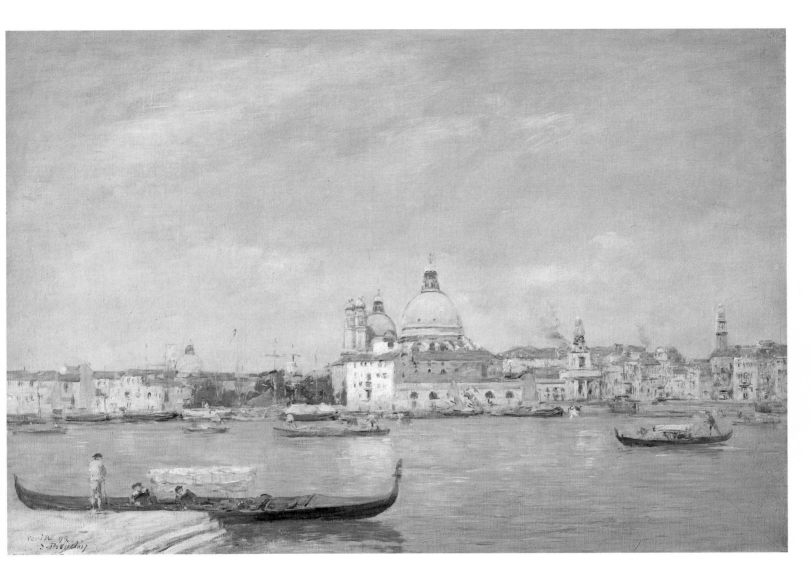

EUGÈNE BOUDIN (1824-1898)
Venice: Santa Maria della Salute from San Giorgio
Oil on canvas, 18⅛ x 25¾ in. (46.3 x 65.4 cm.)
Signed and dated at lower left: *Venise 95 / E. Boudin*
Julia Cheney Edwards Collection. Bequest of Robert J.
Edwards in memory of his mother. 25.111

Boudin was one of the most important and original
marine painters of the nineteenth century, attaining a
mastery of his art equal to that of Constable, Boning-
ton, or Turner in England. Gentle and modest in per-
sonality, Boudin persevered in pursuing his own style
with very little encouragement. It was not until the last
decade of his life that he received official recognition.
At the Exposition Universelle of 1889 he was awarded a
gold medal, and in October of 1892 he was decorated
with the Cross of the Legion of Honor. At the age of
sixty-eight Boudin went to Venice for the first time,
returning there in the summer of 1894 and again in 1895.
Venice held a particular fascination for several of the
nineteenth-century French artists, for example, Monet,
Renoir, and Ziem, who were drawn to its exotic archi-
tecture and wonderful light.

The format of this Venetian painting resembles that
of *Port of Le Havre: Looking Out to Sea* (cat. no. 25) in
its low horizon line and proportion of water and sky, yet
it is entirely different in color and atmosphere. Bathed
in the brilliant, clear Mediterranean sunlight, the scene
is painted in bright pastel tones, rather than the nuanced
grayed blues found in Boudin's northern pictures. In
this painting the Venetian sky is an intense blue with
wispy traces of thin white clouds and a bluish white haze
just above the horizon. The water shimmers with a
gentle movement, disturbing the reflections of the build-
ings along its edge; its color is almost turquoise, a blend
of the reflected blue sky with its own green hues.

Boudin must have been fond of this view, taken from
the steps of San Giorgio looking across the entrance to
the Grand Canal at the white dome of the church of
Santa Maria della Salute, and behind it the dome of the
Dogana, for he painted at least two other versions of
the scene (one dated 1893, the present location of

which is unknown; the other dated 1895, on the Paris art
market in December 1978). As was often the case with
repetitions of views Boudin painted on the coast of Nor-
mandy, he made only slight variations from one painting
to the other in the placement of boats and human fig-
ures. The real difference, and what interested him most,
was the cloud formations in the sky, the light, and the
atmosphere. Although not done with the same methodi-
cal calculation as the series paintings by Monet,
Boudin was, in effect, achieving the same result as the
younger Impressionist artist in capturing different ef-
fects of light and season on the same subject, as, for ex-
ample, the façade of the Rouen cathedral (cat. no. 49).

The shoreline of *Venice: Santa Maria della Salute
from San Giorgio* is gay and warm, with its variety of
low white and beige buildings topped by red tiled roofs,
interrupted by an occasional puff of smoke and the
towers of churches. To the left of the Salute appear a
few dense green trees, relieving the angular lines of the
buildings. All of these details are observed with an
extraordinary freshness of vision and executed with
consummate skill. Unlike Ziem, who often painted his
rather generalized Venetian scenes from memory (see
cat. no. 23), Boudin took delight in recording the shapes
and colors of the individual landmarks of the city, cap-
turing its charm and unique appearance along with its
sparkling atmosphere.

EUGÈNE BOUDIN (1824-1898)
Port of Le Havre: Looking Out to Sea
Oil on canvas, 15¾ x 21⅝ in. (40 x 55 cm.)
Signed at lower right: *Boudin*.
Bequest of Elizabeth Howard Bartol. Res. 27.90

From birth, the sea was an important part of Boudin's life, and it became the dominant theme of his paintings. The son of a sailor, he was born at Honfleur, a picturesque fishing village on the coast of Normandy. As a child he worked on his father's boat, and his love of the sea and skies of this northern coastal area made a lasting impression on him. Without any formal training, Boudin began to sketch and paint in the area around Le Havre when he was eighteen. While working in an art supply shop there, he met Millet and Troyon. However, the two most important influences on his early works were the marine paintings of Eugène Isabey and the seascapes of the Dutch and Flemish seventeenth century that he was able to study during a trip to those countries in 1849. In subsequent years Boudin was to travel extensively and to spend much of his time in Paris, but he always returned to the beaches and coastal towns of Normandy for renewed inspiration.

After struggling to find his personal style by making copies at the Louvre and studying the works of Corot and Courbet, Boudin decided in 1855 to become a marine painter. His compositions did not depend on such dramatic effects as storms and shipwrecks to lend interest, but rather on the handling of light and color. Boudin had a delicate, original manner of painting that was enhanced and lightened in palette under the influence of Corot and gained new freshness and spontaneity after he saw the works of the Dutch marine painter Jongkind in 1862.

Following years of poverty, Boudin began to receive critical recognition for his work in the 1860s and 1870s. By 1884 he was able to build a small house on the Channel coast at Deauville, where he spent the summers, returning to Paris in the winters. *Port of Le Havre* closely resembles another version of the subject dated 1886 (present whereabouts unknown); both pictures were probably executed while Boudin was in Normandy during the summer of that year. As is the case with most of his canvases, the painting is of small format. Three quarters of the composition are devoted to the sky, and one quarter to the sea, the surface of which is dotted with boats. A three-masted ship is tied up alongside the jetty at the entrance to the harbor on the left. On the right, lining the quay, is a row of small beige houses. A large three-masted ship, its sails half unfurled, flying the French tricolor flag, dominates the center right of the picture, with four small rowboats around it.

Corot once declared Boudin the "king of skies," an epithet easily understood when one examines the Boston painting. The magnificent Channel sky is filled with billowing, puffy white and delicate gray clouds with patches of blue showing through, all reflected in the quiet water. The boats provide vertical accents and dashes of color that lend focus to the painting and reveal the artist's firsthand knowledge of the sea. H. Marriott wrote his appreciation of this in a review of an exhibition of Boudin's paintings in *La Vie Moderne* in 1883: "In seeing this work one recognizes the sailor who has spent his life studying the sea in all its aspects, and no one knows boats better than he The success of his exhibition is only homage justly deserved by an artist whose talent is today uncontestable and uncontested" (translated and quoted by Ruth L. Benjamin, *Eugène Boudin*, p. 94).

Boudin's seascapes played a major role in the formation of Monet's style and in the development of the *plein-air* painters. The two artists first met in Le Havre in 1855, when Boudin took Monet, fifteen years younger than he, out-of-doors to sketch. They remained close friends, and Boudin joined in the first Impressionist exhibition in 1874. When Boudin painted *Port of Le Havre* in the mid-1880s, he had in turn come under the influence of his former student, for the freedom of the brushwork in the application of paint, particularly in the sky, reveals Boudin's awareness of the broken, smaller brushstrokes used by the Impressionists.

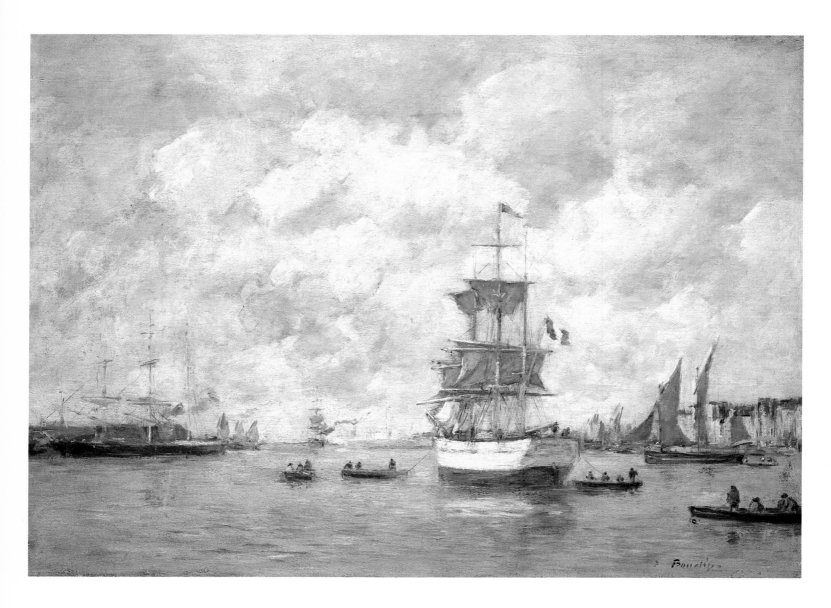

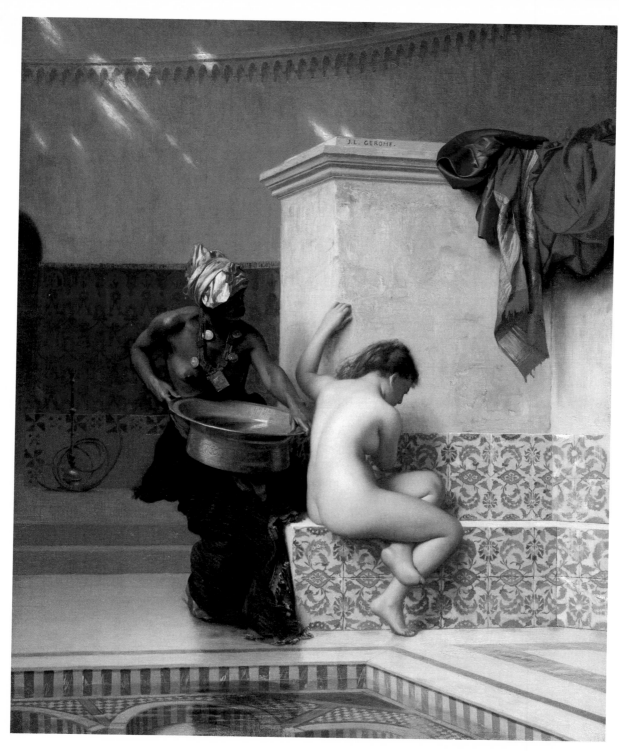

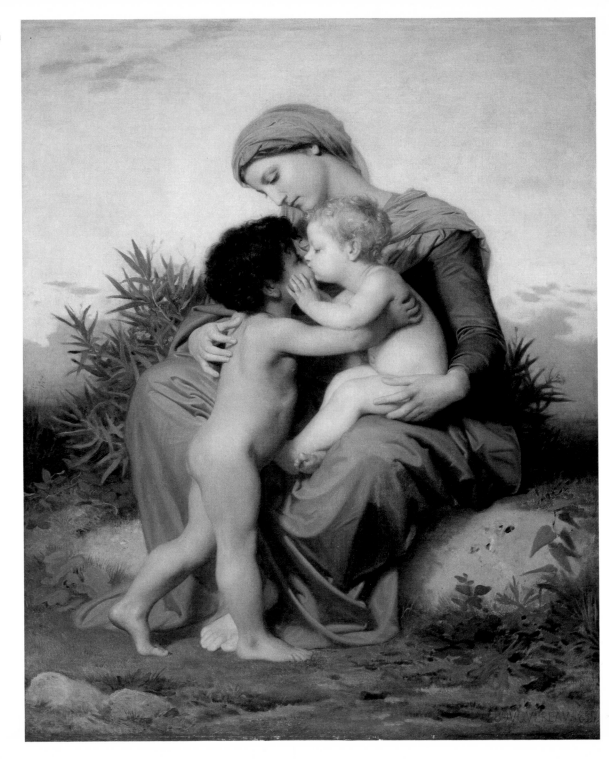

WILLIAM-ADOLPHE BOUGUEREAU (1825-1905)
Fraternal Love
Oil on canvas, 57⅞ x 44¾ in. (147 x 113.8 cm.)
Signed and dated at lower right: *W. BOVGVEREAV.*
1851.
Gift of the Estate of Thomas Wigglesworth. 08.186

Bouguereau was an artist who continued to work in the
tradition of Ingres and French academic painting to the
end of the nineteenth century. He enjoyed a lifetime of
official recognition culminating in election to the In-
stitut de France, and continuous commercial success,
particularly with American collectors. Born in La
Rochelle in 1825, he moved in 1832 to the Île de Ré,
where he received drawing lessons from a former pupil
of Ingres. At sixteen he entered the École des Beaux-
Arts of Bordeaux, and after two years won first prize in
figure painting. He earned enough as a portrait painter
to go to Paris in 1846, entering the studio of Picot, one
of the most celebrated teachers of the time. Within a
few months he was accepted at the École des Beaux-
Arts and the Académie des Beaux-Arts, where the tradi-
tional emphasis on accuracy of drawing both after
plaster casts and from the live model had remained
unchanged since the seventeenth century. Awarded a
second prize in the Prix de Rome competition in 1848,
he won first prize, shared with Baudry, in 1850 with the
painting *Zenobia Discovered by the Shepherds* (Musée
de l'École des Beaux-Arts, Paris).

The Prix de Rome enabled Bouguereau to study in
Italy for four years, and *Fraternal Love*, dated 1851, is
one of the first major works he executed while in Rome.
The picture reflects his admiration for Italian High
Renaissance painting, especially the works of Raphael.
It is purposely reminiscent of Raphael's compositions
of the Virgin and Child with Saint John, yet Bouguereau
chose a more ambiguous and secular title for his paint-
ing. This may be due, in part, to the popularity of gen-
eralized, secular subject matter in mid-nineteenth-
century French painting, and the simultaneous decline
in the demand for overtly religious art. (For example,
many of Millet's paintings seem biblical in tone and

inspiration but have simple, nonreligious titles.) Ironic-
ally, *Fraternal Love* came to be known as the *Madonna
and Child with Saint John* after being brought to the
United States sometime before 1869 by Thomas Wig-
glesworth.

In *Fraternal Love* Bouguereau created a beautifully
unified and monumental composition. Placed in a land-
scape setting, the figure of the mother is seated on a
rock, her head partially in profile. The relatively low
horizon line serves to give importance to the pyramidal
group of figures, outlining them against the gray-blue
sky. The woman's form enfolds that of the blond child
on her knee and the standing, darker-complected figure
of the other boy, as they embrace. The palette is sub-
dued and cool with the grays of the mother's garments
serving as a backdrop for the pale flesh tones of the
children, all of them contrasted with the varied greens
of the foreground landscape. The figures are drawn
with precise outlines and meticulous detail, the color
being of secondary importance. The painting has a por-
celain-like finish with smooth, unobtrusive brushwork.

The stylistic features of *Fraternal Love* are those that
dominated Bouguereau's art until the end of his career.
Like Gérôme (see cat. no. 27), he was first praised and
later maligned for the high technical finish and pre-
cision of detail found in his paintings. He was aware of
his differences with the stylistic developments among
contemporary artists, for he said at the end of his life:
"I am very eclectic, as you see; I accept and respect all
Schools of painting which have as their bases of doctrine
the sincere study of nature, and the search for the true
and the beautiful. As for the mystics, the impressionists,
the pointillists, etc., I can't discuss them, I don't under-
stand them. I do not see at all as they see, or as they
pretend to see. There is no other reason for my negative
opinion of them" (quoted by Robert Isaacson, *William-
Adolphe Bouguereau* [exhibition catalogue], New York
Cultural Center [New York, December 1974-February
1975], p. 11).

AUGUSTE TOULMOUCHE (1829-1890)
The Reading Lesson
Oil on canvas, 14⅜ x 10⅞ in. (36.5 x 27.5 cm.)
Signed and dated at lower left: *A. TOULMOUCHE 1865*
Gift of Francis A. Foster. 24.1

Auguste Toulmouche, known as the "painter of boudoirs," specialized in scenes of upper middle class Parisian domestic life. Born in Nantes in 1829, Toulmouche came to Paris to study painting with Gleyre, who ran a famous independent studio. He first exhibited at the Salon of 1848 and went on to win a second class medal in 1861 and a third class medal in 1878. A proponent of the academic tenets of his time, he worked in a meticulous, minutely detailed style. Like his contemporary Gérôme (see cat. no. 27) he continued in the tradition of Ingres as interpreted by Gleyre. Both Toulmouche and Gérôme espoused the neoclassical principles of the idealization of the model and the supremacy of line over color, and devoted particular attention to the differentiation of textures. However, unlike Gérôme, who frequently painted themes of historic or literary importance, Toulmouche limited himself to painting contemporary domestic scenes that were consciously reminiscent of Dutch seventeenth-century genre interiors as well as of French eighteenth-century *scènes galantes*.

In a review of the Salon of 1861 Toulmouche was favorably compared to Alfred Stevens as an artist who depicted bourgeois scenes effectively and recorded interior decoration and ladies' fashion with great accuracy. *The Reading Lesson*, dated 1865, illustrates Toulmouche's proficiency in this style. While painted with less technical brio and a more modest imagination than works by Gérôme, it is a picture of distinct charm.

The painting may be interpreted as a subtle statement for motherhood and the materialistic values of the French bourgeoisie during the Second Empire. The sitter is shown as a devoted and educated mother, teaching her daughter to read. The piano, with its open book of music, implies that the woman's accomplishments include music. The needlepoint footstool, carefully placed in the foreground, indicates her skill in that art as well. Beautifully dressed, the woman wears jewels on her fingers and a fur-trimmed jacket. The large tapestry in the background establishes the fact that this family lives surrounded by important works of art dating from an earlier time and, therefore, perhaps inherited; one is led to conclude that this is old wealth, not new. While Toulmouche was not a portraitist, he did use wealthy Parisians as his models, and they were doubtless the clients who were, in turn, willing to pay high prices for his works.

Toulmouche enjoyed considerable popularity during his lifetime, yet today he is remembered primarily as Monet's cousin and adviser. It was Toulmouche to whom Monet was sent by his parents when he went to Paris in November 1862. He recommended that Monet enter the studio of Gleyre, saying: "Gleyre is the master of us all. He'll teach you to do a picture" (John Rewald, *The History of Impressionism*, 4th rev. ed. [New York, 1973], p. 70). It is important to remember that in the context of French painting of the mid-nineteenth century Toulmouche's art illustrates the dominant public taste. Given this artistic climate, it is easier to understand why Monet, Renoir, and Cézanne, all of whom entered Gleyre's studio in 1862, had to endure years of poverty and ostracism before encountering any public acceptance. Against this background one can appreciate the true genius and independence of spirit of the Impressionists in their breaking away from the prevailing academic conventions.

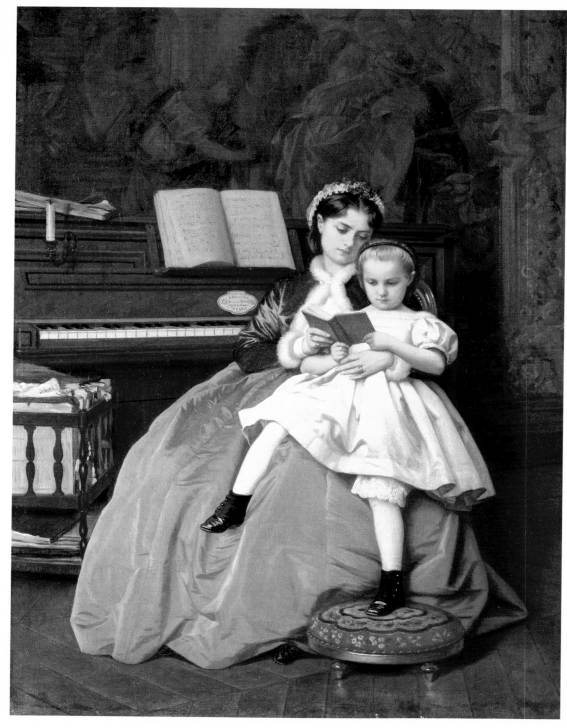



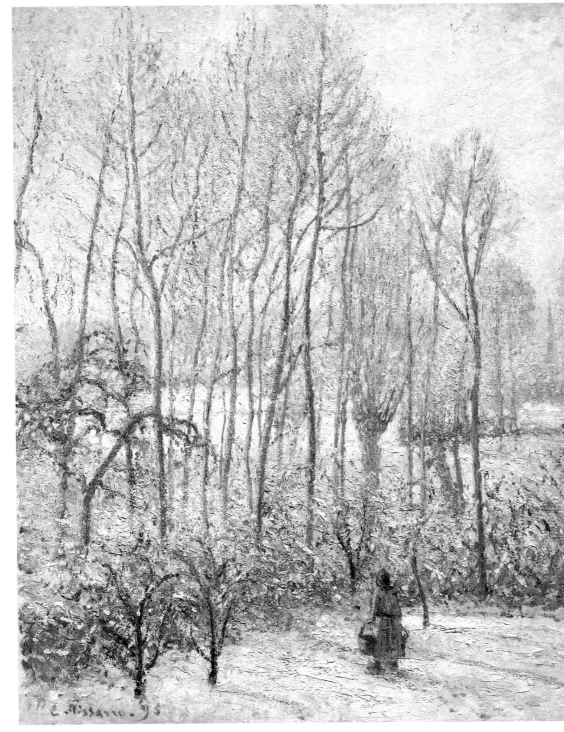

30

CAMILLE PISSARRO (1830-1903)
Morning Sunlight on the Snow, Eragny
Oil on canvas, 32⅜ x 24¼ in. (82.3 x 61.5 cm.)
Signed and dated at lower left: *C. Pissarro. 95*
The John Pickering Lyman Collection. Gift of
 Theodora Lyman. 19.1321

After years of struggle and poverty, Pissarro finally achieved modest recognition and financial stability during the last decade of his life. This period of success coincided with a prolific production of beautiful landscapes, often painted from a window because, due to age and illness, he suffered from working out-of-doors in inclement weather. With the help of Monet he had been able to purchase a home at Eragny, a small village on the Oise River north of Paris. Many of his canvases represent scenes visible from his Eragny house or from hotel windows in Paris and Rouen.

Morning Sunlight on the Snow, Eragny is one of Pissarro's most successful landscapes of this period. He, along with the other Impressionists, had always been fascinated by the depiction of snow scenes. Representing the reflected patterns of light and shadow on the luminous surface of the white snow was a repeated challenge. The Eragny landscape dated 1895 is entirely different in conception and style from the artist's earlier Pontoise snow scene of 1873 (cat. no. 32). Here the solidity and form of the earlier canvas give way to a gossamer atmospheric light, not unlike that found in Monet's paintings of the 1890s (see cat. no. 49). However, Pissarro's palette is quieter with fewer decorative chromatic contrasts.

With an extremely delicate color sensibility Pissarro built up the surface of the painting with a web of small, thick, dry daubs of paint. A wide array of pastel tones, without any pure white, was used to produce the effect of morning sunlight shimmering in the treetops and bushes and casting shadows across the landscape from the left background. The highlighted areas are indicated with a variety of warm tones of yellow, orange, pale beige and pink, all mixed with white. The shadows are painted in a wide range of cool violets, greens, blues,

and grays. The sky is brushed in with thick crisscrossed strokes of pale blue, white, and pink. The painting conveys a sense of quiet and solitude, in part evoked by the single figure of a peasant woman, her back to the viewer, carrying two buckets. A feeling of air and space is masterfully achieved in the field of snow visible beyond the screen of trees and bordered in the distance by another gray-blue band of trees.

The refinement of Pissarro's painting technique during these last years grew, in part, out of his experiments with pointillism in the late 1880s. Dissatisfied with his Impressionist painting style, he adopted the divisionist technique of Seurat and Signac with great enthusiasm in 1886. When he eventually found it to be too constraining and unsuited to his more spontaneous temperament and need for personal expression, he abandoned it in about 1890. He nevertheless retained, in a freer form, the delicate touch and color sensitivity acquired from his divisionist experience.

At the same time, during the 1880s, Pissarro had been experimenting extensively with printmaking, and the quality of his drawing and sense of linear composition improved. *Morning Sunlight in the Snow, Eragny*, with its vertical format and graceful linear pattern of tree trunks and branches, recalls some of his etchings of the early 1880s. In this painting there is also an echo of a tribute to the late landscapes of Pissarro's former master, Corot, in the willowy tall trees and the delicate light effects, all brought into scale by the single foreground figure (see cat. no. 6).

CAMILLE PISSARRO (1830-1903)
The Road to Ennery
Oil on canvas, 20⅝ x 32⅛ in. (52.3 x 81.5 cm.)
Signed and dated at lower right: *C. Pissarro. 1874*
Juliana Cheney Edwards Collection. Bequest of
 Robert J. Edwards in memory of his mother. 25.114

The Road to Ennery of 1874, a serene landscape bathed in limpid sunlight, is a superb example of Pissarro's harmoniously composed pictures of the early 1870s. While the painting style has often been associated with Pissarro's exposure to Constable's work during Pissarro's stay in London at the beginning of the decade, the extraordinary clarity of the light and the creamy texture of the paint applied in sensuous, broad brushstrokes are closer to the Roman landscapes of Pissarro's former teacher, Corot. In fact, Pissarro never forgot what he had learned from Corot. Until the end of his life admiring references to the work of the Barbizon artist appear in his correspondence.

In a letter written to his son in July of 1893 Pissarro wrote of Corot: "Happy are those who see beauty in the modest spots where others see nothing. Everything is beautiful, the whole secret lies in knowing how to interpret" (John Rewald, ed., *Camille Pissarro: Letters to His Son Lucien* [New York, 1943], p. 212). Following this principle Pissarro depicted a scene taken from his immediate environs, a road near his home in Pontoise, and imbued it with a freshness of vision and pure atmospheric light that are uniquely his own. Where Pissarro differs from his predecessor is in the lighter, cooler tonality of his palette and the spontaneous, almost photographic nature of the picture.

Built up in three horizontal bands, the composition is one of balance and repose. The grassy foreground with the sandy path along the riverbank is painted in soft greens and buff tones with gray-blue shadows. The middle distance is defined by the strong horizontal of the river, behind which rise the rooftops of the village interspersed with the fresh green forms of the trees. The blue sky with its puffy white clouds forms the upper zone of the canvas. Anchoring the composition and giving it a vertical counterbalance is the group of four trees on the right. There is no black in the painting, and the shadows are indicated in wonderfully nuanced shades of silvery blue and gray. An unorthodox compositional note is introduced by the man on horseback and the woman walking on the path, who move off the canvas in opposite directions.

1874 was the year of the first Impressionist exhibition in Paris, and Pissarro was instrumental in organizing it. It marks the moment of greatest harmony of style and of purpose among an otherwise disparate group of artists. Their mutual concern with the depiction of light in a landscape and with working directly from nature, combined with their desire to revolt against the tired tenets espoused by the Academy, bound them together. *The Road to Ennery* embodies the Impressionist style and beliefs, but it also serves as a reminder that the movement did not develop without precedent, and that its roots are to be found, in part, in the bold landscapes of the preceding generation.

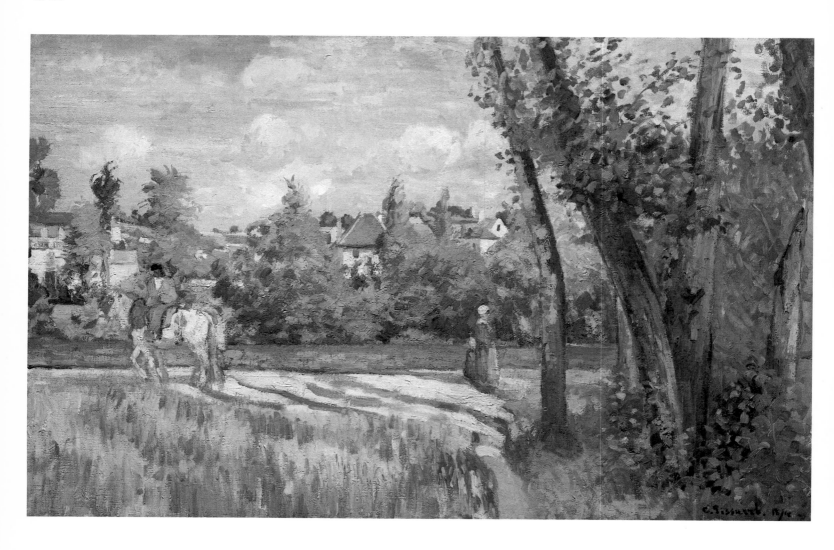

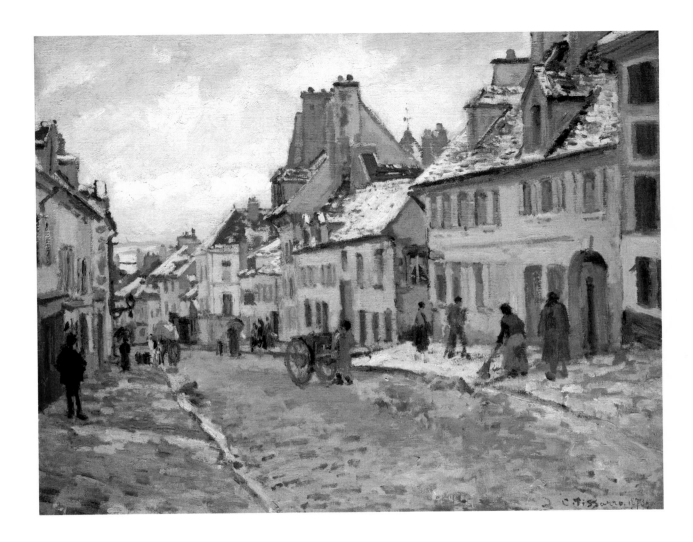

CAMILLE PISSARRO (1830-1903)
Pontoise, Road to Gisors in Winter
Oil on canvas, 23⅜ x 28⅞ in. (59.3 x 73.5 cm.)
Signed and dated at lower right: *C. Pissarro. 1873*
Bequest of John T. Spaulding. 48.587

The Franco-Prussian War of 1870-1871 caused the dispersal of the group of artists who had met in Paris in the 1860s, and who were later to become known as the Impressionists. Pissarro, along with Monet, fled to London, returning to France in June of 1871. In the summer of 1872 Pissarro settled at Pontoise, a small town on the Oise River, northwest of Paris. He was joined there by Cézanne and Guillaumin, and together they painted scenes in the village and the surrounding countryside. The exposure to Monet's light palette while in London and their study of paintings by Constable and Turner, along with the stimulus of the direct contact with nature in Pontoise, all combined to bring about a change in Pissarro's painting style. *Pontoise, Road to Gisors in Winter*, probably executed in the early months of 1873, reflects this stylistic change.

Like Monet in *Snow at Argenteuil* (cat. no. 46) of about 1874, Pissarro chose to depict a specific weather condition, that of a heavy, snow-laden cloudy afternoon, and a specific season, winter. Both artists used a device frequently found in their works of the early 1870s—a street in perspective that serves to penetrate the picture space, giving it depth and definition. Pissarro's painting, however, is limited to the cobblestone street, the buildings that line it, and the figures that populate it, with no trees or grassy areas. In the right foreground a woman sweeps the sidewalk, and Pissarro conveyed in a few brushstrokes the rhythm and posture of her movement. Another figure wearing a workingman's apron pulls a cart over the cobblestones, and the effort he expends is evident in his lowered head and straining arms. Even though summarily indicated, these figures suffuse the scene with human warmth and strike a note of empathy in the viewer. Unlike the figures in some of Millet's paintings, however, they are not sentimentalized.

Pissarro's palette shows his powers of observation and his mastery of subtle color harmony. Muted neutral earth tones dominate the composition in the house fronts and the street, highlighted by the touches of green, gray, and terracotta in the shutters and chimneys. They all serve as a foil for the white snow that lies on the roofs and in patches on the ground. Cooler colors are introduced in the sky with its heavy, off-white clouds and blue-gray background. The artist used broad brushstrokes of pure color in painting the buildings, giving them a block-like solidity with a vertical emphasis. This is balanced both in texture and weight by the strong horizontal broken brushstrokes of the street and sidewalks. The scumbled, fluffy brushwork of the winter sky is reminiscent of Constable's oil studies of clouds. It seems more than likely that the solid structure of the composition owes a great deal also to the influence of Cézanne, who was working with Pissarro at the time.

EDOUARD MANET (1832-1883)
Victorine Meurend
Oil on canvas, 16⅞ x 17⅛ in. (42.9 x 43.7 cm.)
Signed at upper right: *Manet*
Gift of Richard C. Paine in memory of his father,
 Robert Treat Paine II. 46.846

Victorine-Louise Meurend, the young woman represented in this portrait, was Manet's favorite model during the decade of the 1860s. The artist met her in 1862 in the midst of a crowd at the Palais de Justice in Paris, and he was so struck by the originality of her appearance and sculptural features that he asked her to pose for him. The Boston portrait, painted in 1862 when his model was twenty years old, is the first painting he did of her. It was she who posed later that year for Manet's famous *Déjeuner sur l'Herbe* and for the *Olympia* of the following year (both pictures are in the Louvre, Paris).

By 1862 Manet had broken away from the principles of his training in Couture's Paris studio and had scored a modest independent success by having two of his paintings accepted for exhibition at the Salon of 1861. While these pictures reveal the artist's study of Spanish art, particularly Goya and Velázquez, they also show that Manet had developed a distinct style of his own, one that may have been influenced in part by the paintings of Courbet and by contemporary photography.

The portrait of Victorine Meurend has a quality of sharp brilliance and boldness as though it had been painted in a flash of bright light. It is conceived in broad areas of flat color with most halftones eliminated, giving the portrait an abrupt, almost harsh immediacy. The background, consisting of an undefined plane of even warm dark gray, throws the sitter's sharply defined form into relief. This effect of summary lighting can be directly related to that of early photographic portraits. Despite the direct confrontation with the sitter, there is a great psychological distance between the painter and his model. The candid, yet vacant look of Mlle Meurend and the almost mechanical objectivity in depicting her features are characteristic of contemporary photographic portraits and indicate their influence on Manet.

The square format of the canvas with the sitter cut off just below the shoulders adds to the immediacy and impact of the picture. Painted with a lighter palette than Manet's earlier portraits, it gives a premonition of the clear, bright colors he and the Impressionists were to use in the 1870s. The sitter's pale face, brushed in in broad areas of color with abrupt transitions of plane, has none of the softening gamut of intermediary tones used in the modeling of his former teacher Couture's *Portrait of a Woman in White* (cat. no. 19). With extraordinary deftness Manet contrasted the smooth, pale, creamy skin with the pink of the lips, the hazel color of her eyes, and the butterscotch blond of her hair, capped by a bright blue bow. While each outline is precise, the brushwork is extremely free and economical. The white dress with its linear black pattern of trim and the black ribbon at the neck are painted in sure, energetic, and supple strokes.

At the time the portrait of Victorine Meurend was painted Manet was justifiably satisfied with the progress of his work, having completed a number of major compositions. Anticipating acceptance, he decided to present three paintings to the Salon Jury for 1863. All three paintings were rejected, and the ensuing protests resulted in the now-famous *Salon des Refusés*. It was the very qualities of boldness of execution and conception embodied in the Boston portrait that led to Manet's rejection by the official art world and the critics. It is ironic that Manet, who from this time in the early 1860s until the end of his life continued to be maligned and attacked by the majority of the critics and the public, is recognized today as one of the greatest and most innovative artists of the nineteenth century.

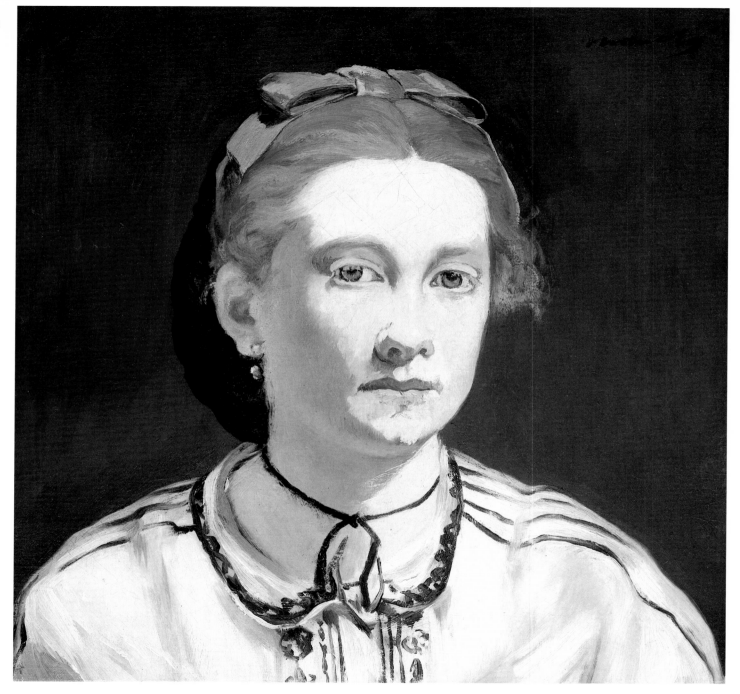

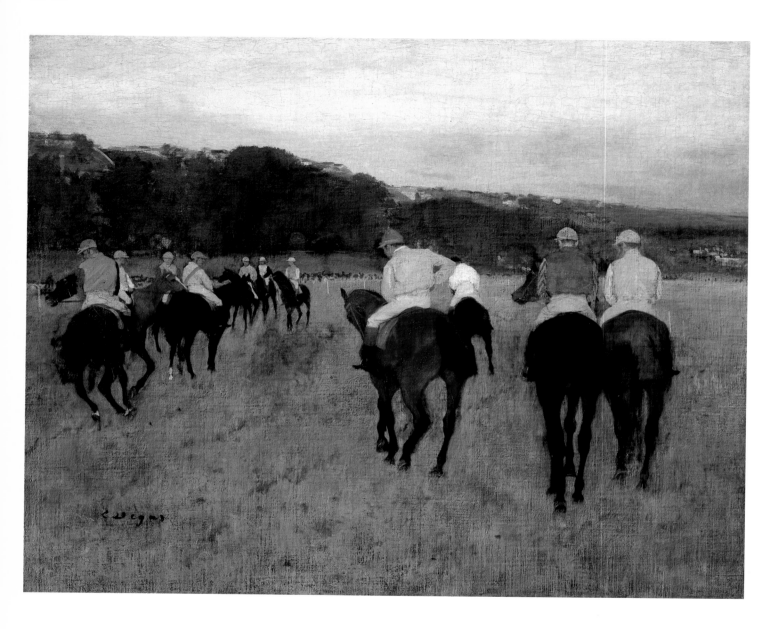

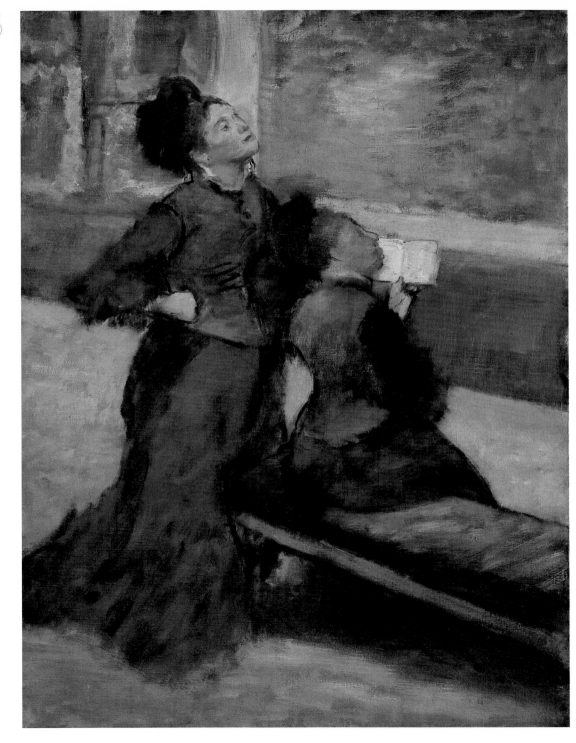

EDGAR DEGAS (1834-1917)
A Visit to the Museum
Oil on canvas, 36⅛ x 26¾ in. (91.8 x 68 cm.)
Signed at lower right: *Degas*
Anonymous gift. 69.49

During the years 1879 and 1880 Degas executed a series of studies of women in museum settings. The theme of people visiting a picture gallery had been painted much earlier by artists such as Panini and Watteau, and in the nineteenth century by Daumier, whose treatment of the subject may have served as a direct inspiration to Degas. In 1878 Daumier's *Picture Gallery* of 1858-1862 was shown at the Galerie Durand-Ruel in Paris. Degas undoubtedly saw the exhibition, and it may have prompted his own exploration of the subject. In both Degas's and Daumier's paintings the figures stand in front of a diagonal wall covered with unidentifiable paintings. In both, the visitors' attention is focused on a work of art outside of the scope of the canvas, and they are turned away from the viewer, absorbed in looking and unaware of being observed. Like Daumier, Degas sought the subjects for his painting from his own contemporary world. He wanted to represent things in a way that did not presuppose an audience, thus lending a fresh perspective to everyday life.

The figure of the standing woman in *A Visit to the Museum* has been said, traditionally, to be the American Impressionist painter Mary Cassatt, a close friend, whom Degas first met in 1877. She and her sister Lydia are thought to be the subjects of a pastel of 1879, which also shows two women, in this case visiting the Grande Galerie of the Louvre. Other writers have suggested that Ellen Andrée, a pantomime artist who posed for Degas in the late 1870s, may have sat for the Boston picture. In fact, the facial features of the two women in *A Visit to the Museum* were so summarily painted by Degas that a positive identification of them is impossible and probably irrelevant. What was important to the artist was the accurate portrayal of the positions of their bodies, their expressive gestures, the placement of their heads and hands. The standing figure dominates the seated one, her hand assertively placed on her waist as she gazes up at a work of art outside the picture space to the right. The seated figure seems more submissive and timid, relying on a guidebook to formulate her opinion about the painting in front of her.

Having studied ballet dancers in the 1870s, Degas became increasingly aware of the expressive power of the body and less attentive to the detailed, realistic portrayal of the physiognomy. During this period he also made numerous studies of women's fashions. In *A Visit to the Museum* Degas delighted in painting the shapes and lines of the women's full, long dresses, fitted bodices, and feathery hats. The palette is subdued, and the application of paint broad and loose, resembling Degas's pastel technique of this period in the softened, blurred outlines of the forms. His interests in this work were pictorial, not narrative. He was intrigued by the idea of paintings within a painting and by the challenge of implying a space and interest beyond the boundaries of the edges of the canvas. This format of pictures within a picture was to have an influence on other artists such as Van Gogh and Toulouse-Lautrec (see cat. no. 64).

The painting's composition consists of a dramatic complex of straight-line diagonals (the floor line, the bench, the frames), which are subtly integrated with the soft curving forms of the women. It is a brilliantly constructed work that borders on the witty in its clever contrasts of round, dark areas with lighter flat, angular ones. The use of the sharply receding diagonal of the floor line recalls the exaggerated angles and perspective one can achieve in photography, an important influence for Degas's art at this time.

The simplification and flattening of forms, along with the arbitrary truncation of the bench and the picture frames, reflect the influence of Japanese prints, which Degas collected and studied. However, the painting is solidly rooted in his own observation and experience, and is thoroughly Western in effect.

HENRI FANTIN-LATOUR (1836-1904)
Plate of Peaches
Oil on canvas, 7⅛ x 12½ in. (18.1 x 32 cm.)
Signed and dated at upper left: *Fantin / 1862.*
Maria Theresa Burnham Hopkins Fund. 60.792

One of the categories of painting that flourished in the second half of the nineteenth century in France was that of the still life. This was in part a result of the realist movement, in which humble, ordinary objects became acceptable subjects for the artist to paint. This development coincided with the relaxation of the academic hierarchy that had stipulated that historical and classical subjects were the highest form of art, and that the artist should look to ancient Greek and Roman and Italian High Renaissance art for inspiration. Millet and Courbet were among the first to introduce simple contemporary subjects taken from everyday life and paint them in a more realistic way. Subsequently, other artists followed their example and also used as precedents and models seventeenth-century Dutch and Flemish art and eighteenth-century French masters of still life, particularly Chardin and Desportes. Perhaps the most important element in the rapid growth of still-life painting was the expanding wealthy industrial bourgeoisie who sought these works to decorate their homes.

Fantin-Latour was a distinguished still-life painter as well as a fine portraitist and lithographer. Trained in drawing from an early age by his father, who was an artist from Grenoble, he studied at the Ecole de Dessin with Lecoq de Boisbaudran beginning in 1850. He entered the École des Beaux-Arts in 1854, but was asked to leave three months later, having failed the exams. He then devoted his time to copying the Old Masters in the Louvre and in so doing became acquainted with the more independent artists of the period, including Whistler, Manet, Degas, and Berthe Morisot. However, as these artists developed their *plein-air* styles and formed the Impressionist group that first exhibited in 1874, Fantin refused to join them, and his art remained far more academic and conservative than that of his friends.

Through Fantin's acquaintance with Whistler and his circle, he met Mr. and Mrs. Edwin Edwards in London in 1861. Edwards was a prominent English lawyer and an amateur artist and his wife was an extremely clever and business-minded woman. Enthusiastic about Fantin's still lifes and flower pieces, Mrs. Edwards became his sponsor and agent in England. She was extremely successful in selling his works, providing him with a modest but steady income and, as a result, his fruit and flower paintings were practically unknown in France during his lifetime.

Plate of Peaches, dated 1862, is a relatively early work. It was executed the year after Fantin's first successful admittance to the Salon in 1861. One of several still lifes of small format painted in the early 1860s, it has an undefined ground thinly brushed on in a warm, dark brown. There is no distinction made between the background and the surface on which the objects rest. Dimly lighted from the right, three peaches and a knife are placed on a simple white plate with a scalloped edge. The painting is a study in contrasts of texture and line, and in style and execution it owes a great debt to the still lifes of fruit by Chardin. The sharp diagonal of the black-handled, gray-bladed knife is a foil for the soft, rounded outlines of the peaches. With great sensitivity to the texture, color, and shape of each piece of fruit, Fantin brushed in their individual nuances of hue as if he were painting a portrait. He captured the transitions of coloration from the deep reds and soft pinks of the peach on the left to the yellow and acid greens of the peach in the background to the lighter reds, oranges, and yellows of the third peach. The feathery brushwork and delicate touch convey the soft, fuzzy texture of the skin of the fruit and are beautifully contrasted with the hard, shiny, white porcelain of the plate and dull metal of the knife. Fantin was to continue until the end of his life to work in rather subdued colors, using a relatively realistic painting style in his still-life canvases. This conservatism is most apparent when one compares his works of the 1870s with contemporary still lifes by Impressionists such as Sisley (see cat. no. 41).

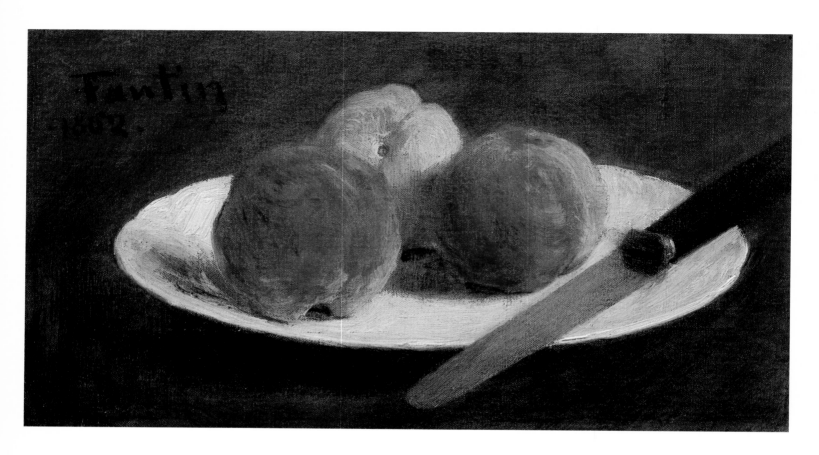

HENRI FANTIN-LATOUR (1836-1904)
La Toilette
Oil on canvas, 20⅜ x 24¾ in. (51.8 x 62.9 cm.)
Signed at lower left: *Fantin*
Juliana Cheney Edwards Collection. Bequest of
 Robert J. Edwards in memory of his mother. 25.110

Fantin-Latour is best known for portraits and still lifes characterized by a tightly drawn, realistic style, a subdued palette, and a tonal unity achieved through modeling figures in a soft interior light. However, from the early 1860s he also painted imaginary scenes in a freer, more delicate, and more painterly manner. These fantasy paintings, often inspired by contemporary music, by the Venetian sixteenth-century canvases he copied in the Louvre, or by classical mythology, reveal an aspect of Fantin's artistic personality that is far less conservative and conventional than that of his portraits.

One reason that the fantasy paintings are not generally well known was that, following 1863, Fantin was reluctant to exhibit them publicly. In that year he had submitted a large imaginary composition entitled *Féerie* (Montreal Museum) to the Salon, and it was rejected by the jury. While this rejection did not discourage him from painting in this genre, it led him to decide to submit only more academic and easily palatable works for public scrutiny. He continued executing these fantasy works until the end of his life.

La Toilette, dated 1902 by Madame Fantin-Latour (*L'Oeuvre complete*, p. 205), is typical of his imaginary compositions. For many years Fantin had copied Old Masters in the Louvre, and he had a special love for the works of the sixteenth-century Venetians, particularly Titian and Veronese. The filmy application of paint in *La Toilette*, achieved by dragging the brush across the canvas in delicate, layered strokes, reveals the artist's study of Venetian painting techniques, while the softly blurred edges and simplified forms are very close in effect to his charcoal drawings and lithographs. The subject, which appears to be a rather chaste, costumed version of the Toilet of Venus, owes its origin in part to the Venetians. For example, the pose of the hands and

arms of the woman in white echo those of Titian's famous *Toilet of Venus* (National Gallery of Art, Washington, D.C.). The delicacy of style and shimmering fabrics also recall some of Watteau's early eighteenth-century *fêtes galantes*.

In 1861 Fantin attended the Paris debut of Wagner's opera *Tannhäuser*, which inspired a passion for the composer's music that would grow with time. In fact, it was music that seems to have stimulated the romantic and imaginative side of Fantin's temperament, and many of his works reflect his personal impression of a particularly moving performance of an opera by Wagner or Berlioz. While *La Toilette* does not depict a scene from an opera, its theatrical setting with benches shaped like truncated columns used as props and its shallow stage-like foreground, which abruptly changes to a schematic landscape of trees, all resemble an opera set. The woman who poses as Venus and her three attendants are more actresses in appearance than mythological goddesses. Fantin's early training in the École de Dessin under Lecoq de Boisbaudran, in which he learned that artist's famous method of drawing from memory, served him well in the execution of these other-worldly paintings.

During the 1870s Fantin withdrew more and more from the circle of avant-garde Impressionist painters he had known and became increasingly involved with literary and musical figures. From the early 1880s until the end of his life the number of imaginary canvases increased in his oeuvre. These paintings, in their personal statement of feeling and subjective mood, as well as in their style, parallel contemporary works by Symbolist painters like Puvis de Chavannes (see cat. no. 26).

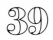

ALFRED SISLEY (1839-1899)
The Waterworks at Marly
Oil on canvas, 18¼ x 24 in. (46.5 x 61.8 cm.)
Signed at lower left: *Sisley*
Gift of Olive Simes. 45.662

Of English origin, Sisley had known as a student the landscapes of Constable and Turner, both of whom had a lasting influence on his art. Like these English artists and Boudin (see cat. no. 25) Sisley was a master of painting sky and water. His lyrical temperament was best suited to rendering the subtle coloring of a cloudy sky or a quiet river. With the exception of several trips to England and to Normandy, Sisley painted almost exclusively in the Île-de-France and the area around Fontainebleau, where the gentle landscapes with their constantly changing atmosphere were perfectly attuned to his talents. Unlike Monet, he never sought the drama of the rampaging ocean or the brilliantly colored scenery of the Côte d'Azur.

From 1875 to 1877 Sisley lived in the area near Marly-le-Roi on the left bank of the Seine just outside Paris. It was at Marly that Louis XIV had built, at the end of the seventeenth century, a château that was destroyed, except for some of the gardens, during the French Revolution of 1789. A short distance from the château was the village of Marly-la-Machine, the location of the famous hydraulic works, one of the great engineering feats of the late seventeenth century. Designed by Rennequin Snalem, it conducted water from the river through three series of force pumps to the aqueduct of Louveciennes; from there the water was carried to Versailles, where it served to animate the fabulous fountains of the park.

This painting represents the waterworks at Marly as they appeared in 1876. A brilliant engineer named Dufrayer had redesigned the hydraulic system in 1859, and it is his construction that Sisley depicted. This is one of several paintings the artist did of the river and the building housing the pumps during his stay in the area. Unfortunately, the machine has since been destroyed.

Like Sisley's beautiful series of canvases of the flood at Marly, also dating from 1876, the Boston picture is painted in delicately nuanced grays and pastels. Most of the canvas consists of water and sky, the former gently reflecting the color and mood of the latter. The brick building housing the hydraulic works is at the left, painted in soft pink and buff with a gray roof. Parallel to it, in a band across the middle ground of the picture, is a bank of trees in fall foliage. They are painted in muted shades of orange, yellow, and green, their colors reflected, along with those of the building, in the slightly broken surface of the water. The painting is given weight and contrast by the dark gray scaffolding partially submerged in the river on the right, and the long gray form of the pier and the small boat on the left.

In a letter written to his friend Adolphe Tavernier, Sisley explained his approach to painting: "The subject, the motif must always be rendered in a way that is simple, understandable, and striking for the viewer. He must be led, through the elimination of superfluous details, to follow the path that the painter indicates to him and to see above all what captured the attention of the artist.... After the subject, one of the most interesting qualities of landscape is movement, life. It is also one of the most difficult things to depict. To give life to a work of art is certainly a fundamental qualification for an artist worthy of the name. Everything must contribute to it: the form, the color, the brushwork. It is the emotion of the creator that gives life, and it is that emotion that awakens the emotion of the viewer" (translated from François Daulte, "Découverte de Sisley" in *Connaissance des Arts*, no. 60 [February, 1957], p. 47). In *The Waterworks at Marly*, so poetically painted, Sisley realized all of his requirements for a painting with life.

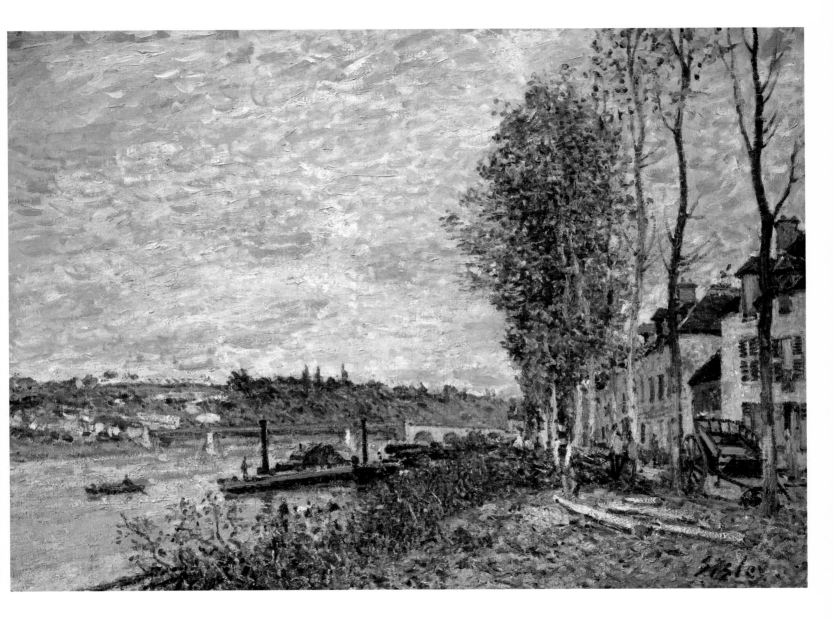

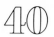

Alfred Sisley (1839-1899)
Saint-Mammès: A Gray Day
Oil on canvas, 21½ x 29⅛ in. (54.8 x 74 cm.)
Signed at lower right: *Sisley.*
Juliana Cheney Edwards Collection. Bequest of Hannah
 Marcy Edwards in memory of her mother. 39.679

In 1880 Sisley moved with his family to Veneux-Nadon, near Moret-sur-Loing in the environs of the Fontainebleau forest, where Corot and the other great Barbizon artists he admired had worked earlier in the century. Sisley lived there until September of 1883, painting the little villages bordering the Loing River and the river itself. This picture represents a view of the village of Saint-Mammès located near the confluence of the Loing and Seine rivers. The composition is of a type repeated many times by the artist, combining a receding road lined on one side by houses and on the other by trees with a view of the river and a vast expanse of sky. The simple one-point perspective of the painting, in which the river, the row of trees, and houses all converge below and to the right of the center of the composition, provides its unity and gives it depth.

Saint-Mammès: A Gray Day is executed in loose, broken, and vigorous brushstrokes of thick paint. The surface is rougher and drier than that of his earlier landscapes (see cat. no. 39), and it has a sharper chromatic range. The main focus of the painting is the sky, which is brushed in in mottled dashes of mauve, blue, gray, and white, all conveying a quickly shifting cloudy atmosphere. The grays of the sky are reflected in the surface of the river, and a contrast to their neutrality is provided by the dark forms of a small boat and two paddlewheel-driven barges that are summarily indicated in black and red. Sisley has used small, deft touches of greens, pinks, reds, and browns to indicate the bushes and grass on the river bank, and the last leaves of late fall on the trees. A cart and a few figures are sketchily painted on the right, adding a note of human interest and scale.

Sisley was to remain in the region of the Forest of Fontainebleau until the end of his life, finding endless inspiration in its gentle landscapes and villages. The entire body of his work was to have the same humility of attitude and empathy with nature that is found in the landscapes of Pissarro. Like his English predecessor Constable, he never tired of painting the infinite colors and cloud formations of skies, particularly overcast ones such as that in *Saint-Mammès: A Gray Day.*

Except for the support of a small group of loyal friends and collectors, Sisley never knew commercial or critical success during his lifetime. His father, a wealthy English businessman living in Paris, had financed his son's early artistic studies until the Franco-Prussian War of 1870, when he was ruined. Sisley was subsequently plunged into poverty; however, he never flagged in his devotion to painting. His landscapes, so sensitive to all the moods and changes of nature, emit a tranquility that reflects an inner peace and contentment unaffected by material adversity. On the eve of Sisley's death in January of 1899 Pissarro wrote a sensitive and perceptive tribute to the artist in a letter to his son Lucien: "Sisley, I hear, is seriously ill. He is a great and beautiful artist, in my opinion he is a master equal to the greatest. I have seen works of his of rare amplitude and beauty..." (letter of January 22, 1899, quoted and translated by John Rewald, ed., *Camille Pissarro: Letters to His Son Lucien* [New York, 1943], p. 334).

41

ALFRED SISLEY (1839-1899)
Grapes and Walnuts
Oil on canvas, 15 x 21¾ in. (38 x 55.4 cm.)
Signed at lower left: *Sisley.*
Bequest of John T. Spaulding. 48.601

Grapes and Walnuts is unusual in Sisley's work. Unlike Renoir, virtually all of Sisley's artistic production was devoted to landscape painting. In a catalogue raisonné of his works, only nine still lifes are listed among almost nine hundred paintings (see François Daulte, *Catalogue raisonné*).

Painted in 1876 with the same delicate sensitivity to color and light that Sisley brought to his landscapes (see cat. no. 40), *Grapes and Walnuts* is executed in an Impressionist style close to that of Monet, using a variety of brushstrokes and a palette of pure colors. Intrigued by the subject, the artist painted another version of a fall dessert on the same round wooden table in 1876, a *Still Life with Apples and Grapes* (now in the Sterling and Francine Clark Art Institute, Williamstown).

The composition of the Boston picture is deceptively simple. On a round table, partially covered with a creased white cloth, are placed a plate of white grapes and small red apples. To the left of the plate five walnuts are scattered on the cloth, and to the right are a knife and a nutcracker. The background is simply painted with the juncture of two walls at an angle behind the table. The wall on the left is thrown into shadow and painted in a scumbled purple-brown, while that on the right is a light beige. The source of light is outside the picture at the right, illuminating one wall and falling across the objects. The painting is given unity and structure through the repetition of rounded shapes: the form of the plate echoes that of the table and in turn the roundness of the fruit and the walnuts. This is contrasted with the grid of straight lines provided by the creases and edge of the white cloth. One crease intersects the angle of the wall, and the knife and nutcracker follow the line of another crease. Thus, what appears to be a random composition is one of careful balance between the abstract rhythms of rectangular and circular forms.

The still life is freely executed with great attention to the texture of the objects depicted. The grapes are painted with small curved multicolored strokes, conveying an extraordinary translucent succulence. In contrast, the walnuts, brushed in in short strokes of pink, ocher, dark red, and black, appear rough and hard. The tablecloth is broadly treated in thick white with gray-blue shadows, while the metal of the knife and the nutcracker are indicated in dark blue with white highlights.

1876 was a particularly productive year for Sisley as well as for most of the Impressionists. His series of canvases of the flood at Port-Marly date from this time and are among his finest works. Despite a lack of financial success, he continued to show with the Impressionist group, sending eight landscapes to their exhibition held in April of 1876. The artists, represented by works that are recognized today as some of their greatest paintings, were reviewed with hostility by the press. Albert Wolff, the most influential critic of the time, wrote in *Le Figaro*: "They barricade themselves within their lack of capacity, which equals their self satisfaction, and every year they return, before the Salon opens, with their ignominious oils and watercolors to make a protest against the magnificent French school which has been so rich in great artists.... I know some of these troublesome impressionists; they are charming, deeply convincing young people, who seriously imagine that they have found their path. This spectacle is distressing..." (quoted and translated by John Rewald, *The History of Impressionism*, 4th rev. ed. [New York, 1973], p. 370).

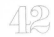

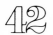

PAUL CÉZANNE (1839-1906)
Still Life: Fruit and a Jug
Oil on canvas, 12¾ x 16 in. (32.3 x 40.8 cm.)
Bequest of John T. Spaulding. 48.524

One type of painting to which Cézanne turned untiringly throughout his career was the still life. Having the advantage of depending neither on the weather nor on the artist's location, still lifes could be painted when portraits or landscapes were impossible. Within the seemingly narrow limitations of the still life he created a superb and infinitely varied series of canvases.

Cézanne's repeated painting of still lifes of pieces of fruit on a table finds its parallel in the series paintings by Monet of, for example, haystacks (cat. no. 47). However, whereas Monet was primarily interested in depicting different effects of sunlight on his objects, Cézanne was more concerned with the harmony of color and form within the composition.

The slow, deliberate pace of his work made it difficult for Cézanne to paint flowers since they almost invariably died before he could complete his canvas. As a result he preferred to paint fruit. He spoke of his reasons for this preference in several letters: "As to flowers, I have given them up. They wilt immediately. Fruits are more reliable. They like having their portraits done. They are there as though they were asking forgiveness for changing color. Their essence is exhaled along with their perfume. They come to you in all of their odors, speaking to you of the fields they have left, of the rain that has nourished them, the sunrises they have seen. In encircling with pulpy brushstrokes the skin of a beautiful peach, the melancholy of an old apple, I perceive in the reflections they exchange the same warm shadow of resignation..." (translated from a letter quoted by J. Gasquet, *Cézanne* [Paris, 1926], p. 202).

Cézanne's tender feeling for his subject is evident in this *Still Life: Fruit and a Jug* of about 1890-1894. In it each piece of fruit reflects the colors found in its immediate surroundings, and the form of the brushstrokes is carefully varied according to the object's shape and texture. The strong warm hues of the oranges, apples, and lemons are beautifully balanced with the cool blues of the geometrically patterned cloth, the gray-blue jug, and the white plate. The cloth in the background, a symphony of all of the colors in the composition mixed and lightened with white, is painted in subtly nuanced parallel strokes.

The early 1890s were years of frequent travel for Cézanne, with Aix-en-Provence as his center of activity. It was a period during which he withdrew from the official art world of Paris and from many of his friends. He became somewhat of a recluse, suffering from diabetes and a nature prone to depression and melancholy. However, his paintings of the 1890s are full of confidence and maturity and express a timeless and yet entirely personal vision of the world.

43 PAUL CÉZANNE (1839-1906)
The Pond
Oil on canvas, 18½ x 22⅛ in. (47 x 56.2 cm.)
Arthur G. Tompkins Fund. 48.244

The decade of the 1870s was an important period in the evolution of Cézanne's art. From early 1872 until the spring of 1874 he stayed at Auvers near Pontoise with his small son and Hortense Fiquet. It was a particularly happy and productive time in the artist's life. While there he studied with Pissarro, learning to paint directly from nature. Pissarro's Impressionist technique of using a light palette and juxtaposing brushstrokes of pure color was a revelation to him and transformed his style.

Although *The Pond* is not dated, judging from its style it can be placed in the years between 1873 and 1875. It illustrates the dramatic change in the artist's work as a result of his stay in the Île-de-France. Probably a scene from the region, *The Pond* is painted in small parallel brushstrokes of vivid color, predominantly blues and greens. Black has been eliminated from his palette, and the few shadows in the painting are indicated in dark blue.

While *The Pond* reveals the strong influence of Impressionism, it also illustrates some of the other stylistic elements that were emerging in Cézanne's painting at this time. The construction of the composition is as important as the depiction of light in a landscape. The painting is carefully, almost geometrically composed on a flat plane. There is a disturbing and unresolved tension between the painted surface pattern and the recession of the figures and the space in the landscape. The figures are strangely out of scale with their setting; however, they act to reinforce the geometry of the composition. The use of shadow and reflection is arbitrary, only in evidence when it serves to emphasize the surface pattern: two of the trees have shadows, but none of the figures does, and whereas the poplar is clearly reflected in the water, the figures are not.

The Pond shows Cézanne's early effort to deal with what he had learned through Pissarro, and it is in some ways awkward and unintegrated. It nevertheless has the solid, carefully constructed composition and the beautifully woven tapestry of color and form that were to become the hallmarks of his great, and entirely personal, mature style. Fascinated by the placement of human figures in a landscape setting, he was to rework and develop this theme many times in his paintings of bathers.

The Pond was one of four works purchased from Cézanne by the Impressionist painter Gustave Caillebotte. At his death in 1894 Caillebotte left his important collection of paintings and drawings to the State with the stipulation that it go to the Luxembourg Museum and eventually to the Louvre. This painting, entitled *Scène Champêtre* in a list of the collected works, was either refused by the State or withdrawn from the bequest by the Caillebotte heirs. It remained in the family of the artist until it was acquired by the Museum of Fine Arts in 1948.

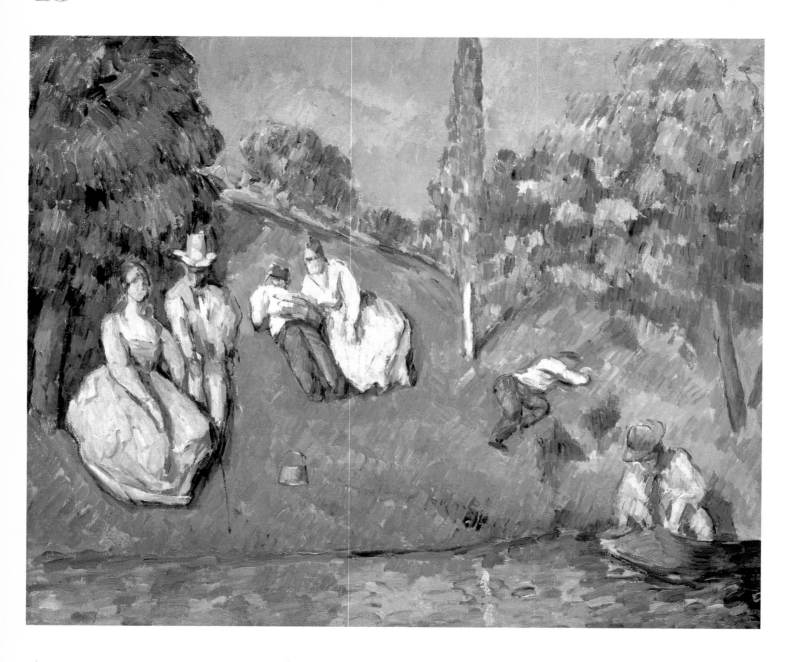

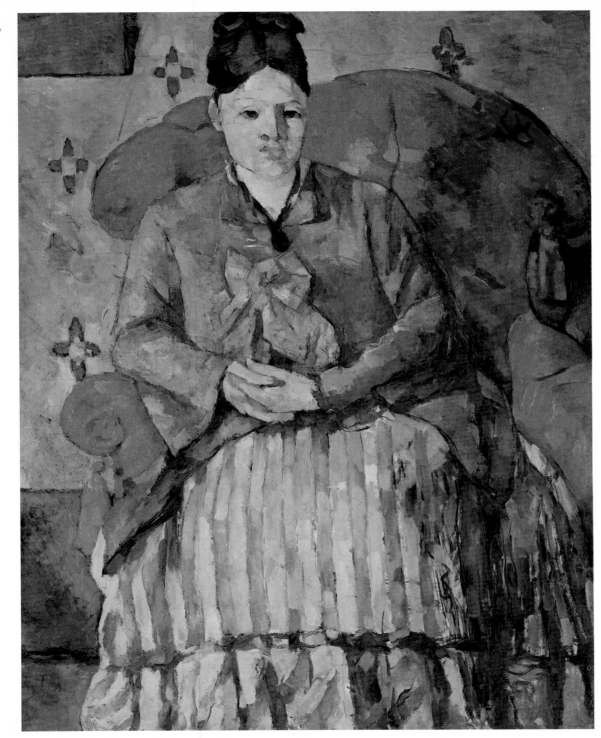

44
PAUL CÉZANNE (1839-1906)
Madame Cézanne in a Red Armchair
Oil on canvas, 28½ x 22 in. (72.5 x 56 cm.)
Bequest of Robert Treat Paine II. 44.776

The chronology of Cézanne's paintings is problematic owing to the fact that so few works are signed or dated. One of the paintings about which there is general agreement as to date is *Madame Cézanne in a Red Armchair*. The date of 1877 has been suggested both through circumstantial evidence and on the basis of style. In 1877 Cézanne occupied an apartment in Paris at 67, rue de l'Ouest. The green-gold and blue wallpaper in one of the rooms appears in the background of this portrait as well as in that of a number of other paintings of that year. The same red armchair and wallpaper appear in another portrait of Madame Cézanne dating from 1877 (Venturi, no. 291). The sitter's long striped skirt with its ruffled hem can also be associated with the Paris fashion of the period.

Cézanne probably first met Marie-Hortense Fiquet in Paris in 1869 when she was working there as a bookbinder. They were living together by the summer of the following year, and she gave birth to his son Paul in January of 1872. They were not married until 1886 so that when this portrait was painted she was not legally Madame Cézanne. In fact, the artist had gone to great lengths to prevent his father from learning of his liaison with her and of the birth of their child. She did not share much of Cézanne's life as an artist, nor were they similar in personality. Cézanne was shy and intellectual, while she was superficial and drawn to the gay life of Paris. He once said of her, "My wife likes only Switzerland and lemonade" (John Rewald, *Paul Cézanne* [New York, 1948], p. 113).

Despite their differences, Hortense Fiquet was a frequent model for the artist, posing for him no fewer than twenty-seven times. It was extremely difficult to pose for Cézanne, and his wife was patient enough to sit for hours in one position without moving or talking. Because he worked very slowly, he would often require as many as one hundred sittings for a portrait.

This work has a calm monumentality in its composition and great strength and balance in the pose of the sitter. It reveals Cézanne's absorption and mastery of Impressionism; however, the technique learned with Pissarro in the early 1870s has given way to a more solid and personal style. The sitter and her surroundings seem to be seen through a prism. The scene, clearly observed directly from life, is transformed into a mosaic of small block-like patches of color, interlocked into an extraordinarily harmonious whole. Unlike the transitory light sparkling in an Impressionist landscape, this picture has a timeless permanence and weight, a classical dignity. In this painting, Cézanne is master not only of his medium but also of his emotions.

In the spring of 1877 Cézanne participated in the third Impressionist group exhibition, and his works continued to be misunderstood and attacked by the general public. Georges Rivière, one of his few defenders, in a review in *L'Impressionniste*, made observations that are valid for this painting: "M. Cézanne is, in his works, a Greek of the great period; his canvases have the calm and heroic serenity of the paintings and terra cottas of antiquity, and the ignorant who laugh at the "Bathers," for example, impress me like barbarians criticizing the Parthenon" (quoted and translated in John Rewald, *Paul Cézanne* [New York, 1948], p. 105).

45

CLAUDE MONET (1840-1926)
The Old Fort at Antibes
Signed and dated at lower left: *Claude Monet 88*
Oil on canvas, 26 x 32½ in. (66 x 82.5 cm.)
Gift of Samuel Dacre Bush. 27.1324

During the 1880s Monet traveled extensively, always in search of new landscapes and challenges to his eye and brush. He painted on the Normandy coast, at Belle-Isle, in the Creuse Valley, even in Holland, seeking to develop new stylistic and technical means of conveying the different transient atmospheric effects that each place presented. Monet made a first trip to the Mediterranean with Renoir in 1884, and he returned there, staying at Antibes and Juan-les-Pins from January until April of 1888. The exposure to the southern light brought about an important change in the chromatic range of his palette. He began to use colors of an unprecedented intensity, often combined in complementary contrasts in order to evoke the brilliance of the sunlight.

Among the subjects that Monet painted repeatedly while he was there was the old city and fort at Antibes. He executed a number of canvases looking across the Baie des Anges from the area of Pointe Bacon to the old city's walled mass of sunbaked buildings perched on the rocky ledge above the sea, each done from a slightly different vantage point. *The Old Fort at Antibes* is among the simplest of these compositions, consisting of three horizontal bands: the sea, the fort with the range of treeless snowcapped mountains behind it, and the sky. As in the *Ravine of the Creuse*, painted in the following year (see cat. no. 52), there is no reference in the foreground to the space occupied by the artist. The viewer is placed before the scene at an undefined point on the water. All traditional compositional devices used to lead the eye into the picture's space from the two-dimensional surface of the canvas have consciously been abandoned.

The unity of the canvas is derived purely from the harmony of its soft pastel colors, not from the construction of its composition. The entire scene is bathed in a pale pink atmospheric light. This pervasive light effect is achieved through the application of a screen of flecks of pink paint. Like threads woven through a fabric, the pink binds the composition together. By juxtaposing soft pinks with a delicately varied range of other complementary colors, and by altering the shape and length of his brushstrokes according to the texture of the area depicted, Monet leads the eye to distinguish the elements of the scene portrayed. The water is painted with short, curved dashes of blue, green, and pink paint combined to give the effect of a shimmering sea. The fort, painted in pale yellows lightened with white and contrasting blue shadows, is differentiated from the mountains both in the wide vertical application of the paint and the warm tone of the whites. The mountains are painted a cooler blue-white with deeper blue shadows, all in short diagonal strokes. The glow of the afternoon sky is painted in much flatter and broader brushstrokes. This deceptively simple painting is an exercise in subtle color harmony within a purposely limited tonal and chromatic range. It is a direct precursor of the compositions of the early 1890s and their liberated personal use of color (see cat. no. 49).

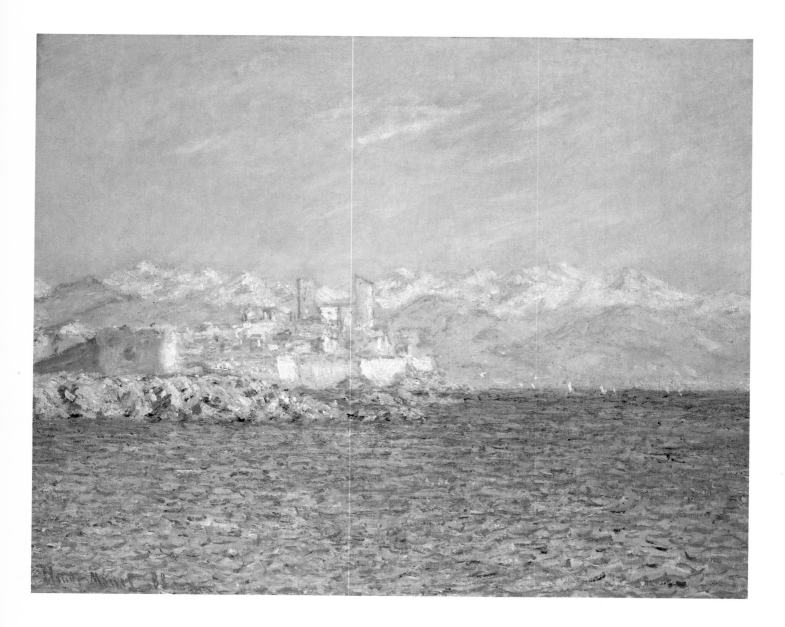

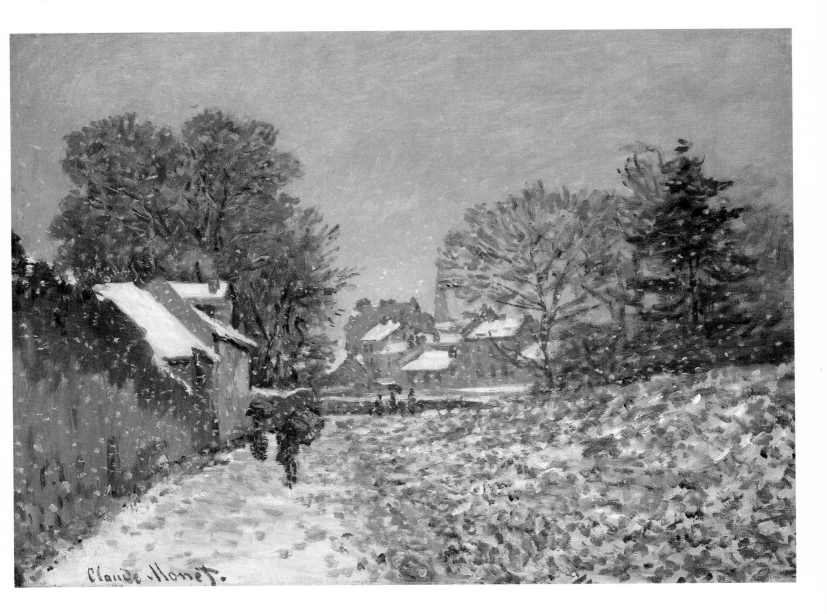

Claude Monet.

CLAUDE MONET (1840-1926)
Snow at Argenteuil
Oil on canvas, 21⅝ x 29 in. (55 x 73.8 cm.)
Signed at lower left: *Claude Monet*.
Bequest of Anna Perkins Rogers. 21.1329

The name of Argenteuil, the small village on the banks of the Seine River, northwest of Paris, inevitably evokes thoughts of the Impressionists. Situated in the heart of the part of the Île-de-France most frequently represented in Impressionist landscapes, Argenteuil was Monet's home from late 1871 until 1878. The summer of 1874, when Monet, Renoir, and Manet worked there side by side, painting the river, the garden, and occasionally each other, was perhaps the most unified moment of the Impressionist movement. In April of the same year the Impressionists had acquired their name and a group identity as a result of their first exhibition in the former studio of Nadar in Paris.

Monet executed an important series of snow scenes in Argenteuil during the winter of 1874-1875. The Boston painting, like the others in the series, represents a scene from the area where he lived, near the train station. The composition is of a type often used by Monet during this period. A small street in perspective penetrates the picture space from the left foreground and leads the viewer's eye to a group of trees in the middle distance and the houses and church of the village in the background. *Snow at Argenteuil* demonstrates Monet's interest in capturing the effects of weather in a specific season and at a specific time of day, masterfully evoking the atmosphere and light of a quiet winter afternoon snowfall. He painted exactly the same scene after the snowstorm (see Wildenstein, *Monet*, cat. no. 349).

The canvas was primed with a light brown-gray paint that shows through many areas of the sky as well as in the trees and the foreground, serving to unify the composition. The brushstrokes are brilliantly varied: rather spare, flat strokes to indicate a heavy, overcast sky; thick, broad ones for the stone wall and the houses in the distance; and fat, small daubs of green, brown, violet, and white for the muddy, partially snow-covered foreground. The painting of the falling snowflakes is a tour de force. Quick touches of white paint on the darker areas and almost invisible specks of gray in the lighter areas combine to give the impression of heavy, damp flakes falling.

It was pictures such as *Snow at Argenteuil* that made Monet a difficult artist for his audience. The representation of a humble, non-anecdotal subject, a cloudy day with unpleasant weather, and the very broken application of paint all contributed to alienating the buying public. As a result, in 1875 Monet was still relatively unknown and unappreciated by the public and in constant financial straits. In January of that year he wrote to his friend Manet, "Here I am again without a cent. If you could, without inconvenience, advance me at least fifty francs, it would be of great help" (Wildenstein, *Monet*, p. 429, no. 79). In March of the same year an auction sale of Impressionist paintings was held at the Hôtel Drouot, and the results were disastrous. Despite poverty and disappointment, Monet continued to pursue atmospheric effects in his paintings. His years at Argenteuil were highly important for the evolution of his personal style as well as for the development of the entire Impressionist movement.

CLAUDE MONET (1840-1926)
Meadow with Haystacks at Giverny
Oil on canvas, 29 x 36¾ in. (73 x 93.5 cm.)
Signed and dated at lower right: *Claude Monet 85*
Bequest of Arthur Tracy Cabot. 42.541

The four seasons have been depicted by Western artists for centuries, and one of the recurring representations of autumn is that of an open field with haystacks, usually accompanied by harvesters cutting or bringing in the crops. In the nineteenth century, this became a popular theme with French artists, particularly those who were interested in the working man and the simple life of the peasant. Léon Lhermitte, for example, did many paintings of fields with harvesters and haystacks (see cat. no. 60). With the rise of the industrial revolution and the growth of cities, a nostalgia developed for what was seen as the healthy, honest simplicity of the country life. Millet imbued his paintings of peasants with an almost religious feeling for nature (see cat. no. 18) and its seasonal tasks.

Unlike Lhermitte or Millet, Monet, who shared Millet's aversion to city living, turned more and more to pure nature and to the seasonal effects of light and weather, rather than to the peasants and their tasks for his subjects. However, in *Meadow with Haystacks at Giverny*, dated 1885, Monet's concern lay not in the sociological or symbolic implications of a bountiful harvest, but rather in capturing on canvas the light and shadow of one ephemeral moment in time and nature. The direct human presence is eliminated; only the haystacks remain as evidence of man's activity. Monet explored here the effect of late afternoon sun falling across the stubble of cut hay, and the shape and texture of the haystack and the way its irregular surface absorbs and reflects light. This effect was to fascinate him for several years, leading to his series of more than fifteen paintings of haystacks in 1890.

Monet applied paint to the canvas in thick, dry, grainy strokes, one built on top of the other. The shape of the strokes varies with the texture of the area painted: the field has short dashes of pink, green, blue, and yellow paint dragged over a rough impastoed surface. The trees are built up from short daubs of deep blue, purple, green, and pink. The sky consists of very thick layers of long streaks of tinted white paint that follow the direction of the sun's rays, and the haystacks are cones of glowing pink and violet. When taken individually the colors seem unrealistic, yet viewed as a whole the canvas becomes a moving and true picture of flickering autumnal light and shade.

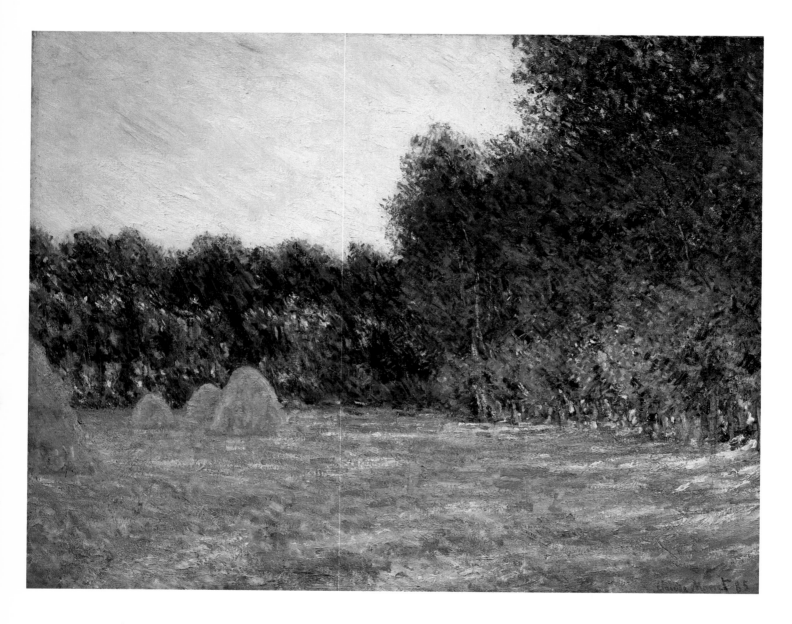

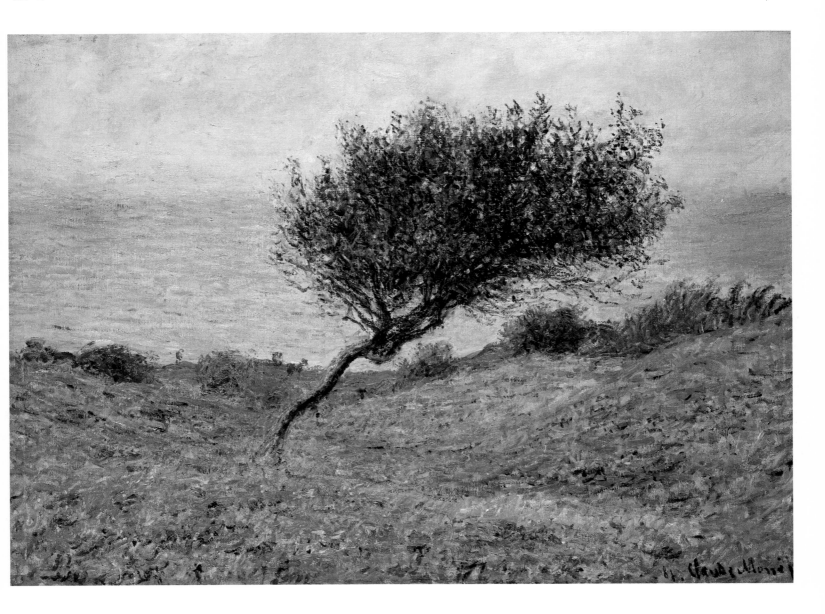

CLAUDE MONET (1840-1926)
Sea Coast at Trouville
Oil on canvas, 23⅞ x 32 in. (60.7 x 81.4 cm.)
Signed and dated at lower right: *81. Claude Monet*
John Pickering Lyman Collection. Gift of Theodora
 Lyman. 19.1314

From the age of five until he established himself in Paris in 1859 Monet lived at Le Havre on the rugged, wind-swept northern coast of Normandy. His earliest artistic training with the painter Boudin was concentrated on representing views of the sea and shoreline. His lifelong devotion to recording atmospheric effects of light and weather was doubtless first awakened by the sky and sea of this region of France. He returned there periodically throughout his life in order to renew contact with its familiar landscapes.

After spending the summer of 1881 at Vétheuil, Monet made a short trip to the Normandy coast in late August and early September during which the Boston picture was probably painted. It represents the coast near Trouville, a small town across the Seine from Le Havre. Monet had painted coastal views in the 1870s in which he showed a similar compositional arrangement of a horizontal band of land with the sea and sky beyond; however, the innovation in his style evident in this paint-ing is that he is less interested in defining the recession of spatial planes, choosing instead to emphasize the surface pattern of the composition and the misty atmo-sphere. The foreground is rather even in texture with a thick carpet of short dashing brushstrokes of green, dark blue, coral pinks, violet, and yellow. The stark silhouette of the gnarled apple tree with its diagonally thrust trunk in the center of the painting emphasizes the daring simplicity of the composition. The tree's dark form, painted in deep plums, blues, and greens with flecks of coral red indicating its early autumn burden of ripening apples, cuts across all of the planes flatten-ing the deep space of the canvas.

The cloudy sky blocks the sun and prevents the tree from casting any more than a hint of a shadow. Small tufts of fuzzy blue-violet bushes define the edge of this foreground plane. Perceptible beyond it is a pasture indicated in brushstrokes of thick, lush green, with minimal touches of red-brown to represent the ever-present cows of the Normandy countryside. Beyond the pasture the hazy blue-white reflections of the sea's sur-face are shown, their distance from the land undefined. The transition between sea and sky is lost in a blur of blue-violet paint. The whole painting brilliantly trans-mits to the viewer the damp, windy, stormy weather that comes so frequently to the northern coast of France. Line and detail have purposely been sacrificed to achieve this extraordinary, almost palpable effect.

From a letter written to Durand-Ruel on September 13, 1881, it is known that Monet had to cut short his trip to Normandy due to the inclement weather: "Here I am back at Vétheuil. The persistence of bad weather having prevented me from doing any sort of work ..." (translated from Lionello Venturi, ed., *Les Archives de L'Impressionnisme*, vol. 1 [Paris, 1939], pp. 223-224).

Sea Coast at Trouville demonstrates the changes that took place in Monet's paintings of the 1880s in which he gradually abandoned a realistic treatment of space and scene in order to create an atmospheric vision of color and light. This liberation from the exact representation of what was before him led to the great personal style of his late canvases.

CLAUDE MONET (1840-1926)
Rouen Cathedral: Sunset
Oil on canvas, 39⅜ x 26⅛ in. (100 x 66.4 cm.)
Signed and dated at lower left: *Claude Monet 94*
Juliana Cheney Edwards Collection. Bequest of Hannah
 Marcy Edwards in memory of her mother. 39.671

After many years of painting landscapes out-of-doors and treating an ever-widening variety of subjects taken from nature, Monet began, in the late 1880s, to paint in series, focusing on a single subject represented under varied effects of light and atmosphere. In February of 1892 he undertook the most famous of these, the paintings of the façade of Rouen cathedral. Monet rented a room on the second floor of a building at 81, rue Grand-Pont, opposite the Tour de Beurre on the west façade of the great cathedral. He stayed there for almost three months, returning in 1893 for several more weeks. He then took the canvases, which may have numbered as many as forty, back to his studio at nearby Giverny and reworked them. By May of 1895 he had readied twenty canvases for exhibition, and they were shown as a group at the Galerie Durand-Ruel in Paris, where they were enthusiastically received by the critics as well as the public and purchased for handsome prices.

There has been a great deal of speculation as to why Monet turned to a purely architectural subject after thirty years of devoting himself to the mastery of landscapes and seascapes. One explanation may lie in the unchanging stability offered by the building's façade. Monet had written to his friend Gustave Geffroy from the Creuse Valley in 1889, complaining: "Never three favorable days in a row, so that I have to make continual changes, because everything is growing and turning green" (quoted by Joel Isaacson, *Claude Monet* [Oxford, 1978], p. 220, no. 94). Since he projected a very long series of paintings and the only variable he wanted to represent was that of the light and atmosphere, the cathedral façade was an ideal subject. The fact that he chose Rouen may have had to do with its being a familiar monument in his native Normandy and, as a practical consideration, it was not far from his house at Giverny.

In Monet's paintings of the late 1880s and the early 1890s there was a growing tendency to seek subjects with rough surfaces that caught the light in complicated patterns of reflection and shadow. The Rouen façade, probably chosen as a subject primarily because of its rich texture, is treated in the same way as the rocky surfaces in the Creuse Valley paintings (see cat. no. 52). There is no underdrawing of the architectural elements or the sculpture on the façade. The moment represented in the Boston painting is sunset. The afternoon sun falling over the richly modeled surfaces is conveyed with a sparkling light pastel palette. An intense blue sky is visible between the towers, and the creamy white highlights are contrasted with gold, blue, and violet shadows. The paint is applied in an extremely thick and dry impasto, giving the surface of the canvas a texture resembling that of the rough stone it depicts.

One senses that Monet recorded his direct visual impression without incorporating preconceived ideas of what a cathedral should look like. Having selected a point of view above street level, Monet filled the canvas with the building, arbitrarily truncating both towers vertically as well as horizontally, and forcing the viewer to perceive the cathedral in a new way with no historical or religious overtones. There is no recession into the pictorial space, and there is no reference to the viewer's space in the foreground. The artist and the viewer seem suspended in midair, hovering before the façade, and the result is a remarkably fresh vision of a familiar building.

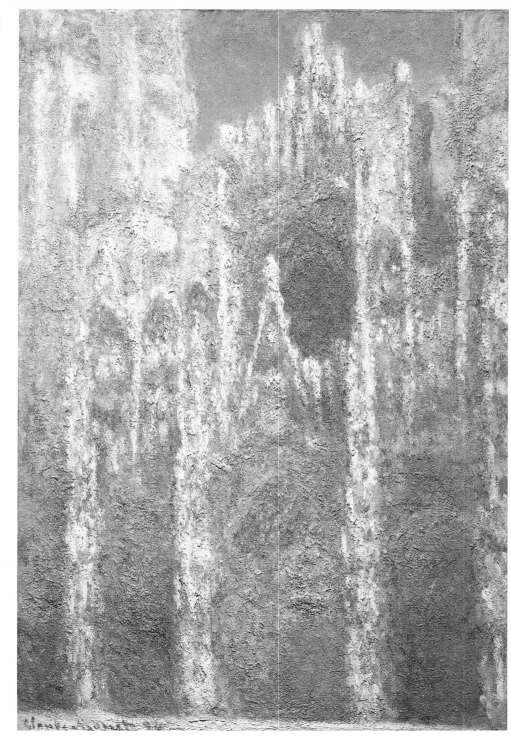

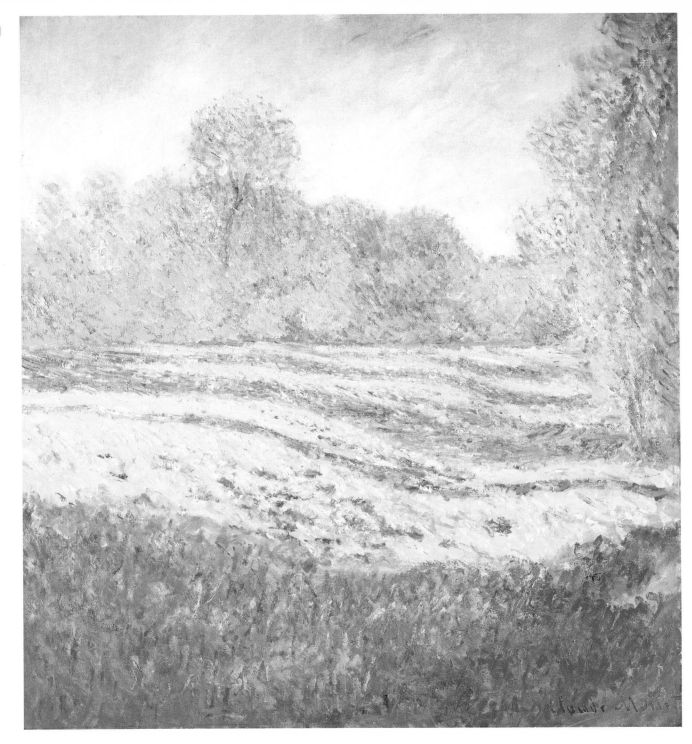

CLAUDE MONET (1840-1926)
Meadow at Giverny in Autumn
Oil on canvas, 36¼ x 32⅛ in. (92 x 81.5 cm.)
Signed at lower right: *Claude Monet*
Juliana Cheney Edwards Collection. Bequest of
 Hannah Marcy Edwards in memory of her mother.
 39.670

The decade of the 1880s was one of gradual yet dramatic change in Monet's painting style, one in which he moved away from pure Impressionism toward the creation of more and more simplified, transitory atmospheric color and light effects. Human figures, animals, and buildings were, for the most part, abandoned in favor of unfettered nature.

In 1883 Monet rented a house in Giverny, a village on the east bank of the Seine where it joins the Epte River, halfway between Paris and Rouen. The varied landscape of this region provided the artist with ever-renewed inspiration, and he stayed on there painting the river, fields, and gardens until the end of his life.

This undated picture of an open field bordered on two sides by trees seems to represent the same field near his home at Giverny as that depicted in *Meadow with Haystacks at Giverny* (cat. no. 47), only from a slightly different point of view. The painting of 1885, with its violet shadows and filtered sunlight, is less abstract and less daring in palette than the present picture. This painting seems to date from about 1888, just before Monet began working on his series paintings of haystacks. The same highly keyed colors and sinuous shadows were effectively used in the poplar series painted in 1891.

The evolution of Monet's style is amply demonstrated by this landscape. More than half of the painting consists of a slightly undulating open field across which fall the long, graceful shadows that indicate the barely visible poplar trees at the right. The brilliantly colored foliage and the sunlight streaming between the poplars create the atmosphere of a late autumn afternoon. There are four horizontal bands of color, each of an iridescent brightness, and each containing and reflecting glints of color from the others. This results in an effect of shimmering sunlight, but it also unites the surface of the canvas in a flat, abstract pattern. All dark colors and sharp lines have been eliminated, leaving only bright greens, yellows, violets, oranges, and, in the sky, whitened blue.

The high chromatic key of this landscape does not appear in Monet's painting before his discovery of the intense light and strong color of the south of France. In 1883 he traveled to the Riviera with Renoir, visiting Cézanne at l'Estaque, and he returned to the south in 1884, painting at Bordighera and Menton. This exposure to the brilliant colors of the Mediterranean certainly was instrumental in changing the palette used in his later paintings.

Meadow at Giverny in Autumn goes beyond painting directly from nature, and becomes a personal exercise in bold, somewhat arbitrary color harmony. The real subject is light and shadow. The shadows falling across the meadow are far more important than the trees that cast them, just as in the later water lily paintings the reflections of the sky in the water become more important than the sky itself. The handling of the paint in small, thick strokes recalls the prismatic palette employed by Cézanne at this time as well as Gauguin's daring innovations in the use of color.

CLAUDE MONET (1840-1926)
Water Garden and Japanese Footbridge
Oil on canvas, 35 x 35⅝ in. (89 x 91.2 cm.)
Signed and dated at lower left: *Claude Monet 1900*
Given in memory of Governor Alvan T. Fuller by the
 Fuller Foundation. 61.959

Monet was sixty years old in 1900, and from that time on he turned increasingly to his home in Giverny and its surrounding gardens as a source for motifs for his paintings. He had purchased the house in 1890 after successes of the late 1880s finally provided a measure of financial security. In 1893, Monet also bought a tract of land adjacent to the main property. From the small river, the Ru, running through it, he was able to create a pond in which he cultivated water lilies and other exotic aquatic plants. Sometime before 1895 he had a Japanese-style footbridge constructed over the pond, following the axis of the alley leading to the entrance of the main house. It has been suggested that this arched footbridge may have been inspired by one of the Japanese prints in his large and important personal collection.

Monet executed a group of three paintings of the footbridge in the winter and early spring of 1895. A second and larger series, all with the footbridge as the central motif, was done in 1899 and 1900, and the Boston painting is one of this second group. It reveals the luxuriant growth of the water lilies and trees during the intervening years since the garden's creation. In fact, the canvas is literally filled with various types of plant growth and their reflection in the water's surface. Only a small corner of pink-mauve sky is visible at the upper left.

The artist seems to have been seated on the bank of the pond looking upstream and, as in other canvases of the series dated 1900, the footbridge is depicted off-center with the right side of its span truncated by the edge of the picture. This arbitrary cutting off of the central motif, a device that he often used, may owe something to his study of Japanese prints.

The palette of *Water Garden and Japanese Footbridge* is one of intense and saturated, almost strident colors. Monet created the impression of spatial recession through the large clump of dark green and magenta growth in the left foreground, as well as through the receding patterns of the floating water lily pads interspersed among the water's mirror-like surface reflections. A great willow and other trees form a background wall of light yellows and pale and dark greens with deep red shadows; along with the violets and blues of the footbridge, these elements create powerful horizontals, and limit and define the picture's spatial depth.

Thirteen of the Japanese footbridge paintings were exhibited in Paris at the Durand-Ruel galleries in November and December of 1900, and the exhibition was a great commercial and critical success. These works represent a continuation of Monet's interest in painting a series of canvases with one motif represented in a variety of atmospheric and light conditions. In them one finds the precursors of the great water lily paintings of his last years. *Water Garden and Japanese Footbridge*, however, goes far beyond the early Impressionist concept of the direct observation of nature. Both the setting and the painting have become an internal vision of Monet's private world. The artist not only developed an entirely personal style and palette but he also artificially grew and controlled his own version of nature. With complete technical mastery he expressed in the Boston painting his inner emotional state through the external appearance of his garden.

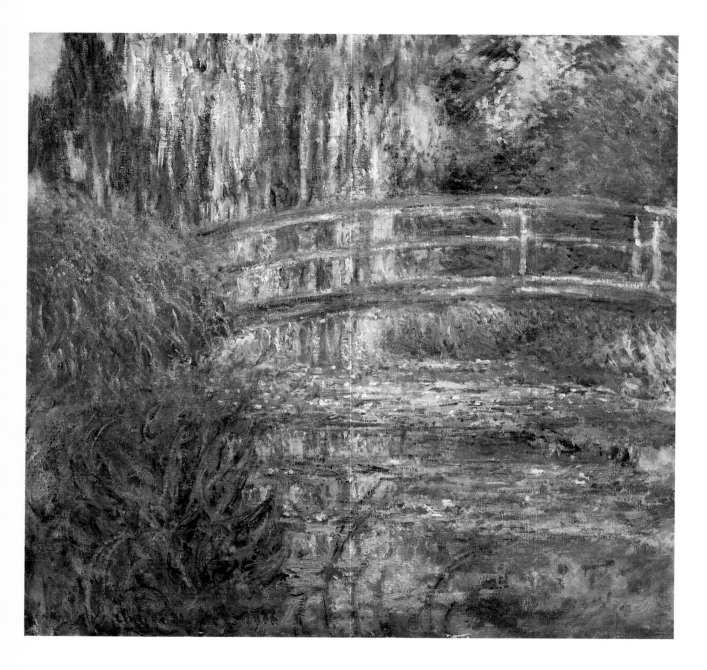

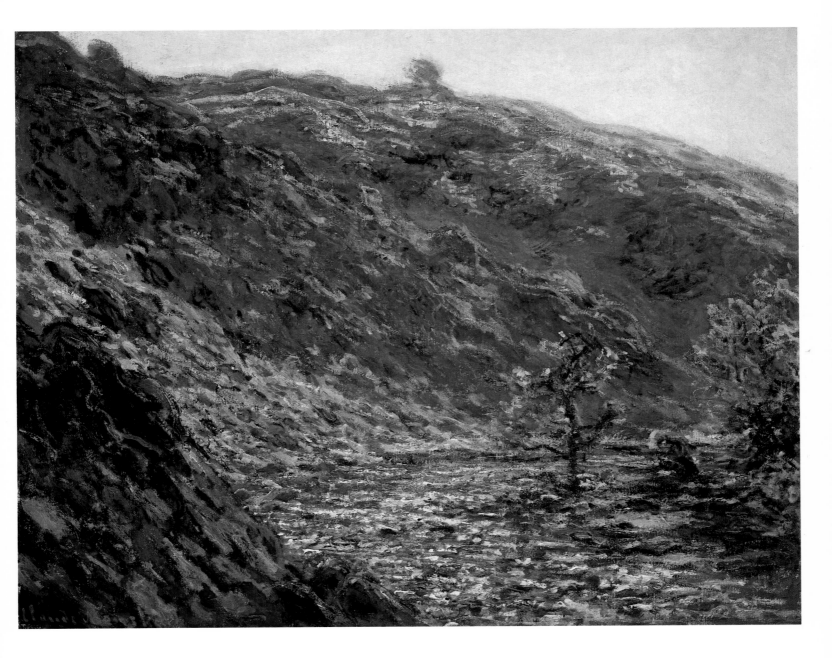

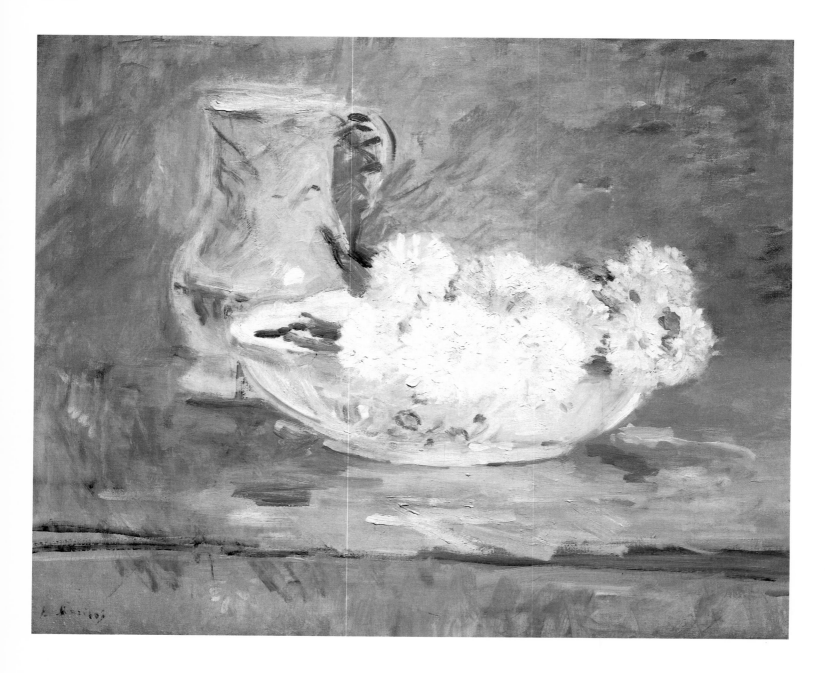

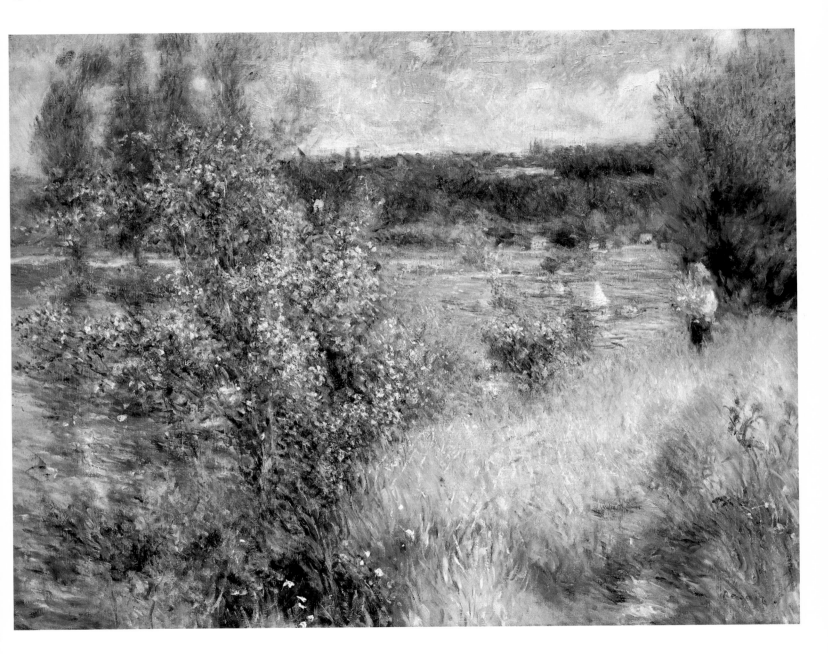

54 PIERRE-AUGUSTE RENOIR (1841-1919)

The Seine at Chatou
Oil on canvas, 28⅞ x 36⅜ in. (73.3 x 92.5 cm.)
Signed at lower right: *Renoir*.
Gift of Arthur B. Emmons. 19.771

Chatou, a small town located on the banks of the Seine northwest of Paris, was easily reached by train from the city beginning in about 1859. The availability of public transportation made it a popular center of recreation for Parisians on weekends and it was frequently the site of boating parties, picnicking, sailing, and bathing during the summer months. The happy, carefree atmosphere and the attractive landscape with its winding river provided many motifs for the Impressionist artists. During the summer of 1869, for example, Renoir and Monet painted in and around Chatou, producing their great canvases of La Grenouillière, a restaurant and boat rental center on the river.

The Impressionists developed a whole genre of outdoor leisure painting in which they depicted middle class people enjoying a variety of activities, including eating, dancing, rowing, or riding, all in natural poses and light-filled landscapes. Similar to eighteenth-century *fêtes galantes* in their focus on pleasurable outdoor activities, the Impressionists' works were less contrived and artificial and dealt with the new urban middle class rather than the aristocracy.

In the summer of 1879 Renoir returned to Chatou, where he did several of these leisure paintings. Although it is undated, Boston's *Seine at Chatou* was probably painted at this time. Sparkling with color and light, the picture evokes the joyous atmosphere of a summer afternoon. The little girl on the right walks forward, her arms filled with freshly picked wildflowers, and on the water to the left of her are the gay red and white shapes of the pleasure boats. The painting is imbued with an almost pantheistic love of nature and a profound appreciation of its visual richness.

Painted on a rough canvas, with the unpainted surface showing through in many areas, the picture shows a variety of brushstrokes to convey light as it strikes differ-ent textures. The flowering bush in the left foreground is painted with thick dots of white and pink with dark greens and blues in the shadows, making it seem to shimmer in the light breeze. The tall grass on the bank is built up in long, wispy strokes of yellow and green, one on top of the other. The water, painted in horizontal dashes of light blues and white, is effectively contrasted with the dark blues and greens of the hills beyond.

At the time Renoir painted this landscape he was beginning to break away from the other Impressionists. Anxious to receive recognition in the official art world, he had refused to exhibit with the Impressionist group in the spring of 1879, preferring to send his paintings to the Salon. He submitted the large portrait *Mme Charpentier and Her Children* (Metropolitan Museum of Art, New York), which was accepted and well received by the critics, establishing his reputation as a portraitist and a figure painter. While he was to continue to paint landscapes until the end of his life, the majority of his works would be figure paintings, particularly of women. *The Seine at Chatou* seems to have been executed for the artist's personal pleasure and is eloquent testimony to his continuing skill in painting directly from nature.

PIERRE-AUGUSTE RENOIR (1841-1919)
Gabrielle and Coco Playing Dominoes
Oil on canvas, 20½ x 18⅛ in. (52 x 46.2 cm.)
Signed at upper left: *Renoir.*
Given in memory of Governor Alvan T. Fuller by the
Fuller Foundation. 61.960

During Renoir's long and prolific career he painted
more than two thousand portraits. After his marriage to
Aline Charigot in 1885 most of those portraits were of
his wife, his three sons, Pierre, Jean, and Claude, members of his household, or close friends. The portraits provide a warm and intimate record of the domestic atmosphere in which he lived.

Among Renoir's favorite models within the household
was Gabrielle Renard, a young peasant girl from Essoyes who came to work for the family at the age of fourteen in 1893. First serving as a nursemaid for Jean, she
became an integral part of the family. When Claude,
who was affectionately nicknamed Coco, was born in
August of 1901 Gabrielle became his companion. Of his
three sons, Renoir painted Coco most often, capturing
on canvas the sweetness and charm of each stage of his
son's early childhood. The Boston painting, probably
dating from 1905, depicts Gabrielle teaching Coco to
play dominoes. Comparison with contemporary photographs reveals how accurately Renoir portrayed the
features of his son. It is one of several canvases in which
Renoir painted Coco learning skills or diversions with
Gabrielle as his instructor.

In this painting both of Renoir's models are concentrating so intently on their game that they seem unaware of the artist's presence. Without artifice Renoir
captured the loving patience of the young woman, then
twenty-six years old, as she oversees the child's mastery
of the game, contrasting it with his total absorption
in the activity.

The composition is extremely simple and moving without being sentimental. Gabrielle's ample, well-rounded
form envelops that of the child, making his smallness
and vulnerability more evident. The placement of the
table in the foreground cuts the two figures off at waist
height, focusing the viewer's attention on their hands
and faces. The background has been left an undefined
area of flat color, which throws the figures into relief.

As is typical of Renoir's late works, warm reds and
yellows dominate the painting. He gave relief to the
mellow, warm colors of the figures in painting the
background a contrasting yellow green. The application
of paint is summary and flat, and each area of color is
generalized with a minimum of attention to texture. The
woman's hair, for example, is painted as a smooth mass
with no differentiation of individual strands. Light and
shadow are used with restraint to indicate broad areas of
volume and mass, as in the child's smock. The paint is
thin and applied in smooth even strokes with very little
impasto.

Renoir was sixty-five when he painted this picture and
was suffering increasingly from rheumatoid arthritis,
which doubtless affected his painting style. A new economy of expression replaces the freedom and brio of his
earlier brushwork. However, *Gabrielle and Coco Playing Dominoes* displays an extraordinary sureness of
drawing, and it embodies his continuing pleasure in conveying the tender quality of trust and intimacy between
women and children.

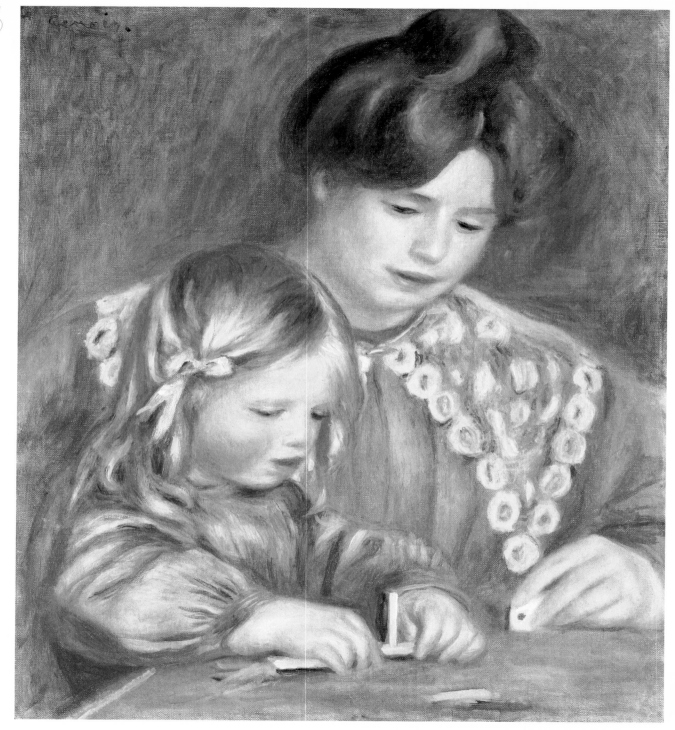

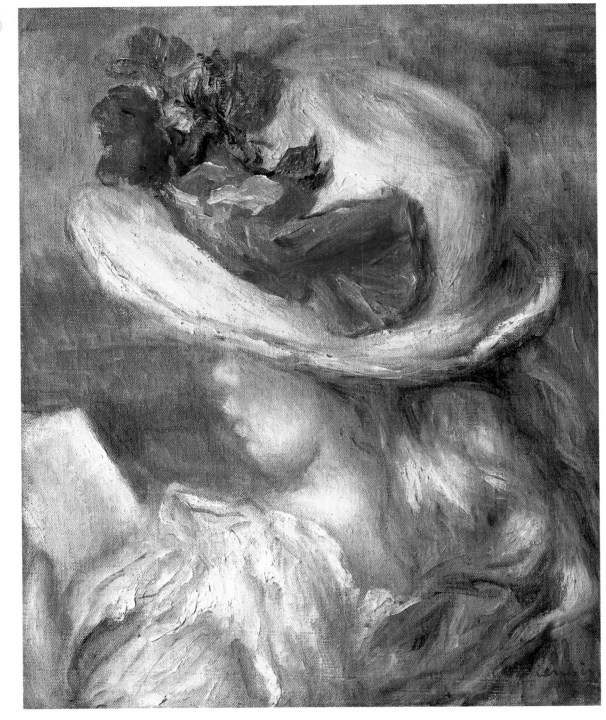

PIERRE-AUGUSTE RENOIR (1841-1919)
Girl Reading
Oil on canvas, 16⅛ x 13 in. (41 x 33 cm.)
Signed at lower right: *Renoir.*
Juliana Cheney Edwards Collection. Bequest of Robert
 J. Edwards in memory of his mother. 25.116

Although *Girl Reading* is not dated, its style and subject
can be associated with a group of works executed in the
early 1890s, a period in which Renoir painted many
studies of young girls involved in quiet, simple daily ac-
tivities such as playing the piano, reading, or sewing.
The Boston picture is related to several drawings and
paintings of girls wearing flowered hats and reading. It
represents the same blonde child wearing the same hat
as does the painting *Young Children Reading* of 1890
(collection of Paul Kantor, Beverly Hills, California).
 During the summers of 1890 and 1891 Renoir often
visited his close friend Berthe Morisot and her husband
Eugène Manet at a house they had rented at Mézy, a
town overlooking the Seine near Paris. Renoir some-
times painted there, occasionally using Berthe Morisot's
daughter, Julie Manet, and her nieces Jeannie and
Paule Gobillard as models; the Boston painting may
represent Jeannie Gobillard, who had long blonde hair,
and who, like Julie, would have been about twelve years
old in 1890. The intimate quality of the picture is similar
to that found in contemporary canvases by Berthe Mori-
sot, and Renoir's painting doubtless reflects her influ-
ence.
 The Boston picture is not intended to be a conven-
tional portrait since the young girl is depicted with her
back to the viewer and her head in profile. Her wide-
brimmed yellow hat with its red ribbon and flowers cov-
ers her eyes, allowing only the lower half of her face to
show. By having his model concentrate on a specific
task, Renoir rendered the pose completely natural and
unaffected, and the presence of the artist unobtrusive.
He captured on canvas her absorption in reading a book
and was able to give the painting a spontaneous charm.
One has only to compare *Girl Reading* with Toul-
mouche's *Reading Lesson* (cat. no. 29) to realize how
effectively Renoir eliminated all self-consciousness.
 After painting for almost a decade in what he called
his *manière aigre*, a dry, linear style in which he con-
sciously tried to discipline all outlines and to tighten his
former Impressionist brushwork, Renoir returned to his
earlier painterly style, using an even richer palette dom-
inated by warm colors. *Girl Reading* is an example of
this new style, which began in the early 1890s. The pic-
ture seems to have been drawn on the canvas with a
loaded brush, every stroke effortless and sure. The mod-
eling and the use of color, applied in free, creamy
strokes, recalls that of Fragonard and Boucher, the two
eighteenth-century artists Renoir admired most. The
forms are painted with great economy, eliminating un-
necessary detail, and with a consummate sense of color
harmony.
 Charmed by the frivolous femininity of a flowered and
beribboned hat, Renoir modeled it in warm reds and yel-
lows that contrast effectively with the delicate pale col-
oring of the sitter's white skin, pink cheeks and lips, and
the long, wavy blonde hair that tumbles down her back.
Her dress, made of a white material with red stripes and
ruffled at the shoulder, is painted with real brio. The
background, thinly brushed in and undefined in shades
of blue and blue-green, is the perfect complement to the
warm colors of the hat and skin.
 Girl Reading shows that Renoir, even as he reached
the age of fifty and was beginning to suffer from arthri-
tis, continued to find joy in painting the simplest things
around him, particularly the activities and appearance
of women and children. The sheer delight that he took
in painting this little girl's hat is testimony to his contin-
uing freshness of vision.
 In 1892 Durand-Ruel organized a retrospective of
Renoir's work, and it was a great success, establishing
his importance as a major figure in modern art. *Girl
Reading*, painted on the eve of Renoir's public recogni-
tion, already has the fusion of warm color and spontan-
eity of execution with a mature knowledge of form that
would be the stylistic hallmarks of his last years.

57 PIERRE-AUGUSTE RENOIR (1841-1919)
Lady with a Parasol
Oil on canvas, 18½ x 22¼ in. (47 x 56.2 cm.)
Signed at lower left: *Renoir*.
Bequest of John T. Spaulding. 48.593

After the first Impressionist group exhibition in the spring of 1874, Monet, Manet, and Renoir met during the summer at Argenteuil, a small town on the Seine near Paris, where Monet was then living with his wife and son. The three artists painted out-of-doors together, occasionally using friends and family as models. Often working from the same motif, they explored the use of a light palette in trying to convey the momentary effect of sunlight on their subjects. They attained a harmony of purpose and of style never to be equaled in the Impressionist movement.

Lady with a Parasol, which embodies the quintessence of pure Impressionism, is traditionally assigned a date of 1877. However, it is more likely that it was executed at Argenteuil during the summer of 1874. The type of composition, consisting of a woman and a child in a sunlit outdoor setting in which no sky appears, was one with which all three artists were experimenting during their summer together. Frequently Camille Monet served as their model, and the lovely young dark-haired, dark-eyed woman in the Boston painting closely resembles other known portraits of her dating from the same year (see John Rewald, *The History of Impressionism*, 4th rev. ed. [New York, 1973], pp. 343-345). The small child in the background of *Lady with a Parasol*, whose hesitant steps in the tall grass are so economically and yet convincingly captured by the artist, cannot be Jean, Monet's son, for he was six years old in 1874.

With long, feathery brushstrokes, Renoir conveyed the effect of brilliant sunlight as it filters through a tree and falls across the high, soft grass, the small toddling form of the blond child, and the delicate white dress of the woman. The dappled spots of shadow on the grass are painted in deep blue-greens, while the sunny areas are bright yellow and white. The soft, translucent quality of the white dress with its flickering reflections of

pink, blue, and black in the deepest shadows, is a tour de force of painting. The woman's face, framed by a chignon of dark hair, is defined in soft greens and pinks reflected from the grass and the pink lining of her parasol. The painting sparkles with light and touchingly juxtaposes feminine warmth and grace with the tentative vulnerability of a small child just learning to walk.

Renoir's use of black in the hair, shoes, and shadows of *Lady with a Parasol* may reflect, in part, the influence of Manet, who had masterfully used blacks in figure painting, and whose works Renoir admired. In contrast, by the mid-1870s Monet had entirely eliminated the use of black from his palette.

The composition of the painting, with the child wandering off into an undefined dark area in the right background, his back turned to the viewer, makes it seem spontaneous and unposed. The picture is filled with a joyous kind of warmth, a quality that pervades many of Renoir's paintings of the 1870s. Renoir was to continue painting women and children until the end of his life, never losing his freshness of vision or his sensitivity to their innate charm. Monet, on the other hand, was to abandon figure painting in the mid-1870s, devoting himself almost exclusively to landscape painting.

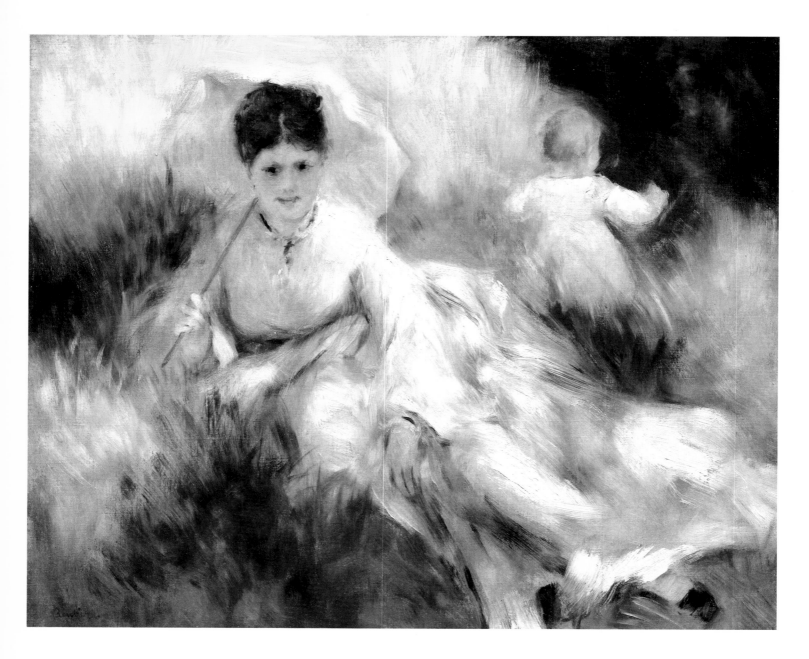

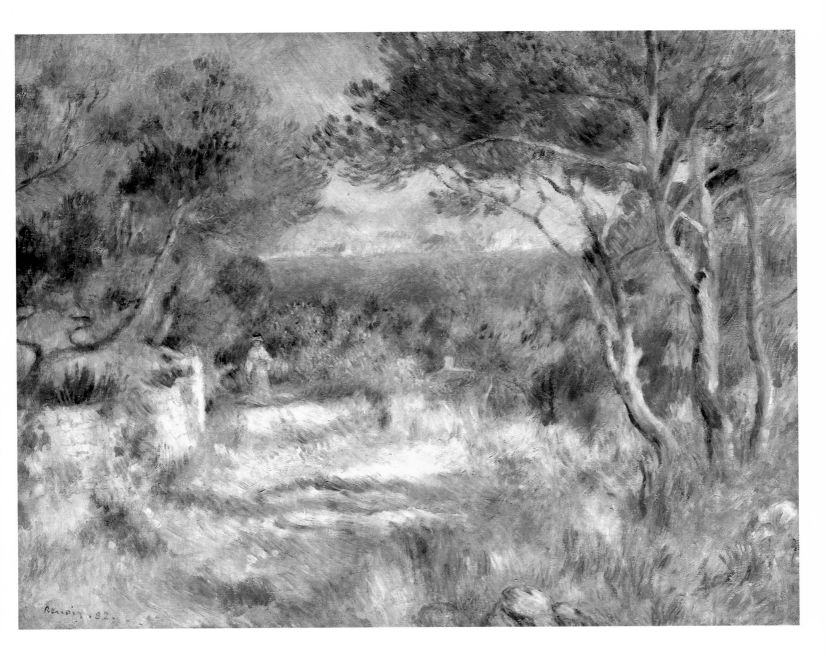

58 PIERRE-AUGUSTE RENOIR (1841-1919)
L'Estaque
Oil on canvas, 25⅞ x 31⅞ in. (65.8 x 81 cm.)
Signed and dated at lower left: *Renoir. 82*
Juliana Cheney Edwards Collection. Bequest of Hannah
 Marcy Edwards in memory of her mother. 39.674

In the fall of 1881 Renoir, who was dissatisfied with the limitations of pure Impressionism, made a long trip through Italy. Exposure to the art of Raphael in Rome and the fresco paintings in Pompeii, as well as the landscapes and colors of Venice, Naples, and Capri, all served to transform his style and to give his art a powerful new classical strength, firmly rooted in the past.

On his return trip to France in January of 1882 Renoir met Cézanne in Marseilles and decided to stay with him for a while at L'Estaque, a small village on the Mediterranean coast. Cézanne and Renoir had known each other since 1863, when they met as students at Gleyre's studio in Paris, and they had remained friends during the intervening years. Cézanne, who in his own way sought to reconcile the classical tradition with painting directly from nature, must have been enthusiastic about Renoir's findings in Italy. The two artists painted views of the countryside around L'Estaque together, and Boston's *L'Estaque* is among the works that Renoir did during his visit there.

Renoir, anxious to apply what he had learned in Italy, wrote to one of his patrons, Mme Charpentier, from L'Estaque: "... while warming myself, and observing a great deal, I shall, I believe, have acquired the simplicity and grandeur of the ancient painters. Raphael, who did not work out-of-doors, nevertheless studied sunlight, for his frescoes are full of it. Thus as a result of seeing the out-of-doors, I have ended up by not bothering any more with the small details that extinguish rather than kindle the sun" (translated and quoted by John Rewald, *The History of Impressionism*, 4th rev. ed. [New York, 1973], p. 464).

The Boston painting is a synthesis of several influences. Its soft, blond colors painted with feathery brushstrokes reveal Renoir's sensitivity to the bleaching in-

tensity of the Mediterranean sunlight. His brushwork reflects the influence of Cézanne for, like him, Renoir juxtaposed small strokes of subtly varied pure color, making the canvas seem to vibrate with light. Renoir's use of this technique is softer, however, and his painting less geometric and structured than Cézanne's. With his extraordinary and very personal color sense Renoir employed a rainbow of pastel shades to define the elements of the composition.

The influence of Renoir's Italian studies can be felt in the smooth surface of the canvas, prepared with a white ground, and in the thinner consistency of the paint, which is applied in flat strokes that are almost without impasto. There is a new attention to drawing with each brushstroke carefully applied. But even though the application of paint is tighter, it is no less spontaneous in feeling. There is an economy of expression in which Renoir skillfully abbreviated the visual elements of the painting, giving them life with a few deft strokes.

The composition is rather conventional with a path, framed by arching trees on either side, leading from the foreground into the middle distance. The woman in a long white dress provides a touch of human life and scale. The whole scene is set off against the distant blue water of the sea and the shoreline and mountains beyond. It is the style and execution of *L'Estaque* that make it an important step toward the classicizing works Renoir was to paint during the rest of the 1880s. His trip to Italy and to the Mediterranean provided him with the models of linear strength and construction on which to base his paintings and gave the whole course of his art a new impetus.

PIERRE-AUGUSTE RENOIR (1841-1919)
Algerian Girl
Oil on canvas, 20 x 15⅝ in. (50.8 x 40.5 cm.)
Signed and dated at lower right: *Renoir 81.*
Juliana Cheney Edwards Collection. Bequest of
 Hannah Marcy Edwards in memory of her mother.
 39.677

By the early 1880s the Impressionist group had begun to dissolve, partially as a result of some of the artists seeking new stylistic directions for their work, and partially because of strong differences of opinion among its members concerning the purpose and content of the group exhibitions. When an Impressionist exhibition was finally organized in the spring of 1881, Renoir, Monet, Sisley, and Cézanne did not participate, preferring to try to exhibit their paintings at the Salon and elsewhere.

Renoir, feeling tired and depressed, decided to make a trip to Algeria in February and March of 1881. Full of self-doubt and deeply dissatisfied with his art, he was in search of a new source of inspiration. The trip seems to have provided the stimulus that he needed. He wrote to his dealer, Durand-Ruel, from Algiers in March: "I have stayed far away from other painters, in the sun, in order to think things through well. I believe that I have reached my goal and have found a solution. I could be wrong; however, it would surprise me very much if I am" (translated from Lionello Venturi, *Les Archives de l'Impressionnisme*, vol. 1 [Paris, 1939], p. 115).

It was during this first trip to Algeria that Renoir painted the *Algerian Girl* now in the collection of the Museum of Fine Arts. Its delicate execution and brilliant palette seem to substantiate Renoir's contention that he had found a new "solution" in the sunlight of North Africa. The painting emanates a joyous delight in the depiction of a local Algerian model. Renoir used a variety of brushstrokes to paint the jewelry and fabrics of her costume and the rich patterns of the oriental rug and divan on which she sits.

The picture has the freshness of a watercolor, an impression achieved by painting the canvas with a smooth, opaque ground and then using a very thin, translucent colored paint over it. The white ground glistens through the glazes of brightly colored paint, lending a sparkling clarity to the blues, greens, orange-reds, and yellows.

Even though Renoir's model is a young Algerian girl, she seems to be of a physical type that resembles many of the artist's French sitters. Her soft, rounded face with its smiling mouth, wide almond-shaped dark blue eyes, rosy cheeks, and frame of dark hair echoes that of many of his earlier paintings of young women. It was not his intention to explore and define the traits of the typical native physiognomy, nor to record details of the setting with historical accuracy, as Gérôme had done (see cat. no. 27), but rather to capture the sensual charm, the light, and the dazzling color of his exotic subject.

Renoir's trip to Algeria may have been prompted, in part, by his profound admiration for the North African paintings of Delacroix (see cat. no. 8). In 1869 and 1870 he had devoted a great deal of time to the study of Delacroix's oriental paintings in the Louvre. Their romantic appeal and rich color led him to paint several canvases of women in Algerian costumes in 1870, among them the *Parisian Women Dressed as Algerians* (National Gallery of Western Art, Tokyo), which was inspired directly by Delacroix's *Women of Algiers* painted in 1834 (Louvre, Paris). Again, in 1875 Renoir painted a copy of the beautiful *Jewish Wedding* of 1839 (Louvre, Paris) and proudly acknowledged his source by signing it "Renoir, after Delacroix."

59

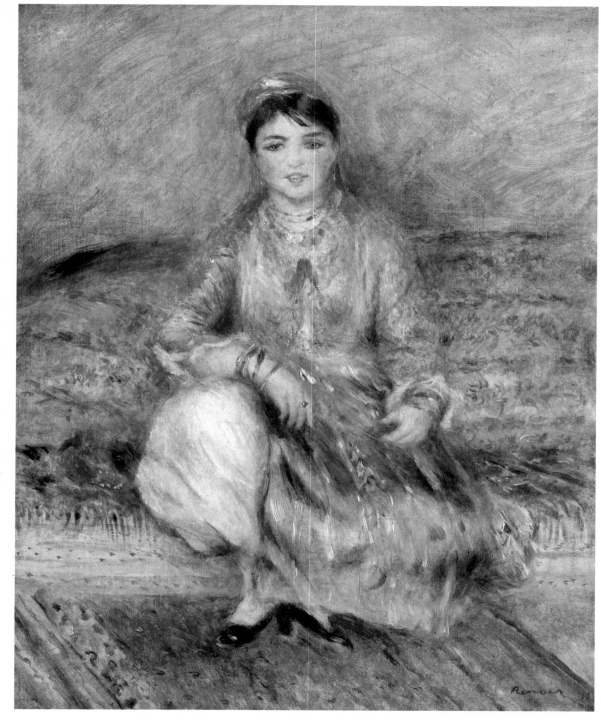

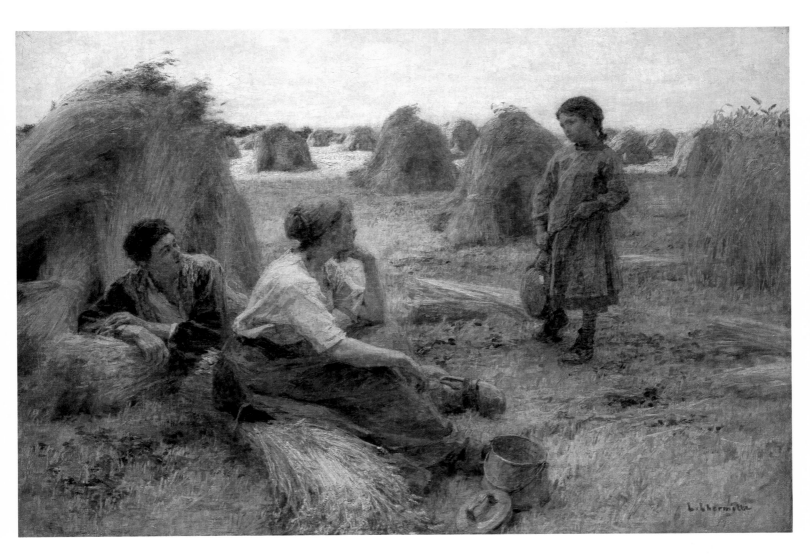

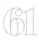

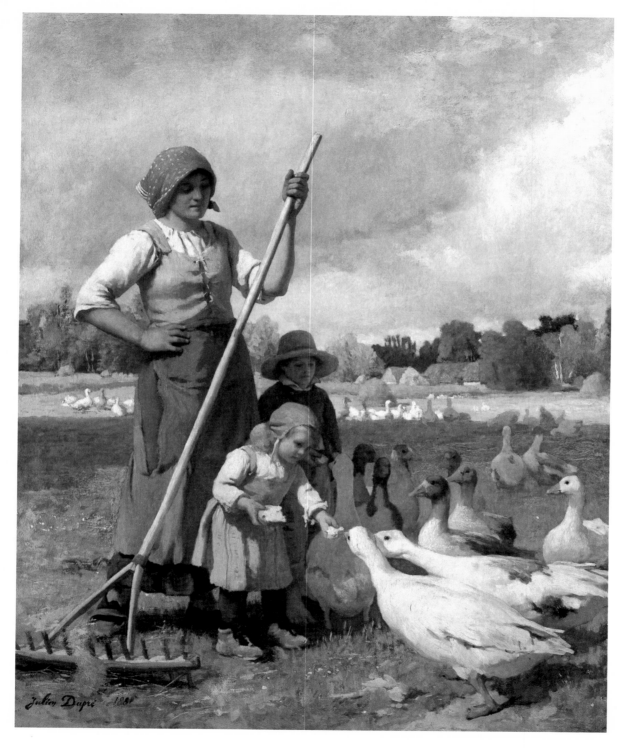

Julien Dupré 1881

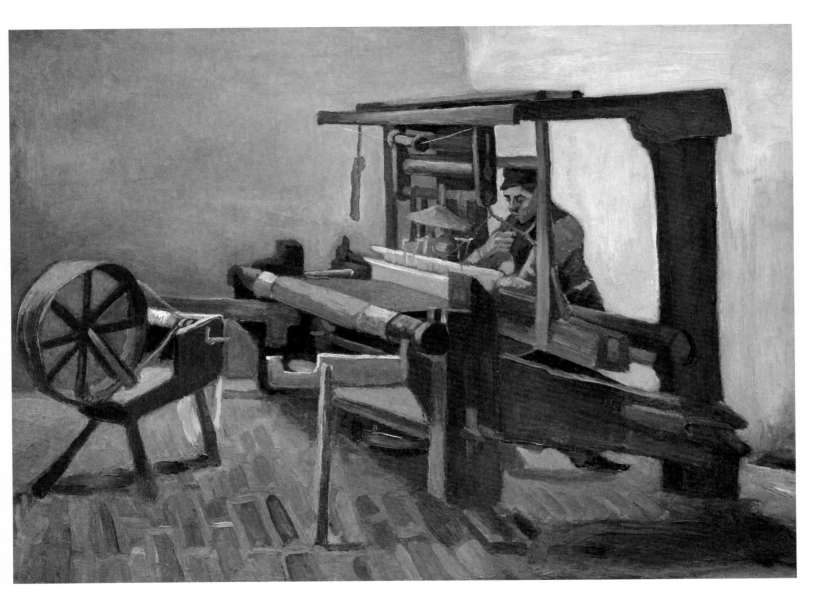

 VINCENT VAN GOGH (1853-1890)
The Weaver
Oil on canvas, 24¾ x 33¼ in. (62 x 84 cm.)
Arthur Gordon Tompkins Residuary Fund. 58.356

To a greater degree than most artists, Van Gogh expressed in his art his personal moral convictions and emotions. Born in a small Dutch village in 1853, the son of a Protestant minister, he was twenty-eight years old before he decided to become an artist. Due in part to his Christian upbringing and in part to his temperament, Van Gogh felt a profound sympathy for the laboring poor and, in art as well as in literature, he admired those works that dealt with their plight. He held the paintings and the engravings of Millet and of Rembrandt in highest esteem, at the same time appreciating the nineteenth-century Dutch artists who depicted scenes of peasant life, particularly the paintings of his cousin Anton Mauve, with whom he studied briefly in 1882 and 1883.

After leaving Mauve's studio in The Hague in December of 1883, Van Gogh returned to live with his family at Nuenen for two years. One of the themes that preoccupied him during this period was that of the weaver. As early as 1880 he had written: "The miners and weavers still constitute a race apart from other laborers and artisans, and I feel great sympathy for them. I should be very happy if someday I could draw them, so that those unknown or little-known types would be brought before the eyes of the people" (translated and quoted in *The Complete Letters of Vincent Van Gogh*, [Greenwich, Conn., 1958], vol. 1, no. 136, p. 206). During the time that Van Gogh spent in Nuenen he executed no fewer than ten oil paintings as well as a number of drawings and watercolors of the Brabant weavers and their looms.

In a letter to his brother Théo, dated May 1884, Van Gogh wrote: "I am working on a rather large picture of a weaver. . . . And at the same time another one, which I began last winter—a loom on which a piece of red cloth is being woven; there the loom is seen from an angle. . . . Those looms will cost me a lot of hard work yet, but in reality they are such splendid things, all that old oak-wood against a grayish wall, that I certainly believe it is

a good thing that they are painted once in a while" (*op. cit.*, vol. 2, no. 367, pp. 288, 290). The Boston picture is the only one of the series known to have a red cloth on the loom, thus it is probable that it is the painting mentioned in the letter.

By 1884 the hand loom and the spinning wheel had been almost totally eclipsed by industrial textile mills. *The Weaver* thus recalls Millet's *Spinner* (see cat. no. 15) in its portrayal of a dying craft. But whereas Millet elevated his figure and her humble task to a plane of human dignity and nobility, Van Gogh depicted the figure of the weaver as a brutalized automaton engulfed by his loom, caught in a corner of a windowless, shadowy room. His point of view was expressed in another letter: "This colossal black thing which had become so dingy-looking—an old-oak color—with all its ribs standing out in sharp contrast to its gray surroundings; and in the midst of it sits a black ape or gnome or ghost who makes those ribs clatter all day" (Vincent Van Gogh, *Letters to an Artist* [New York, 1936], no. 46, pp. 178–179). Van Gogh used both composition and palette to convey his feelings about the fate of his anonymous subject. His style and handling of light in this picture owe a great debt to his study of interiors by Millet and by Rembrandt. The soft grays of the walls serve to emphasize the dark browns of the wooden loom, which are in the same chromatic range as the blues of the weavers' clothing and the unattended spinning wheel in front of them. The only spots of vivid color are the red yarn on the wheel and on the spool, and the red cloth on the loom.

The sharp diagonals of the loom serve an expressive purpose, drawing the viewer into the picture space and, at the same time, forming a linear cage for the weaver. This effect is accentuated by the tipped-up perspective of the brick floor. A hint of the powerful brushwork of Van Gogh's subsequent years in France is found in the vigorous application of paint in the floor area, each brick having been blocked in in forceful single strokes of thick paint.

VINCENT VAN GOGH (1853-1890)
Houses at Auvers
Oil on canvas, 29¾ x 24¾ in. (75.5 x 61.8 cm.)
Bequest of John T. Spaulding. 48.549

In the late spring of 1889, after a period of intermittent attacks of mental illness, Van Gogh voluntarily entered an asylum at Saint-Rémy near Arles in the south of France. By the following spring he felt sufficiently recovered to leave the hospital and return north to Paris, where he visited his brother Théo. Unable to withstand the pressures of being in the city, Van Gogh went to the small village of Auvers-sur-Oise, northwest of Paris, with Pissarro's recommendation that he seek the care of Dr. Paul Gachet. Pissarro and Cézanne had painted in the area of Auvers in the early 1870s and had met and befriended Dr. Gachet, an eccentric physician who had long been interested in the arts and in psychiatry.

Van Gogh arrived at Auvers on May 21, 1890, and in the space of two months was able to paint a number of canvases, among them *Houses at Auvers*. Apparently provoked by a small incident with the doctor, Van Gogh suddenly lost confidence in him, becoming irritable and withdrawn. While on a painting excursion in late July he shot himself, dying two days later at the age of thirty-seven. During his short and troubled life Van Gogh created a body of works that were to have an immeasurable impact on the course of twentieth-century art, fundamental to the development of Fauvism and the entire expressionist movement.

Houses at Auvers represents a street scene in the village, not far from Dr. Gachet's house. Van Gogh wrote to his brother Théo immediately upon his arrival there: "Auvers is very beautiful, among other things a lot of old thatched roofs, which are getting rare" (translated and quoted in *The Complete Letters of Vincent Van Gogh*, [Greenwich, Conn., 1958], vol. 3, no. 635, p. 273). In his next letter he commented: "But I find the modern villas and the middle-class country houses almost as pretty as the old thatched cottages which are falling into ruin" (*ibid.*, no. 636, p. 275). Comparison with contemporary photographs reveals that Van Gogh depicted the placement of the street and houses in this painting as they actually appeared.

It is through the use of a high-keyed pastel palette, a variety of vigorously applied, thickly impastoed brushstrokes, and the brilliant manipulation of outline that he electrified the scene, charging it with an emotional power that demands the attention of the viewer. Imbued with the artist's passionate energy and inner vision, it is a painting that required keen observation, control, and a conscious choice in handling the medium. It is artistically coherent and not, as has often been stated, the work of a madman.

The style of painting that Van Gogh developed in the short time between his arrival in France from Holland in 1886 and his death reveals the impact of the Impressionists in the lightened palette and use of brushstrokes of pure color. He was also deeply affected by the decorative compositional devices and flattened surfaces found in Japanese prints. *Houses at Auvers*, with its emphasis on sinuous linear contours, reveals this awareness of Japanese art. The most important influence for him, however, was the art of Gauguin. The concept of using color as a vehicle for personal expression, free from the actual appearance of the objective world, led to the explosion of color in Van Gogh's paintings. Van Gogh went beyond Gauguin's Symbolist use of flat areas of solid color by modifications not only of hue but also of the thickness and shape of his brushstrokes. In *Houses at Auvers* every part of the canvas pulsates with life and energy, transmitting the profound feelings of the artist before nature.

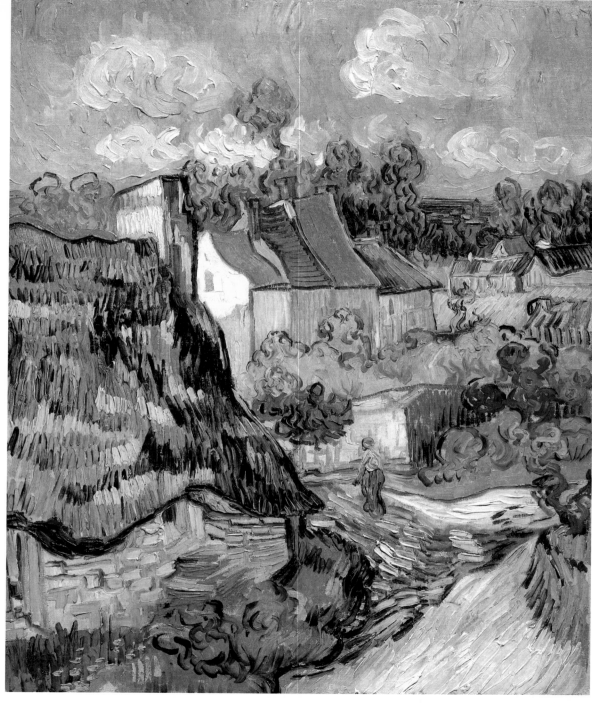

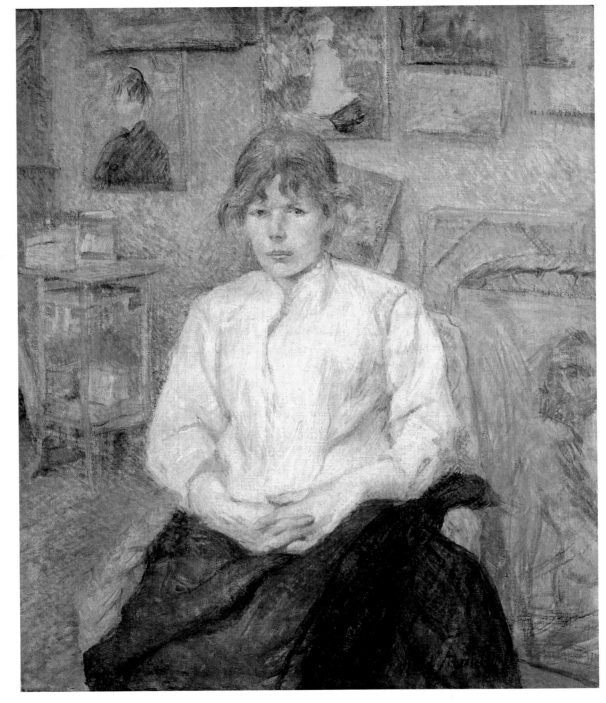

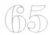

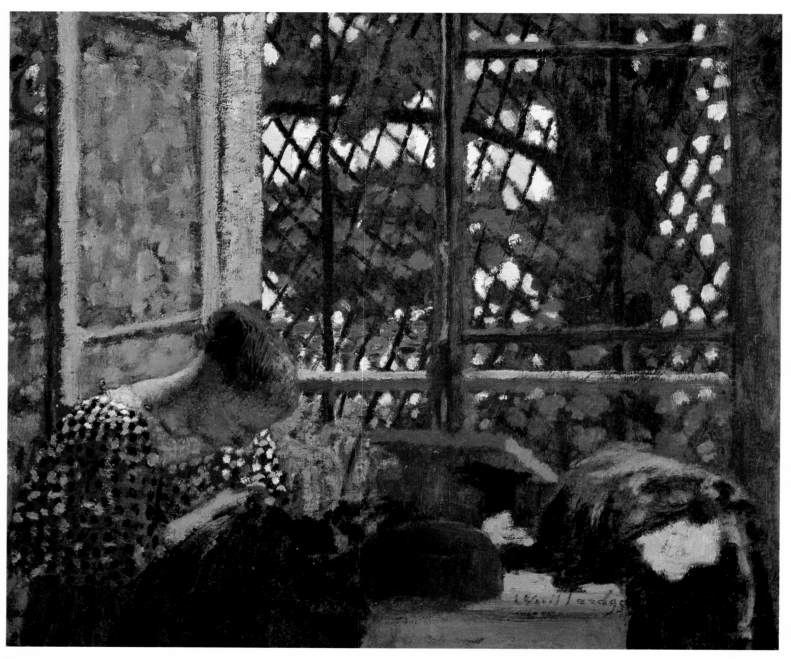

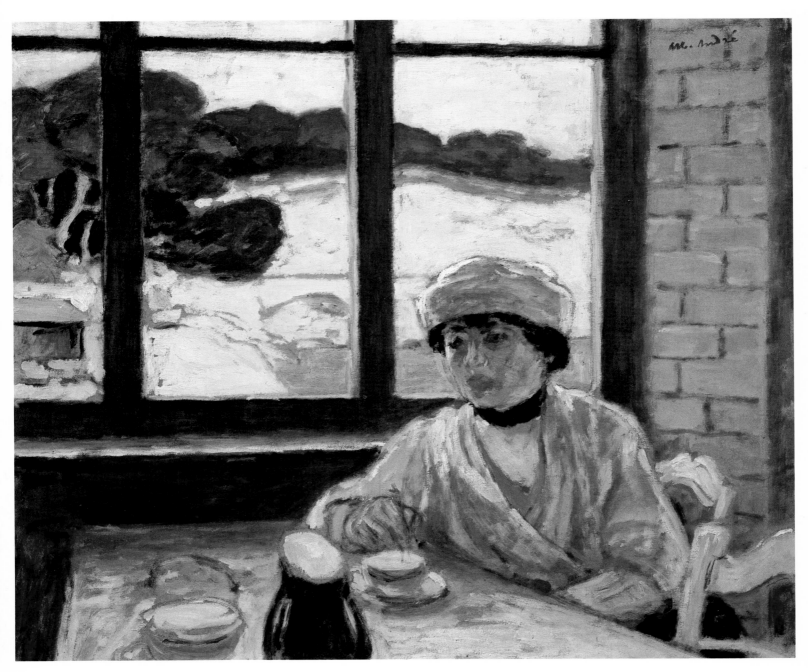

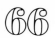

ALBERT ANDRÉ (1869-1954)
Woman at Tea
Oil on heavy paper attached to canvas, 20 x 23⅜ in.
 (50.8 x 59.4 cm.)
Signed at upper left: *Alb. André*
Bequest of John T. Spaulding. 48.517

Albert André was a contemporary of Vuillard and Bonnard. Like their works, his paintings reflect the influence of the Impressionists, but have a more intimate and personal style. Born in Lyon, André came to Paris when he was twenty, first studying at the Académie Julian and then in the studio of Bouguereau (see cat. no. 28), where he met and befriended Roussel, Bonnard, Vuillard, and other young artists. He exhibited five paintings at the Salon des Indépendents in 1894 and, at Renoir's suggestion, the famous dealer Durand-Ruel bought all five paintings, establishing André's reputation. André and Renoir were to become and remain close friends until the latter's death in 1919.

Although the Boston painting *Woman at Tea* is undated, a letter of February 14, 1922, written by Durand-Ruel to the painting's former owner, John Spaulding, indicates that it was executed in 1917. The dealer states further that the canvas was painted at Renoir's house at Cagnes in the south of France and that it may represent André's wife, the painter Marguerite Carnillac.

Woman at Tea is typical of André's work in that it represents an intimate domestic scene. A young woman, seated at a table simply spread with a milk pitcher and two teacups, indolently stirs her tea with a spoon held in her right hand. The depiction of a second cup in the left foreground indicates the presence of the artist and his participation in the scene, and by implication the viewer is drawn into the picture space. The woman's face and torso are thrown into shadow by the strong Mediterranean sun that streams in the window behind her. This type of composition, including a table in front of a landscape seen through a window or door, was often used by Bonnard. The palette, dominated by broad areas of warm pink-reds, yellows, and creams, and balanced by dark greens and the black of the sitter's neckband

and hair, also reflects Bonnard's influence, although André's colors are more subdued.

The landscape of chalky, yellow-white hills with their rim of deep green pine trees and the pale turquoise patch of water are typical of the Midi in France. André was deeply attached to this region; he had inherited a house from his father at Loudun, and he spent at least six months of every year there, returning to Paris only during the winter.

It has often been said that André's art was profoundly influenced by that of Renoir; in this painting, however, the influence seems to be more one of attitude than of style. *Woman at Tea* expresses André's unpretentious appreciation of the simplest things of everyday life and of nature, a quality found in the paintings of Renoir. André wrote two books about Renoir, and in them he expressed his admiration for the artist's sheer pleasure in painting what was around him, a joy he clearly shared, even if his talents were more modest. When one thinks of the artistic explosion that was taking place in postwar France with the advent of Cubism and the Fauves, André's painting takes its place as a rather conservative continuation of the tenets of Impressionism as interpreted by the generation of Bonnard and some of his contemporaries. André was to continue to work in this style until his death in 1954.

HENRI MATISSE (1869-1954)
Carmelina
Oil on canvas, 32 x 23¼ in. (81.3 x 59 cm.)
Signed at lower left: *Henri. Matisse*
Arthur Gordon Tompkins Residuary Fund. Res. 32.14

In his *Notes of a Painter* Matisse wrote: "What interests me most is neither still life nor landscape but the human figure. It is through it that I best succeed in expressing the nearly religious feeling that I have towards life" (translated by Alfred H. Barr, *Henri Matisse Retrospective Exhibition* [New York, 1931], p. 34, from "Notes d'un Peintre," first published in *La Grande Revue* [Paris], December 25, 1908). *Carmelina* illustrates the expressive power Matisse was able to realize in depicting the female nude. An early work executed in 1903, it has a plasticity and boldness that reflect his study of Cézanne and his experience painting from the nude model in Carrière's studio in 1898. It represents a turning point in his work away from the brightly colored Impressionist-influenced works of the late 1890s.

Painted in broad areas of predominantly earth-toned colors, the picture has a carefully calculated quality in the geometric balance of its composition, consisting of a series of interlocking rectangles of color and form and the rigidly frontal figure of the model, who is placed just off-center to the right. Matisse achieved in the *Carmelina* his declared goal: "Expression...does not consist of the passion mirrored upon a human face or betrayed by a violent gesture. The whole arrangement of my picture is expressive. The place occupied by figures or objects, the empty spaces around them, the proportions, everything plays a part. Composition is the art of arranging in a decorative manner the various elements at the painter's disposal for the expression of his feelings" (Barr, *op. cit.*, p. 30).

In *Carmelina* a strong clear light falls on the model from the right, casting shadows of deep brown with touches of red and green. Eliminating most halftones and detail, Matisse used color in a daring, if subdued way. The model's right hand, for example, is indicated as a flat area of orange-red paint. The composition, like that of many of Matisse's later masterpieces, is unified by an extraordinarily skillful harmony of line and color. There is a subtle balance of reds (in the shadows around the figure, the table covering, and the artist's shirt) and blue-greens (in the hair ribbon, the shadows of the drapery across the model's thigh, and the frame over the fireplace) played off against the blocks of warm golds, ochers, and brown-grays of the architectural elements and frames in the background.

The model faces the viewer frontally and from above, making the presence of her body more immediate and forceful. The figure of the artist is reflected in the rectangular mirror on the dressing table behind her. Like that of the artist, who is seated, the viewer's eye level is in line with the model's breasts, giving the painting an overtly sexual emphasis. This is not a portrait, but rather a celebration of the female body, the round curves of which are set off against an angular backdrop.

In the years between 1900 and 1903 Matisse painted a number of male and female nudes. This coincided with his creation of small sculptures of female figures under the influence of Rodin, and may in part explain the vigorous modeling of the *Carmelina*. The Boston painting's solidity and tight structural composition reflect not only his study of Cézanne's *Bathers*, a version of which he owned, but also his awareness of the nudes of Manet and Courbet. This phase of Matisse's art immediately preceded his Fauve period between 1905 and 1913, and was fundamental to his subsequent experiments with a modified Cubism in the years before World War II.

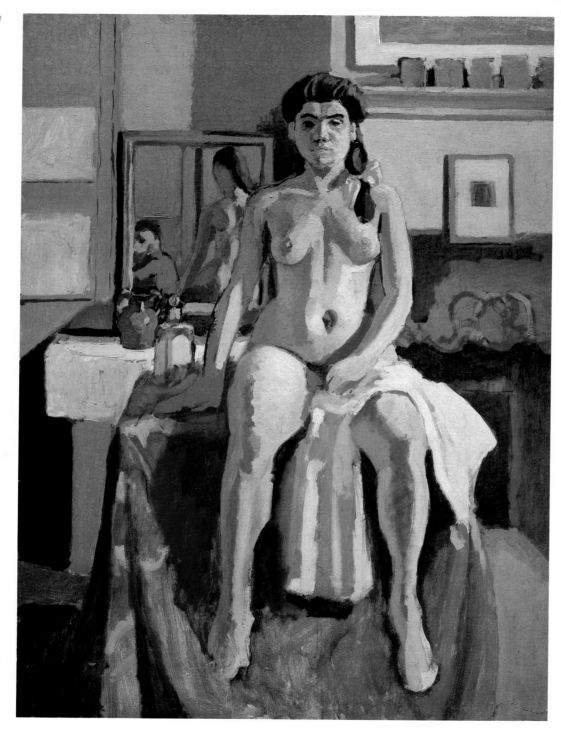

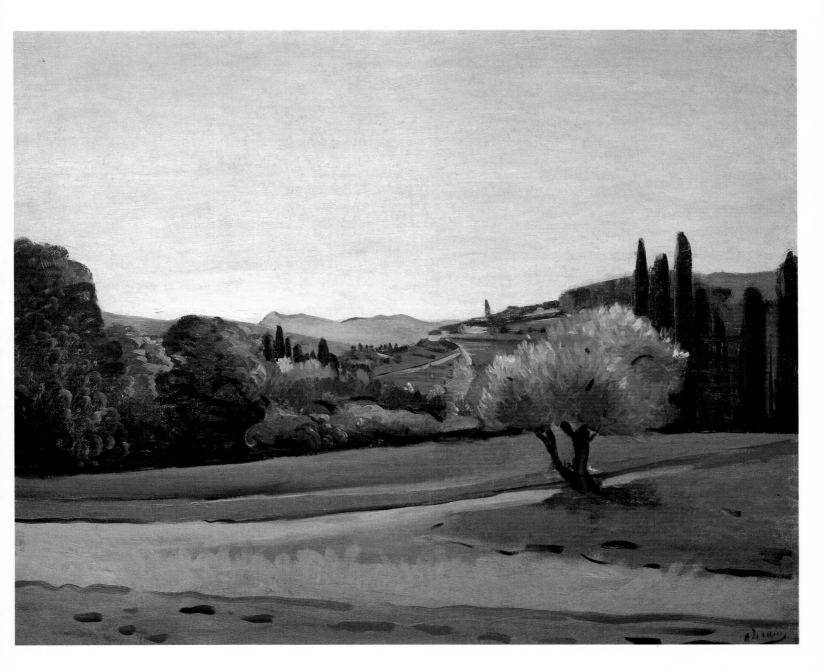

Andrè Derain (1880-1954)
Landscape, Southern France
Oil on canvas, 19⅞ x 23⅞ in. (50.4 x 60.8 cm.)
Signed at lower right: *A Derain*
Bequest of John T. Spaulding. 48.535

Landscape, Southern France represents the same scene, from a slightly different viewpoint, as another landscape dated 1927 in the Phillips Collection, Washington, D.C. The two canvases are extremely close in style, thus the Boston picture must date from about the same time. The dealer Durand-Ruel purchased it from Derain on July 13, 1929, confirming that it was executed at least by the summer of that year.

Broadly painted in wide bands of strong color, true to the palette of the vegetation of Provence, the canvas has great solidity and clarity of composition. The cloudless blue sky is wonderfully luminous, the blue-white glow at the horizon intensifying gradually toward the upper limits of the canvas. The composition consists of several interlocking triangular areas, each painted with sureness and economy. It progresses back in space from the reddish brown and flat green of the foreground to the middle distance with its bank of varied trees on the left and cypresses on the right, all in dark greens with black shadows. Beyond the trees appears a village on a hill with its sides stepped for cultivation, and in the far distance rises the form of blue-gray mountains.

The painting represents a specific landscape in southern France, but the composition has the structural balance of a landscape by Poussin, realized in a more bold and simplified form. The brushwork is flat and unobtrusive, and the total impression is one of peace, calm, and unity. In this unpretentious work Derain achieved his declared goal of continuing the classical tradition within the scope of his own style and vision.

Derain is an artist whose long career was marked by vicissitudes both in his painting style and in the critical reaction to it. A prolific artist of considerable intellect and culture, he eludes categorization due to his extreme independence and to the variety of styles in which he worked. Born at Chatou in the Île-de-France, he became,

along with Vlaminck and Matisse, a daring leader in the Fauve movement at the beginning of the century. In about 1910 he experimented with the principles of Cubism and was among the first to appreciate and collect African art. Before the outbreak of the war he began to paint landscapes that reveal his study of the late structural paintings of Cézanne. He spent five years in the army, and the war experience seems to have had a profound effect on his art.

After 1919 Derain consciously sought continuity with the past and rejected the expressionist direction taken by his contemporaries. An ardent admirer of the Old Masters, particularly Poussin, he saw his painting as a continuation through Cézanne of the cool, cerebral, and structured classical style of the seventeenth century. At the same time he was a realist who sought to record what he saw around him more than what he felt, which separated him from the mainstream of contemporary art. Today, with the prevalence of photo-realism and representational art, the postwar paintings of Derain are being reassessed and seem more as precursors than as retardatory works.

GEORGES BRAQUE (1882-1963)
Still Life
Oil on canvas, 12¼ x 25⅝ in. (31 x 65 cm.)
Signed and dated at lower left: *G. Braque/21*
Gift by Contribution. Res. 32.21

Today Braque is known primarily as the co-founder (with Picasso) of Cubism, one of the most important and revolutionary stylistic developments in twentieth-century art. During the years between 1909 and 1914 the two artists formulated a new pictorial language for the representation of space and volume that no longer depended on a conventional system of perspective or traditional illusionism. In searching for this new stylistic expression, Braque preferred to paint still lifes of simple, inanimate objects. Throughout his long career he was to continue to favor and to create his greatest works in the genre of still life.

This *Still Life*, dated 1921, is representative of Braque's style during the first years following the war. Braque, who had been drafted into the army in 1914, had sustained a head injury that required a long convalescence. When he began to paint again in 1918, he declared that he no longer believed in anything and that he wanted his pictures to have no symbolic meaning beyond their innate quality as works of art. He wrote: "Objects do not exist for me except in so far as a harmonious relationship exists between them and also between them and myself. When one attains to this harmony, one reaches a sort of intellectual non-existence which makes everything possible and right" (quoted and translated by George Heard Hamilton, *Painting and Sculpture in Europe 1880-1940* [New York, 1972], p. 449, from *Cahier de Georges Braque 1917-1947* [New York and Paris, 1948]).

In this painting, Braque used a freer, bolder, more tactile style than he had in the prewar period, to explore further and refine the possibilities of Cubism. A long horizontal composition, the painting has a background of shifting planes in pale yellows, ochers, and light browns, with shadows falling from different directions. The canvas of the painting was primed with black paint, which serves to throw the forms superimposed on it into relief. Several of the planes are elegantly patterned with lines and dots, and they, like the table, are painted from shifting points of view. For example, both the front edge of the table and its surface are depicted parallel to the picture plane. Arranged on the table, like a shallow low relief, are a schematically painted bunch of grapes, two pears, and three peaches.

A consummate craftsman who had been trained as a *peintre-décorateur* before becoming a painter, Braque was the first artist to give texture to paint by adding other substances, such as sand, to his pigment. A subtle variety of textures and colors were used in the Boston painting, enriching its surface and capturing the variety of the objects depicted. Braque dragged a comb across the thick brown paint of the tabletop to simulate the texture of wood grain. The grapes are painted in a spongy, light green paint, while a different, rougher texture is used for the thick-skinned yellow-green pears. In contrast, the softer peaches are thinly painted in feathery strokes of yellow and orange, and circumscribed by a band of blue and white representing a cloth. The overall color harmony is subdued and decorative with blues, yellows, and greens thoughtfully set off against more neutral colors.

This painting has a classical, timeless balance in its chromatic range, texture, and form. Braque, like Chardin, his eighteenth-century predecessor in great still-life painting, succeeded in creating a beautiful work of art with humble, everyday objects as his point of departure. However, in freeing himself from traditional representational formulas, he achieved a heightened and more personal level of artistic expression.

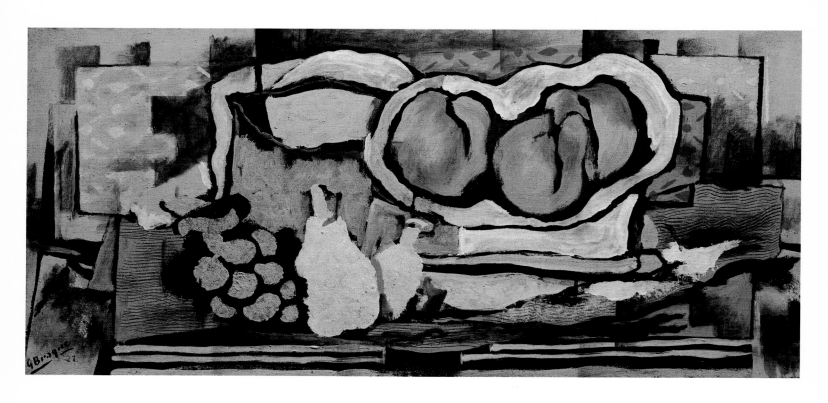

References

1

COROT, *Portrait of a Man*

Alfred Robaut, *L'Oeuvre de Corot: catalogue raisonné et illustré*, vol. 2, Paris, 1905, no. 1030, illus. no. 1030; C. Bernheim de Villers, *Corot: peintre de figures*, Paris, 1930, no. 124; illus. no. 124; Charles C. Cunningham, "Some Corot Paintings in the Museum's Collection" in *Bulletin* of the Museum of Fine Arts, Boston 34, no. 206 (December 1936), p. 101, illus. p. 100; George H. Edgell, *French Painters in the Museum of Fine Arts: Corot to Utrillo*, Boston, 1949, illus. p. 12; W. G. Constable, ed., *Summary Catalogue of European Paintings*, Boston, 1955, p. 14.

2

COROT, *Young Woman Weaving a Wreath of Flowers*

Alfred Robaut, *L'Oeuvre de Corot: catalogue raisonné et illustré*, vol. 3, Paris, 1905, no. 2142, illus. no. 2142; C. Bernheim de Villers, *Corot: peintre de figures*, Paris, 1930, no. 315, illus. no. 315: W. G. Constable, ed., *Summary Catalogue of European Paintings*, Boston, 1955, p. 14.

3

COROT, *Forest of Fontainebleau*

Henri Dumesnil, *Corot: souvenirs intimes*, Paris, 1875, p. 41; George A. Wall, ed., *An Illustrated Catalogue of the Art Collection of Beriah Wall*, Providence, 1884, p. 14, no. 27; Alfred Robaut, *L'Oeuvre de Corot: catalogue raisonné et illustré*, vol. 2, Paris, 1905, no. 502, illus. no. 502; Etienne Moreau-Nélaton, *Corot raconté par lui-même*, vol. 1, Paris, 1924, p. 60, fig. 97; Charles C. Cunningham, "Some Corot Paintings in the Museum's Collection" in *Bulletin* of the Museum of Fine Arts, Boston 34, no. 206 (December 1936), pp. 100-101, illus. p. 102, fig. 4; George H. Edgell, *French Painters in the Museum of Fine Arts: Corot to Utrillo*, Boston, 1949, illus. p. 11; W. G. Constable, ed., *Summary Catalogue of European Paintings*, Boston, 1955, p. 14.

4

COROT, *Farm at Recouvrières, Nièvre*

Alfred Robaut, *L'Oeuvre de Corot: catalogue raisonné et illustré*, vol. 2, Paris, 1905, no. 292, illus. no. 292; Charles C. Cunningham, "Some Corot Paintings in the Museum's Collection" in *Bulletin* of the Museum of Fine Arts, Boston 34, no. 206 (Decem-ber 1936), p. 100; W. G. Constable, ed., *Summary Catalogue of European Paintings*, Boston, 1955, p. 14; Jean Leymarie, *Corot*, Geneva, 1966, p. 49.

5

COROT, *Twilight*

Alfred Robaut, *L'Oeuvre de Corot: catalogue raisonné et illustré*, vol. 2, Paris, 1905, no. 614, illus. no. 614; W. G. Constable, ed., *Summary Catalogue of European Paintings*, Boston, 1955, p. 14.

6

COROT, *Turn in the Road*

Alfred Robaut, *L'Oeuvre de Corot: catalogue raisonné et illustré*, vol. 3, Paris, 1905, no. 1542, illus. no. 1542; W. G. Constable, ed., *Summary Catalogue of European Paintings*, Boston, 1955, p. 14.

7

COROT, *Morning Near Beauvais*

Alfred Robaut, *L'Oeuvre de Corot: catalogue raisonné et illustré*, vol. 2, Paris, 1905, no. 1012, illus. no. 1012; Charles C. Cunningham, "Juliana Cheney Edwards Collection" in *Bulletin* of the Museum of Fine Arts, Boston, 37, no. 224 (December 1939), p. 98, no. 4; W. G. Constable, ed., *Summary Catalogue of European Paintings*, Boston, 1955, p. 14.

8

DELACROIX, *The Lion Hunt*

André Joubin, ed., *Journal d'Eugène Delacroix*, Paris, 1932, vol. 3, p. 189 (entry for April 26, 1858); Adolphe Moreau, *E. Delacroix et son oeuvre*, Paris, 1873, p. 280; Edward Strahan, *The Art Treasures of America*, vol. 2, Philadelphia, 1879, p. 16, illus. with engraving p. 17; Alfred Robaut, *L'Oeuvre complet d'Eugène Delacroix: peintures, dessins, gravures, lithographies*, Paris, 1885, p. 364, no. 1349, illus.; E. Durand-Gréville, "La Peinture aux Etats-Unis: les galeries privées" in *Gazette des Beaux-Arts* 36 (1887), p. 71; anonymous, "Pictures at the Union League Club" in *Studio* 4, no. 1 (December 1888), p. 22; Etienne Moreau-Nélaton, *Delacroix raconté par lui-même*, vol. 2, Paris, 1916, p. 185, fig. 396; Julius Meier-Graefe, *Eugène Delacroix*, Munich, 1922, illus. p. 219; Raymond Escholier, *Delacroix: peintre, graveur, écrivain*, Paris, 1929, p. 246; Jean Alazard, *L'Orient et la peinture française au XIXᵉ siècle d'Eugène Delacroix à Auguste Renoir*, Paris, 1930, p. 71, illus. opposite p. 49; R. H. Wilenski, *French Painting*, Boston, 1936, p. 209; Lucien Rud-rauf, *Eugène Delacroix et le problème du romantisme artistique*,

Paris, 1942, p. 319, pl. xii; W. G. Constable, ed., *Summary Catalogue of European Paintings*, Boston, 1955, p. 18; George P. Mras, "The Delacroix Exhibition in Canada" in *Burlington Magazine* 105 (February 1963), p. 72, fig. 51; Frank Anderson Trapp, *The Attainment of Delacroix*, Baltimore, 1971, pp. 213-217, fig. 132; Luigina Rossi Bortolatto, *L'opera pittorica completa di Delacroix*, Milan, 1972, no. 756, illus.

9

Diaz de la Peña, *In a Turkish Garden*

W. G. Constable, ed., *Summary Catalogue of European Paintings*, Boston, 1955, p. 19.

10

Diaz de la Peña, *Gypsies Going to a Fête*

Théophile Silvestre, *Histoire des artistes vivants: français et étrangers*, Paris, 1856, p. 225; A. Frapp, "Chronique des Ventes" in *Arts* 2, no. 14, (February 1903), p. 34; Arthur Tomson, *Jean-François Millet and the Barbizon School*, London, 1905, p. 161; John La Farge, *The Higher Life in Art*, New York, 1908, p. 119, illus.; W. G. Constable, ed., *Summary Catalogue of European Paintings*, Boston, 1955, p. 19; Dario Durbe and Anna Maria Damigella, *La Scuola di Barbizon*, Milan, 1967, p. 19, pl. xviii; Jean Bouret, *The Barbizon School*, Greenwich, Conn., 1973, p. 122, illus. p. 105.

11

Diaz de la Peña, *Wood Interior*

W. G. Constable, ed., *Summary Catalogue of European Paintings*, Boston, 1955, p. 19.

12

Daumier, *The Horsemen*

Erich Klossowski, *Honoré Daumier*, Munich, 1923, pp. 39, 88, fig. 32; André Fontainas, *La Peinture de Daumier*, Paris, 1923, illus.; Guy Pène du Bois, "Corot and Daumier" in *Arts* 17 (November 1930), illus. p. 91; Jacques Lassaigne, *Daumier*, New York, 1938, illus. p. 115; Charles C. Cunningham, " 'The Horsemen' by Honoré Daumier" in *Bulletin* of the Museum of Fine Arts, Boston 40, no. 237 (February 1942), pp. 8-9, illus. p. 9; George H. Edgell, *French Painters in the Museum of Fine Arts: Corot to Utrillo*, Boston, 1949, illus. p. 14; Jean Adhémar, *Honoré Daumier*, Paris, 1954, pp. 78, 124, no. 107, fig. 107; W. G. Constable, ed., *Summary Catalogue of European Paintings*, Boston, 1955, p. 17; K. E. Maison, *Honoré Daumier: Catalogue Raisonné of the Paintings, Watercolors, and Drawings,*

vol. 1: The Paintings, New York, 1968, p. 93, nos. 1-76, pl. 69; Luigi Barzini and Gabriele Mandel, *L'opera pittorica completa di Daumier*, Milan, 1971, p. 96, no. 94, pl. xx.

13

Troyon, *Fox in a Trap*

W. G. Constable, ed., *Summary Catalogue of European Paintings*, Boston, 1955, p. 64.

14

Rousseau, *Pool in the Forest*

W. G. Constable, ed., *Summary Catalogue of European Paintings*, Boston, 1955, p. 57.

15

Millet, *The Spinner*

Louis Soullié, *Les Grands Peintres aux ventes publiques*, vol. 2: *Peintures, aquarelles, pastels, dessins de Jean-François Millet relevés dans les catalogues de ventes de 1849 à 1900*, Paris, 1900, p. 33; anonymous, *Quincy Adams Shaw Collection: Italian Renaissance Sculpture, Paintings and Pastels by Jean-François Millet*, Boston, 1918, p. 54, no. 13; Etienne Moreau-Nélaton, *Millet raconté par lui-même*, vol. 2, Paris, 1921, pp. 122-123, fig. 174; W. G. Constable, ed., *Summary Catalogue of European Paintings*, Boston, 1955, p. 43.

16

Millet, *The Washerwomen*

Edward Strahan, *The Art Treasures of America*, vol. 3, Philadelphia, 1879, p. 81; E. Durand-Gréville, "La Peinture aux Etats-Unis: les galeries privées" in *Gazette des Beaux-Arts* 36 (July 1887), p. 67; W. G. Constable, ed., *Summary Catalogue of European Paintings*, Boston, 1955, p. 44.

17

Millet, *Fishing Boat at Cherbourg*

Anonymous, *Quincy Adams Shaw Collection: Italian Renaissance Sculpture, Paintings and Pastels by Jean-François Millet*, Boston, 1918, p. 62, no. 21; Etienne Moreau-Nélaton, *Millet raconté par lui-même*, vol. 3, Paris, 1921, pp. 70-71, fig. 264; W. G. Constable, ed., *Summary Catalogue of European Paintings* Boston, 1955, p. 45.

18

MILLET, *Planting Potatoes*

Edward Strahan, *The Art Treasures of America*, vol. 3, Philadelphia, 1879, p. 87; Alfred Sensier, *La Vie et l'oeuvre de J.-F. Millet*, Paris, 1881, pp. 205, 221-226, 233, 301, 303; David C. Thomson, *The Barbizon School of Painters: Corot, Rousseau, Diaz, Millet, Daubigny, etc.*, New York, 1890, pp. 235, 241; anonymous, *Masters in Art*, part 8: Millet, Boston, 1900, p. 35, pl. 10; Louis Soullié, *Les Grands Peintres aux ventes publiques*, vol. 2: *Peintures, aquarelles, pastels, dessins de Jean-François Millet relevés dans les catalogues de ventes de 1849 à 1900*, Paris, 1900, pp. 52-53; Kenyon Cox, *Artist and Public and Other Essays on Art Subjects*, New York, 1914, pp. 61-62, pl. 5; anonymous, "The Quincy Adams Shaw Collection" in *Bulletin* of the Museum of Fine Arts, Boston 16, no. 94 (April 1918), p. 14, illus. p. 13; anonymous, *Quincy Adams Shaw Collection: Italian Renaissance Sculpture, Paintings and Pastels by Jean-François Millet*, Boston, 1918, p. 44, illus. p. 45; Etienne Moreau-Nélaton, *Millet raconté par lui-même*, Paris, 1921, vol. 2, pp. 73, 104, 108–111, 119, 122, fig. 164, and vol. 3, pp. 19, 25; W. G. Constable, ed., *Summary Catalogue of European Paintings*, Boston, 1955, p. 43.

19

COUTURE, *Woman in White*

Bertauts-Couture, *Thomas Couture (1815-1879): sa vie, son oeuvre, son caractère, ses idées, sa méthode*, Paris, 1932, p. 156; W. G. Constable, ed., *Summary Catalogue of European Paintings*, Boston, 1955, p. 15.

20

COUTURE, *The Miser*

Ernest Wadsworth Longfellow, "Reminiscences of Thomas Couture" in *Atlantic Monthly* (August 1883), p. 240; Bertauts-Couture, *Thomas Couture (1815-1879): sa vie, son oeuvre, son caractère, ses idées, sa méthode*, Paris, 1932, p. 156; W. G. Constable, ed., *Summary Catalogue of European Paintings*, Boston, 1955, p. 15.

21

COURBET, *Forest Pool*

Julius Meier-Graefe, *Courbet*, Munich, 1924, pl. 58; Charles Léger, *Courbet*, Paris, 1929, pl. 52; Pierre MacOrlan, *Courbet*, Paris, 1951, pl. 44 with detail; Helen Comstock, "The Connoisseur in America" in *Connoisseur* 138 (November 1956), p. 144, illus. p. 143; J. W. Goodison and Denys Sutton, *Fitzwilliam Museum, Cambridge: Catalogue of Paintings*, vol. 1: [French, German, and Spanish], Cambridge, 1960, p. 157; Douglas Cooper, "Courbet in Philadelphia and Boston" in *Burlington Magazine* 102 (June 1960), p. 245.

22

FROMENTIN, *The Standard Bearer*

W. G. Constable, ed., *Summary Catalogue of European Paintings*, Boston, 1955, p. 26.

23

ZIEM, *Venetian Coasting Craft*

W. G. Constable, ed., *Summary Catalogue of European Paintings*, Boston, 1955, p. 70.

24

BOUDIN, *Venice: Santa Maria della Salute from San Giorgio*

Ruth L. Benjamin, *Eugène Boudin*, New York, 1937, p. 185; Charles C. Cunningham, "The Juliana Cheney Edwards Collection" in *Bulletin* of the Museum of Fine Arts, Boston 37, no. 224 (December 1939), p. 98, no. 2; W. G. Constable, ed., *Summary Catalogue of European Paintings*, Boston, 1955, p. 7.

25

BOUDIN, *Port of Le Havre: Looking Out to Sea*

Ruth L. Benjamin, *Eugène Boudin*, New York, 1937, p. 185; W. G. Constable, ed., *Summary Catalogue of European Paintings*, Boston, 1955, p. 7.

26

PUVIS DE CHAVANNES, *Homer: Epic Poetry*

W. G. Constable, ed., *Summary Catalogue of European Paintings*, Boston, 1955, p. 53.

27

GÉRÔME, *Moorish Bath*

Louis Gonse, *L'Art moderne à l'exposition de 1878*, Paris, 1879, p. 48; Edward Strahan, ed., *Gérôme*, New York, 1881, illus.; Fanny Field Hering, *Gérôme*, New York, 1892, p. 225-226; M. H. Spielmann, "Jean Léon Gérôme: 1824-1904/Recollections" in *Magazine of Art* 2 (1904), p. 208; George H. Edgell, *French Painters in the Museum of Fine Arts: Corot to Utrillo*, Boston, 1949, pp. 28-29, illus.; W. G. Constable, ed., *Summary Catalogue of European Paintings*, Boston, 1955, p. 28.

28

BOUGUEREAU, *Fraternal Love*

Edmond About, *Voyage à travers l'Exposition des Beaux-Arts*, Paris, 1855, p. 149; Théophile Gautier, *Les Beaux-Arts en Europe: 1855*, Paris 1857, p. 305; anonymous, "Fraternal Love" in *Art Journal* 2 (1876), p. 335, illus. with engraving, opposite p. 321; Edward Strahan, *The Art Treasures of America*, vol. 3, Philadelphia, 1880, p. 85; Marius Vachon, *W. Bouguereau*, Paris, 1900, p. 146; W. G. Constable, ed., *Summary Catalogue of European Paintings*, Boston, 1955, p. 7; Frank A. Trapp, "The Universal Exhibition of 1855" in *Burlington Magazine* 107 (June 1965), p. 301.

29

TOULMOUCHE, *The Reading Lesson*

W. G. Constable, ed., *Summary Catalogue of European Paintings*, Boston ,1955, p. 64.

30

PISSARRO, *Morning Sunlight on the Snow, Eragny*

Ulrich Thieme and Felix Becker, eds., *Allgemeines Lexikon der Bildendèn Künstler von der Antike bis zur Gegenwart*, vol. 27, Leipzig, 1933, p. 109; Ludovic Rodo Pissarro and Lionello Venturi, *Camille Pissarro: son art—son oeuvre*, Paris, 1939, vol. 1, pp. 63, 207, cat. no. 911, vol. 2, pl. 185, no. 911; W. G. Constable, ed., *Summary Catalogue of European Paintings*, Boston, 1955, p. 51.

31

PISSARRO, *The Road to Ennery*

Ludovic Rodo Pissarro and Lionello Venturi, *Camille Pissarro: son art—son oeuvre*, Paris, 1939, vol. 1, p. 115, no. 255, vol. 2, pl. 51, no. 255; Charles C. Cunningham, "The Juliana Cheney Edwards Collection" in *Bulletin* of the Museum of Fine Arts, Boston 37, no. 224 (December 1939) pp. 96-108, no. 43, illus. p. 109. Charles C. Cunningham, "From Gainsborough to Renoir: Boston Exhibits Its New Bequest of the J. C. Edwards Collection" in *Art News* 38, no. 10 (December 9, 1939), p. 16; George H. Edgell, *French Painters in the Museum of Fine Arts: Corot to Utrillo*, Boston, 1949, illus. p. 33; W. G. Constable, ed., *Summary Catalogue of European Paintings*, Boston, 1955, p. 51.

32

PISSARRO, *Pontoise, Road to Gisors in Winter*

Forbes Watson, "American Collections: The John T. Spaulding Collection" in *Arts* 8 (December 1925), p. 336, illus. p. 344;

Arthur Pope, "French Paintings in the Collection of John T. Spaulding" in *Art News* 28 (April 26, 1930), p. 98, illus. p. 103; Ludovic Rodo Pissarro and Lionello Venturi, *Camille Pissarro: son art—son oeuvre*, Paris, 1939, vol. 1, p. 107, no. 202, vol. 2, pl. 41, no. 202; Charles H. Pepper, *The Collections of John Taylor Spaulding/1870-1948*, Boston, 1948, p. 16, no. 64; George H. Edgell, *French Painters in the Museum of Fine Arts: Corot to Utrillo*, Boston, 1949, illus. p. 35; John Rewald, *Pissarro (1830-1903)*, New York, 1954, pl. 19; W. G. Constable, ed., *Summary Catalogue of European Paintings*, Boston, 1955, p. 52; John Rewald, *Camille Pissarro*, New York, 1963, p. 88, illus. p. 89.

33

MANET, *Victorine Meurend*

D. S. MacColl, *Nineteenth Century Art*, Glasgow, 1902, p. 151, illus. opposite p. 148; Arsène Alexandre, "Exposition d'art moderne à l'Hôtel de la Revue 'Les Arts'" in *Arts* 11 (1912), illus. p. VIII; Théodore Duret, *Histoire d'Edouard Manet et de son oeuvre*, Paris, 1919, pp. 238-239, no. 30; Paul Jamot, "Le Centenaire de Manet" in *Gazette des Beaux-Arts* 8 (1932), illus. p. 53; Paul Jamot and Georges Wildenstein, *Manet*, Paris, 1932, vol. 1, p. 121, no. 50. vol. 2, pl. 33; Théodore Duret, *Manet*, New York. 1937, fig. 33; Michel Florisoone, *Manet*, Monaco, 1947, p. 99, no. 18, fig. 18; A. Tabarant, *Manet et ses oeuvres*, Paris, 1947, pp. 58, 535, no. 62; George H. Edgell, *French Painters in the Museum of Fine Arts: Corot to Utrillo*, Boston, 1949, illus. p. 39; Douglas Cooper, *The Courtauld Collection*, London, 1954, p. 65; W. G. Constable, ed., *Summary Catalogue of European Paintings*, Boston, 1955, p. 39; John Richardson, *Edouard Manet: Paintings and Drawings*, London, 1958, pp. 20, 21, 120, no. 16, fig. 16; Marcello Venturi and Sandra Orienti, *L'opera pittorica di Edouard Manet*, Milan, 1967, p. 92, no. 58; Anne Coffin Hanson, *Manet and the Modern Tradition*, New Haven, 1977, p. 76, fig. 42.

34

DEGAS, *Portrait of a Man*

Forbes Watson, "American Collections: The John T. Spaulding Collection" in *Arts* 8 (December 1925), p. 333, illus. p. 322; Arthur Pope, "French Paintings in the Collection of John T. Spaulding" in *Art News* 28 (April 26, 1930), p. 98, illus. p. 104; Camille Mauclair, *Degas*, London, 1937, illus. p. 36; P.-A. Lemoisne, *Degas et son oeuvre*, vol. 2, Paris, 1946, p. 208, no. 389, illus. p. 209; Charles H. Pepper, *The Collections of John Taylor Spaulding/1870-1948*, Boston, 1948, p. 10, no. 16; W. G. Constable, ed., *Summary Catalogue of European Paintings*, Boston, 1955, p. 18; Franco Russoli and Fiorella Minervino, *L'opera completa di Degas*, Milan, 1970, no. 445, illus.

35

DEGAS, *Race Horses at Longchamp*

Georges Grappe, *E. M. Degas*, London, 1911, illus. p. 48; P.-A. Lemoisne, *Degas*, Paris, 1912, pp. 77-78, pl. XXXI; Paul Lafond, *Degas*, vol. 2, Paris, 1919, p. 42; J. B. Manson, *The Life and Works of Edgar Degas*, London, 1927, pp. 28, 46, pl. 48; anonymous, *International Studio* 92 (April 1929), illus. p. 34; R. H. Wilenski, *French Painting*, Boston, 1931, p. 272; P.-A. Lemoisne, *Degas et son oeuvre*, Paris, 1946, vol. 1, p. 86, detail illus. opposite p. 86, and vol. 2, p. 174, no. 334, illus. p. 175; George H. Edgell, *French Painters in the Museum of Fine Arts: Corot to Utrillo*, Boston, 1949, illus. p. 44; W. G. Constable, ed., *Summary Catalogue of European Paintings*, Boston, 1955, p. 17; Pierre Cabanne, *Edgar Degas*, New York, 1958, pp. 28, 48, 110, no. 45 (p. 126), detail pl. 45; Franco Russoli and Fiorella Minervino, *L'opera completa di Degas*, Milan, 1970, no. 384, illus.

36

DEGAS, *A Visit to the Museum*

Camille Mauclair, *Degas*, London, 1937, illus. p. 74; P.-A. Lemoisne, *Degas et son oeuvre*, vol. 2, Paris, 1946, p. 256, no. 464, illus. p. 257; anonymous, *Centennial Acquisitions: Art Treasures for Tomorrow*, Museum of Fine Arts, Boston, 1970, p. 90, no. 58, illus. p. 91; Lucretia H. Giese, "A Visit to the Museum" in *Bulletin* of the Museum of Fine Arts, Boston 76 (1978) pp. 44-52, illus.

37

FANTIN-LATOUR, *Plate of Peaches*

Madame Fantin-Latour, *Catalogue de l'oeuvre complet (1849-1904) de Fantin-Latour*, Paris, 1911, p. 28, no. 196; anonymous, "Accessions of American and Canadian Museums" in *Art Quarterly* 23, no. 3 (Autumn 1960), p. 307.

38

FANTIN-LATOUR, *La Toilette*

Madame Fantin-Latour, *Catalogue de l'oeuvre complet (1849-1904) de Fantin-Latour*, Paris, 1911, p. 205, no. 1918; Charles C. Cunningham, "The Juliana Cheney Edwards Collection" in *Bulletin* of the Museum of Fine Arts, Boston 37, no. 224 (December 1939), p. 100, illus. p. 99; George H. Edgell, *French Painters in the Museum of Fine Arts: Corot to Utrillo*, Boston, 1949, illus. p. 48; W. G. Constable, ed., *Summary Catalogue of European Paintings*, Boston, 1955, p. 22.

39

SISLEY, *Waterworks at Marly*

W. G. Constable, ed., *Summary Catalogue of European Paintings*, Boston, 1955, p. 61; François Daulte, *Alfred Sisley: catalogue raisonné de l'oeuvre peint*, Lausanne, 1959, no. 216, illus.

40

SISLEY, *Saint-Mammès: A Gray Day*

Charles C. Cunningham, "The Juliana Cheney Edwards Collection" in *Bulletin* of the Museum of Fine Arts, Boston 37, no. 224 (December 1939), p. 110, no. 54, illus. p. 107; anonymous, "Great Edwards Collection Given to Boston" in *Art Digest* 14 (December 15, 1939), p. 6, illus.; George H. Edgell, *French Painters in The Museum of Fine Arts: Corot to Utrillo*, Boston, 1949, p. 53, illus. p. 52; W. G. Constable, ed., *Summary Catalogue of European Paintings*, Boston, 1955, p. 61; François Daulte, *Alfred Sisley: catalogue raisonné de l'oeuvre peint*, Lausanne, 1959, no. 374, illus.

41

SISLEY, *Grapes and Walnuts*

Forbes Watson, "American Collections: The John T. Spaulding Collection" in *Arts* 8 (December 1925), p. 335, illus. p. 323; Arthur Pope, "French Paintings in the Collection of John T. Spaulding" in *Art News* 28 (April 26, 1930), illus. p. 112; Edward A. Jewell, *French Impressionists and Their Contemporaries Represented in American Collections*, New York, 1944, illus. p. 92; Charles H. Pepper, *The Collections of John Taylor Spaulding/1870-1948*, Boston, 1948, p. 18, no. 77; George H. Edgell, *French Painters in The Museum of Fine Arts: Corot to Utrillo*, Boston, 1949, illus. p. 53; W. G. Constable, ed., *Summary Catalogue of European Paintings*, Boston, 1955, p. 61; François Daulte, *Alfred Sisley: catalogue raisonné de l'oeuvre peint*, Lausanne, 1959, no. 233, illus.

42

CÉZANNE, *Fruit and a Jug*

Forbes Watson, "American Collections: The John T. Spaulding Collection" in *Arts* 8 (December 1925), p. 334, illus. p. 321; Arthur Pope, "French Paintings in the Collection of John T. Spaulding" in *Art News* 28 (April 26, 1930), p. 97, illus. p. 109; Lionello Venturi, *Cézanne: son art — son oeuvre*, Paris, 1936, vol. 1, p. 197, no. 612, vol. 2, pl. 197, no. 612; Charles H. Pepper, *The Collections of John Taylor Spaulding/1870-1948*, Boston, 1948, pp. 5, 9, no. 9; George H. Edgell, *French Painters in the*

mary *Catalogue of European Paintings*, Boston, 1955, p. 54;
François Daulte, "Vive Renoir" in *Art News* 68 (April 1969),
p. 32, illus.; François Daulte, *Auguste Renoir: catalogue
raisonné de l'oeuvre peint*, vol. 1: Figures—1860-1890,
Lausanne, 1971, no. 367, illus.

60

LHERMITTE, *The Wheatfield, Noonday Rest*

W. G. Constable, ed., *Summary Catalogue of European Paintings*, Boston, 1955, p. 38.

61

DUPRÉ, *Feeding the Geese*

W. G. Constable, ed., *Summary Catalogue of European Paintings*, Boston, 1955, p. 20.

62

VAN GOGH, *The Weaver*

The Letters of Vincent Van Gogh to His Brother: 1872-1886,
vol. 2, London, 1927, no. 364 (p. 400) and no. 367 (p. 403);
J.-B. de La Faille, *L'Oeuvre de Vincent Van Gogh: catalogue
raisonné*, Paris, 1928, vol. 1, no. 29, p. 19, vol. 2, pl. VIII, no. 29;
J.-B. de La Faille, *Vincent Van Gogh*, Paris, 1939, p. 54, no. 34,
illus.; Thomas N. Maytham, "The Weaver by Vincent Van Gogh"
in *Bulletin* of the Museum of Fine Arts, Boston 59, no. 315
(1961), pp. 4-12, illus. cover and fig. 1 (p. 4).

63

VAN GOGH, *Houses at Auvers*

Julius Meier-Graefe, *Vincent*, Munich, 1921, illus. p. 98; J.-B. de
La Faille, *L'Oeuvre de Vincent Van Gogh: catalogue raisonné*
Paris, 1928, vol. 1, no. 805, p. 228, and vol. 2, pl. CCXXVI, no. 805;
Arthur Pope, "French Paintings in the Collection of John T.
Spaulding" in *Art News* 28 (April 26, 1930), p. 98, illus. p. 103;
J.-B. de La Faille, *Vincent Van Gogh*, New York, 1939, illus.
p. 539, no. 789; Charles H. Pepper, *The Collections of John
Taylor Spaulding/1870-1948*, Boston, 1948, p. 12, no. 33, illus.
p. 23, pl. III; George H. Edgell, *French Painters in The Museum
of Fine Arts: Corot to Utrillo*, Boston, 1949, illus. p. 84; André
Malraux, "Auvers vu par les peintres" in *L'Amour de l'Art* 31
(1952), p. 15, illus.; W. G. Constable, ed., *Summary Catalogue
of European Paintings*, Boston, 1955, p. 29; Leopold Reide-
meister, *Auf den Spuren der Maler der Ile-de-France*, Berlin,
1963, illus. p. 164; Paolo Lecaldano, *L'opera pittorica completa
di Van Gogh e i suoi nessi grafici*, vol. 2, Milan, 1977, no. 853,
illus.

64

TOULOUSE-LAUTREC, *Woman in a Studio*

Gustave Coquiot, *Lautrec, ou quinze ans de moeurs parisiennes*,
Paris, 1921, p. 207, illus. opposite p. 56; Maurice Joyant, *Henri
de Toulouse-Lautrec:1864-1901*, Paris, 1926, p. 266, illus.
p. 97; Arthur Pope, "French Paintings in the Collection of
John T. Spaulding" in *Art News* 28 (April 26, 1930), illus.;
Jacques Lassaigne, *Toulouse Lautrec*, New York, 1939, p. 165,
illus. no. 51; George H. Edgell, *French Painters in The Museum
of Fine Arts: Corot to Utrillo*, Boston, 1949, illus. p. 86; W. G.
Constable, ed., *Summary Catalogue of European Paintings*,
Boston, 1955, p. 64; Douglas Cooper, *Henri de Toulouse-
Lautrec*, London, 1955, p. 78; Giorgio Caproni and G. M. Sugana,
L'opera completa di Toulouse-Lautrec, Milan, 1969, p. 101,
illus. p. 100.

65

VUILLARD, *Woman Sewing*

Charles H. Pepper, *The Collections of John Taylor Spaulding/
1870-1948*, Boston, 1948, p. 20, no. 88; George H. Edgell,
French Painters in the Museum of Fine Arts: Corot to Utrillo,
Boston, 1949, p. 89, illus. p. 90; W. G. Constable, ed., *Summary
Catalogue of European Paintings*, Boston, 1955, p. 68.

66

ANDRÉ, *Woman at Tea*

Forbes Watson, "American Collections: The John T. Spaulding
Collection" in *Arts* 8 (December 1925), p. 336, illus. p. 333;
Marius Mermillon, *Albert André*, Paris, 1927, p. 38, cat. no. 26,
illus.; Arthur Pope, "French Paintings in the Collection of
John T. Spaulding" in *Art News* 28 (April 26, 1930), p. 98,
illus. p. 105; Charles H. Pepper, *The Collections of John Taylor
Spaulding/1870-1948*, Boston, 1948, p. 8, no. 1; W. G. Con-
stable, ed., *Summary Catalogue of European Paintings*, Boston,
1955, p. 1.

67

MATISSE, *Carmelina*

Elie Faure, Jules Romains, Charles Vildrac, Léon Werth, *Henri
Matisse*, Paris, 1920, fig. 1; Roger Fry, *Henri Matisse*, London,
1935, fig. 3; George H. Edgell, *French Painters in The Museum
of Fine Arts: Corot to Utrillo*, Boston, 1949, p. 91, illus. p. 92;
Gaston Diehl, *Henri Matisse*, Paris, 1954, pp. 26, 132, fig. 16;
W. G. Constable, ed., *Summary Catalogue of European Paint-
ings*, Boston, 1955, p. 41; Jean Leymarie, Herbert Read, Wil-

liam S. Lieberman, *Henri Matisse*, Berkeley, 1966, p. 10, fig. 16; Albert Elsen, "The Sculpture of Matisse—Part 2: Old Problems and New Possibilities" in *Artforum* 7 (October 1968), p. 28, illus. p. 29; Alan Bowness, *Matisse and the Nude*, Lausanne, 1969, pp. 28-29; H. Aragon, *Henri Matisse: A Novel*, vol. 1, New York, 1972, p. 350, pl. XLII; Carol Duncan, "Virility and Domination in Early 20th Century Vanguard Painting" in *Artforum* 12, no. 4 (December 1973), p. 33, illus. p. 35; Jack D. Flam, "Some Observations on Matisse's Self-Portraits" in *Art News* 74 (May 1975), p. 51, illus. p. 52.

68

DERAIN, *Landscape, Southern France*

Arthur Pope, "French Paintings in the Collection of John T. Spaulding" in *Art News* 28 (April 26, 1930), p. 98, illus. p. 128; Charles H. Pepper, *The Collections of John Taylor Spaulding/ 1870-1948*, Boston, 1948, p. 10, no. 19; George H. Edgell, *French Painters in The Museum of Fine Arts: Corot to Utrillo*, Boston, 1949, p. 94, illus.; W. G. Constable, ed., *Summary Catalogue of European Paintings*, Boston, 1955, p. 19.

69

BRAQUE, *Still Life*

W. G. Constable, ed., *Summary Catalogue of European Paintings*, Boston, 1955, p. 7; Marco Valsecchi and Massimo Carrà, *L'opera completa di Braque*, Milan, 1971, p. 94, no. 187, illus. p. 95; Maeght, ed., *Catalogue de l'oeuvre de Georges Braque: peintures 1916-1923*, Paris, 1973.

Index